THE COMPLETE
Digital Video
GUIDE

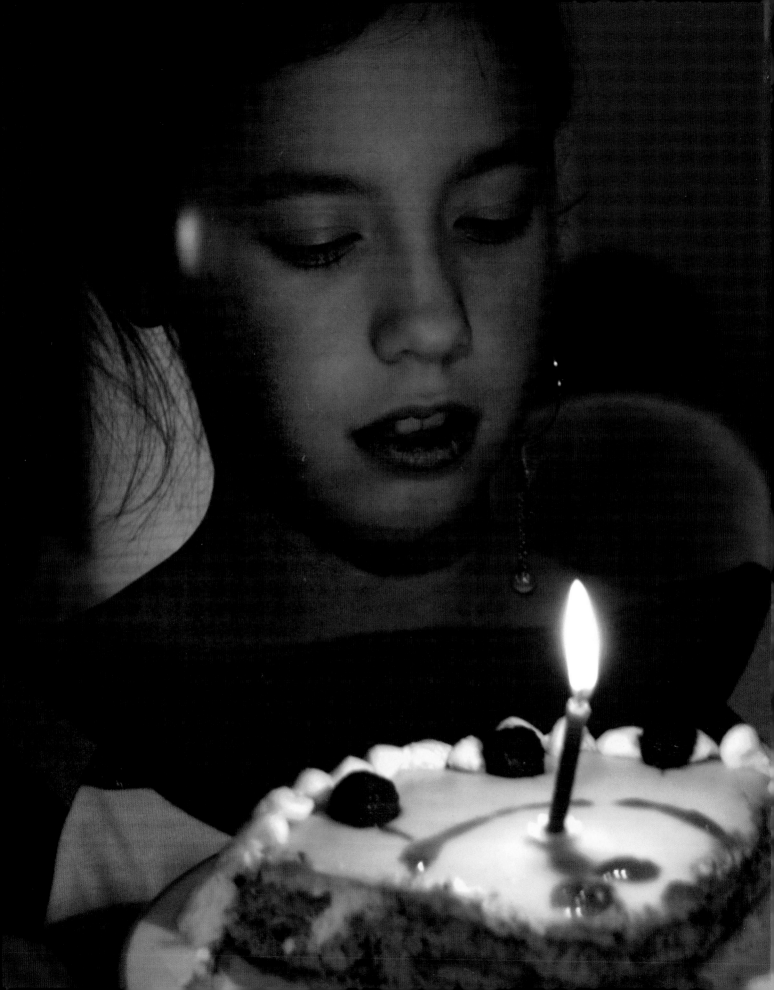

THE COMPLETE
Digital Video
GUIDE

A Step-by-Step Handbook for Making Great
Home Movies Using Your Digital Camcorder

Bob Brandon

Reader's Digest

The Reader's Digest Association, Inc.
Pleasantville, NY/Montreal/Sydney

A READER'S DIGEST BOOK

This edition published by The Reader's Digest Association, Inc.,
by arrangement with Hylas Publishing

FOR HYLAS
Project Editor: Gail Greiner
Editor: Marjorie Galen
Designer: David Perry
Assistant Designer: Loraine Machlin
Editorial Director: Lori Baird
Creative Director: Karen Prince
Publisher: Sean Moore
Illustrator: Joaquín Ramon Herrera

FOR READER'S DIGEST
U.S. Project Editor: Kim Casey
Canadian Project Editor: Pamela Johnson
Project Designer: George McKeon
Executive Editor, Trade Publishing: Dolores York
Manufacturing Manager: John L. Cassidy
Director of Production: Michael Braunschweiger
President & Publisher, Books & Music: Harold Clarke

Library of Congress Cataloging-in-Publication Data
Brandon, Bob.
 The complete digital video guide: a step-by-step handbook for making great
 home movies using your digital camcorder / Bob Brandon
 p. cm.
ISBN 0-7621-0656-5
ISBN 978-0-7621-0656-1
1. Video recording--Handbooks, manuals, etc. 2. Digital video--Handbooks, manuals,
etc. I. Reader's Digest Association II. Title.
TR850.B63 2005
778.59--dc22 2005051007

Address any comments about *The Complete Digital Video Guide* to:
 The Reader's Digest Association, Inc.
 Adult Trade Publishing
 Reader's Digest Road
 Pleasantville, NY 10570-7000

For more Reader's Digest products and information, visit our website:
 www.rd.com (in the United States)
 www.readersdigest.ca (in Canada)
 www.readersdigest.com.au (in Australia)

Printed in China

1 3 5 7 9 10 8 6 4 2

For Kristi, Ron, and Ellie—
my sails
and Mom—
my rudder

CONTENTS

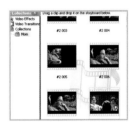

INTRODUCTION

"Cut it in the camera, Brandon. You're up against deadline!" I heard that refrain over the TV station's two-way radio too many times to count in my career. A last-minute story would crop up, and I would race to grab a brief visual report. In those days, before video camcorders were invented, we shot everything on film. The station operated a film processor to develop the footage as quickly as possible, but it always took between 20 and 40 minutes to snake the footage through countless pulleys and loops, into and out of chemical solutions, then to be dried by heat and collected on a huge reel.

The race continued out the door and down the hall to the edit room, where I would slap a length of white leader on the front and back of the short segment of film and deliver it into the hands of the projectionist, hoping I had made it before the anchorman had begun to read his script of the event.

The story made air only because I had edited in the camera as I shot. It wasn't necessary, nor was there time, to project the footage, select scenes, then splice them together. I could have made a more cohesive story with a few more minutes in the edit room, but minutes are golden in the television news business. Faced with the alternative of not airing the story at all, I would opt to air an imperfect piece. If I had done a decent job of editing in the camera—shooting selectively—the piece would make sense.

The technology of moviemaking is vastly different today, but when you open the box containing your new camcorder, you are faced with similar decisions. As you begin to shoot stories to show family and friends, you will need to choose a shooting structure that will require extensive editing or one that will need almost no additional editing at all because you have already done the work while shooting. This is called "editing in the camera," and it's a great way to get started

telling your story right away. And if you think about your story before you start and while you are shooting, you won't wind up with hours of footage you don't need and that no one, not even your mother, will want to watch. In this book, we focus on teaching you about editing in the camera so you will be able to document your family life in the most fun and efficient way possible. We also spend some time on the basics of editing on your computer, for those of you who want to move in that direction.

Either way you edit, in the camera while shooting or on your computer, you will be molding your work to tell the story you want to tell. Thus, a thorough understanding of good storytelling technique is absolutely necessary before you can attempt to shoot a good movie.

Storytelling

Good visual storytelling follows the same guidelines used by great storytellers since the beginning of the spoken word. Well-told stories are full of vivid descriptions, gathering tension, explosive relief, eloquent comparisons and contrasts. They keep you on the edge of your seat with anticipation. And when a really great story is over, you can "see" it in your head.

Over the past 100 years or so, many storytellers found ways to use photographs, then motion picture film, then videotape to enhance their stories. In these pages, we put forth lessons in visual storytelling, showing you ways to do a better job of making home movies. Make no mistake: the art of visual storytelling is complex. It requires lots of practice, trials and failures, and patience—lots of patience.

Equipment

A carpenter needs a good hammer to build a good house, and a photographer needs a good camera to build a good story. Good and expensive are not by necessity the same; nevertheless, you need a camera that will allow control of

the essential operations, such as exposure, focus, and zoom. The principles outlined in this book apply to any camera. It is important to know the camera, really know it. If you keep using your camera and challenging your skills, you'll soon know where each button is located and what it does, and you'll know which way to turn the knob to get the desired effect without looking away from the viewfinder. Otherwise, you may miss an important scene while searching for the proper control.

Lights, Camera, Story

Each button, knob, or menu on the camera represents a photographic principle. Becoming familiar with the principle is essential. It does no good to twirl the aperture knob unless there is some comprehension of how changing the aperture affects the picture. The first chapters of this book explain the principles of camera operation so they can be applied to the camera. We stress the importance of a steady picture; how many fledgling video movies have died in the first few minutes because viewers became seasick from all the swinging and swaying of the camera? And we cover the principles of exposure, focus, lens focal length, depth of field, and the rules of composition. With a bit of practice, you'll soon be controlling the camera without thinking.

Light is the most important tool the photographer possesses. The use of light consequently becomes the most important skill to learn. A photographer, even a professional, learns more about light every day. This book gives you a strong foundation on which to build. The foundation begins with the discovery of the different types of light and how the camera perceives them. It builds with explanations of light ratios, soft and hard light, basic lighting setups, specialty or mood lighting, and the terms used to describe different lights in a setup.

Then it is time to attack the nitty-gritty: story construction. All the principles discussed up to this point apply to still photography as well as video photography. The assembly of scenes into a cohesive story is unique to the craft of video storytelling. There are rules of story construction that help guide the way.

The purpose of this book is to gather under one cover the basic principles of video storytelling. This, by its nature, must include a lot of technical information because many people learn from charts and graphs. Other readers are tactile learners; they grasp the principles only when they get their hands on the camera. Go back and forth from this visual step-by-step guide to your camera. Read a section and then use it, and learn it.

Treat this book as a beginning primer in video storytelling. Master the principles and practice them zealously. Simply recording an image is not telling a story. The single thing that sets this book apart from all the other how-to books on the market is that our goal is to convince you to make camera operation secondary to storytelling. The camera should be treated as an instrument of the craft, a necessary evil. Those of us who have spent our lives infected with the cinematography bug have always been saddled with the burden of heavy equipment. But you don't need a lot of equipment to tell a great video story.

My Story

I began my career when film was the medium for visual communication on television. My first camera was a hand-wound 16-mm film camera made by Bell & Howell called the 70DR. I shot black-and-white film because color film was not yet available for use on television. The industry graduated from black-and-white to color in the late 1960s and from film to video in the mid-1970s.

Each advancement in equipment brought a new camera for me to learn. I would spend countless hours fiddling with the knobs and switches until I could operate them blindfolded. New cameras usually meant new lenses, and I would spend equal amounts of time learning the capabilities and limitations of the lens. The photographer must become one with the lens because it is through the lens that he sees life. He can only record images the lens is capable of capturing.

When I worked for KPRC Television in Houston, Texas, I would occasionally ride the ferry from Galveston to the mainland, about a 30-minute trip. I would haul the camera to the stern of the boat where the seagulls followed,

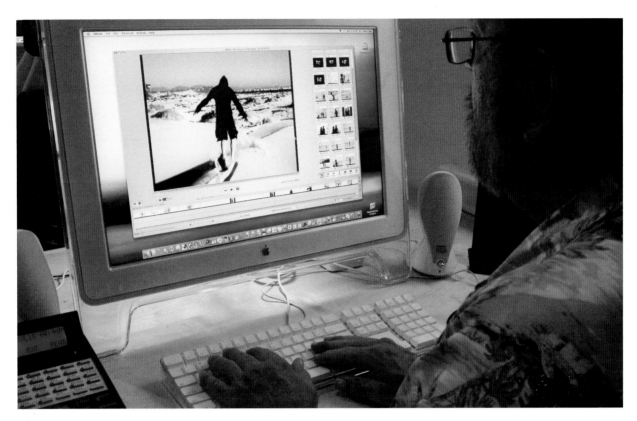

soaring and dipping to the water in search of food. I would zoom in for a close-up on one gull and attempt to follow it wherever it flew. The flight of a seagull, or any bird for that matter, is notoriously hard to predict. So in my attempt to follow the bird, I was not only learning to anticipate its flight but also reacting smoothly to the wild turns. I would also attempt to keep the bird in focus as it came nearer or flew farther away. At first the movements are hard to coordinate, but with practice they become one fluid connection of framing and focus.

I tell this story to illustrate two important points: The first is that the only way you can become better than an ordinary home-movie shooter is to practice, practice, practice with the camera. The second important point is that as the photographer, you must know the camera, all its attributes and foibles, before your practice will be beneficial. Let the camera become like a third hand, an instrument so familiar that thinking about the operation of it isn't necessary. It frees the

mind to concentrate on the story. I frequently keep my camera in the car seat beside me, at the ready, in case I see something interesting I would like to record. In the old film days I also kept my camera in the car, but stopping to shoot something was more complicated. Because the lens had to be manually adjusted, I would rest my hand on the aperture and adjust it to the outside lighting conditions as they changed. When a cloud obscured the sun, I would open the aperture by one f-stop. When the sun returned, I would close it one f-stop.

I required total concentration to do a good job. I have included other personal stories in this book in the "Pro Tip" and "A Story from the Field" boxes to inspire, instruct, and maybe even entertain you. But remember, you don't have to be a seasoned news photographer to tell a good visual tale with your camera. Any story given the benefit of a moment's pause for thought and preparation before shooting is going to be a better story.

CHAPTER 1: CHOOSING THE CAMERA THAT'S RIGHT FOR YOU

How do you choose among the hundreds of camcorders on the market today? Ask yourself how you plan to use your camera: Do you want to shoot your child's baseball games? Capture family vacations? Or make documentaries about your grandmother's life or the neighborhood potter? The camera you buy should suit your needs, whatever they are. Here's some guidance to help narrow down the choices and find that camera.

TYPES OF CAMERAS

Digital video (DV) camera prices range from a few hundred dollars for a no-frills compact camcorder with few manual controls to thousands of dollars for a high-definition camcorder with all sorts of buttons and knobs. The smallest camcorders are almost shirt-pocket size and are ideal for carrying on a hike or on vacation. The industry is still evolving, so prices will continue to drop while quality improves. The options fall into three categories: compact, mid-level, and top-of-the-line camcorders. Most digital video cameras record onto mini DV tape. The same basic rules apply whether you are shooting with a small pocket camera or a fancy high-definition-video (HDV) recorder. Your goal is to tell a story, and that is what this book is about: teaching you how to tell a great story on video. The first step is choosing a camera.

Compact

These are the smallest of the digital camcorders, and they are great for recording family events. Each tape holds between 40 and 60 minutes of video. There are fewer manual controls on these cameras, so you'll most likely be shooting in automatic mode.

Mid-Level

The mid-level camcorders cost more, and all of them offer access to manual controls. The more expensive models allow easier access to the manual functions.

Top-of-the-Line

The top-of-the-line camcorders are the most expensive and can produce near-professional quality images. These are the cameras you would choose if you want to produce videos for events such as weddings, bar mitzvahs, parties, or personal profiles.

Recording Alternatives

Some digital video cameras offer other recording options. Cameras are available that record video onto DVDs or a microchip. The information on a microchip can be loaded quickly and easily into computer editing software. One thing to keep in mind: You cannot archive onto these chips. At some point that soccer game you shot has to be dubbed onto a tape if you want to keep it.

Where to Buy Your Camera

The best customer service is usually found at your local camera store. The sales staff will be familiar with all the specifications of the different cameras, and if the salespeople are good, they will be anxious to help you find the camera that's right for you. The store should also be a place where you are encouraged to come back to get your questions answered—regardless of whether or not you are there to buy anything else.

The Internet can be a good source for the best prices, but use caution before considering an Internet purchase. Make sure the camera has a full manufacturer's warranty and that it was built to local specifications. Some distributors offer cameras built in other countries that may not work well on American video systems. Consider checking your deal by comparing it to the cameras offered by a reputable Web site, such as www.reviews.cnet.com.

DIGITAL VIDEO BASICS

Small camcorders have been available for years, slowly evolving from the crude, large, and heavy VHS portable camcorders to today's tiny digital marvels. Video cameras have shrunk in size and price due to the development of digital photography technology.

What Is a Pixel?

Digital pictures are recorded by exposing an image to the camera's sensor or microchip, called a CCD sensor or charge-coupled device. The chip senses the light and changes it to a numerical value. The numbers are organized and sent to a recording medium as an image file. If you were able to view the file, it would look like your word-processor screen gone wild. Long strings of 1s and 0s represent the value of a tiny piece of light falling onto a tiny portion of the sensor. That portion of the sensor is a "pixel"—an abbreviation for picture element.

Though every digital image is broken up into tiny picture elements called pixels, these are usually invisible to the eye.

By enlarging a digital image, you will be able to see the pixels that make up the image.

How the Camera Sees

Smaller cameras, such as compact camcorders, have one sensor. Higher-end cameras have three. In the compact camcorders, imagine that each pixel on the one chip has a primary color filter: red, blue, or green. The blue filter, for example, senses the amount of blue light in that small bit of the image. All the pixel images are sent to the camera and re-combined to make a digital image of a complete picture. This picture is then recorded onto the tape or other medium.

In the more expensive cameras, a prism in the camera splits the light—directing it to each sensor, which then filters it. Each sensor filters one of the three primary colors. So instead of each individual pixel being filtered, the entire chip sees all the image information and filters for its color. It follows that the resolution and color are much better on a three-sensor camera than on the less expensive, one-sensor model.

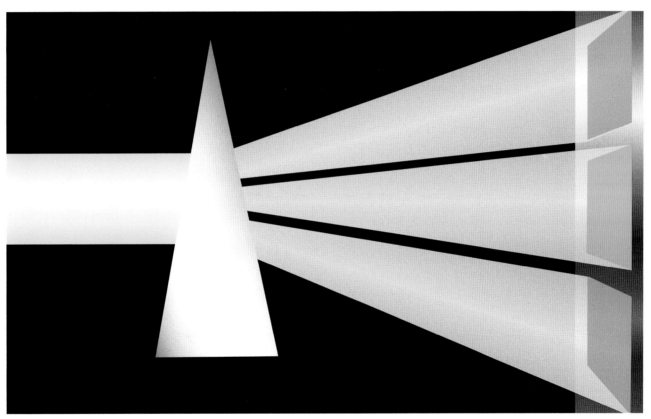

On higher-end cameras that have three sensors, the camera's prism splits light into three primary colors: red, green, and blue. This results in better resoluton of images than those shot from one-sensor cameras.

PRO TIP: Something to Think About When Choosing a Camera

Many of the controls on today's smaller cameras are located on inconvenient menus. These menus are sometimes difficult to negotiate and require you to cease all photography until you have made the necessary adjustments. You can compensate, though, by simply becoming even more adept at handling the camera, knowing which menu to access, and how to do it quickly. When looking at cameras, ask the salesperson to show you how to switch to manual aperture and shutter-speed. This will give you an idea of how difficult the camera will be to operate and should help you narrow down your choices.

COMPACT CAMERAS

Compact cameras are designed for size—a small size. Many controls that were once external dials on film-based cameras have been moved off the exterior and into the camera. This means that most of the settings are accessed through the camera menu and viewed on the camera LCD (Liquid Crystal Display) screen. On these cameras, adjustments are limited. You may or may not be able to control the shutter speed and aperture, and you will probably not be able to control the focus.

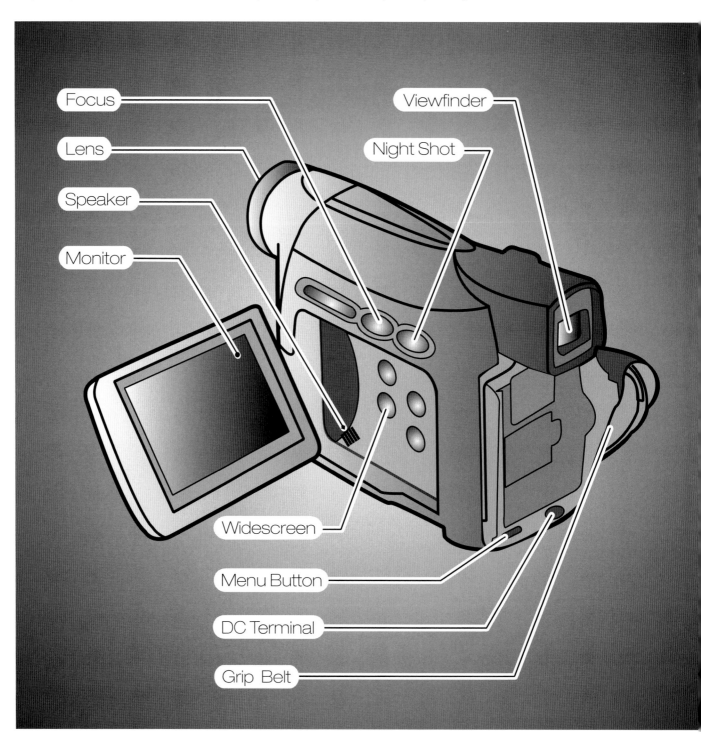

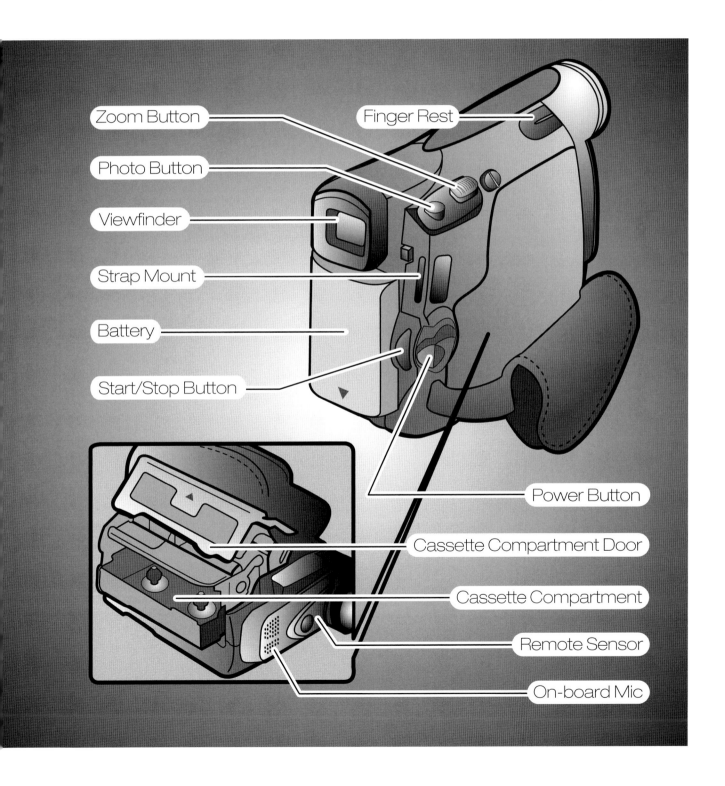

Zoom Button

Finger Rest

Photo Button

Viewfinder

Strap Mount

Battery

Start/Stop Button

Power Button

Cassette Compartment Door

Cassette Compartment

Remote Sensor

On-board Mic

LARGER CAMERAS

The term "larger cameras" covers a wide range of models and prices. All allow you to control aperture, shutter speed, gain, and focus. How you control those functions, whether by external switches and knobs or by an internal menu, varies depending on the camera.

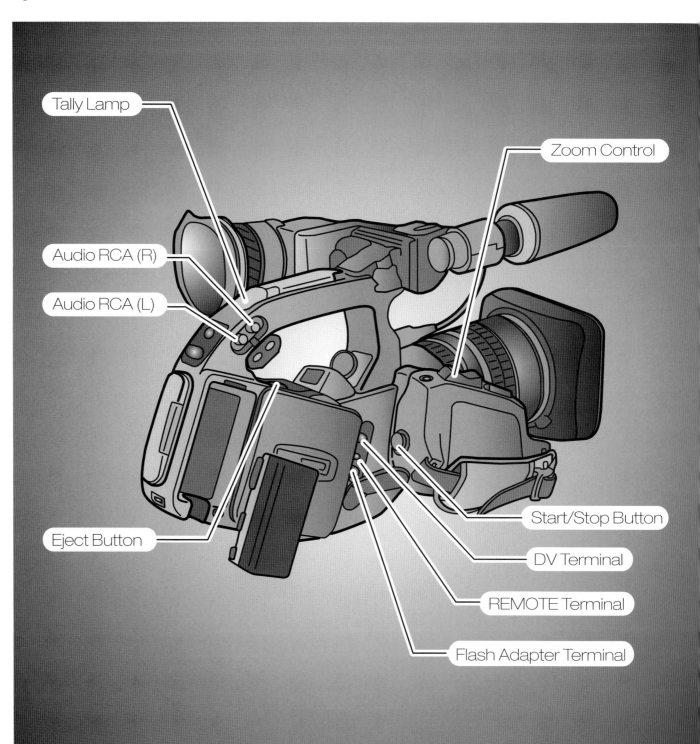

Tally Lamp

Zoom Control

Audio RCA (R)

Audio RCA (L)

Eject Button

Start/Stop Button

DV Terminal

REMOTE Terminal

Flash Adapter Terminal

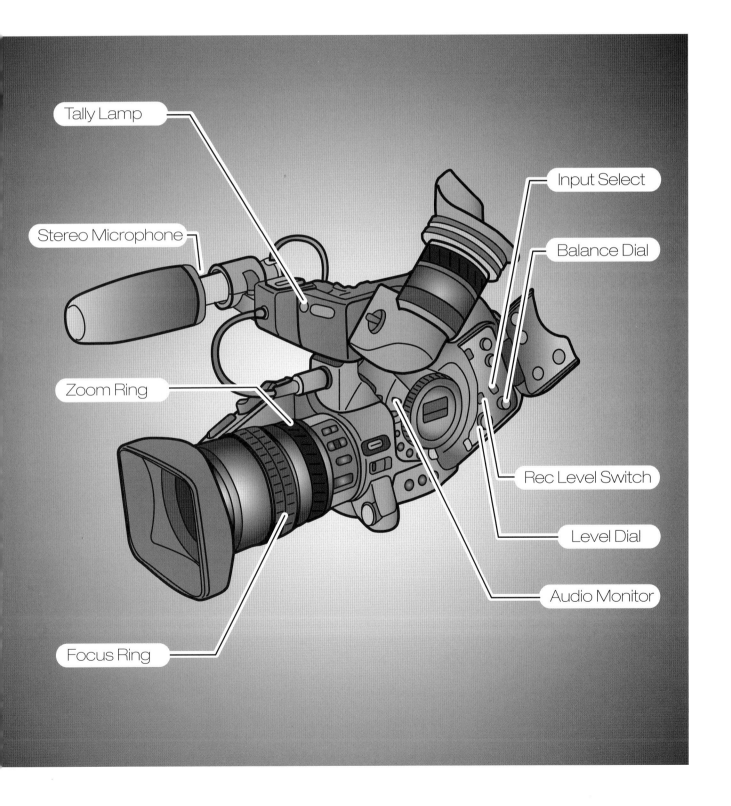

Tally Lamp

Stereo Microphone

Zoom Ring

Focus Ring

Input Select

Balance Dial

Rec Level Switch

Level Dial

Audio Monitor

CAMERA MENUS AND DISPLAYS

All camera menus are different, but most use the same icons on the LCD screen to show which camera settings are currently in effect. The diagrams below will show you what each icon represents.

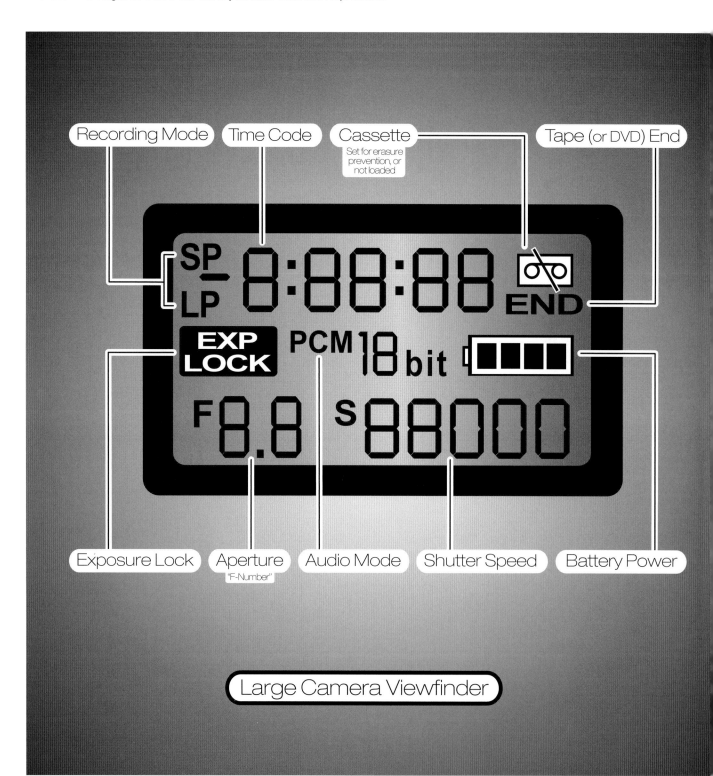

Recording Mode · Time Code · Cassette (Set for erasure prevention, or not loaded) · Tape (or DVD) End

Exposure Lock · Aperture ("F-Number") · Audio Mode · Shutter Speed · Battery Power

Large Camera Viewfinder

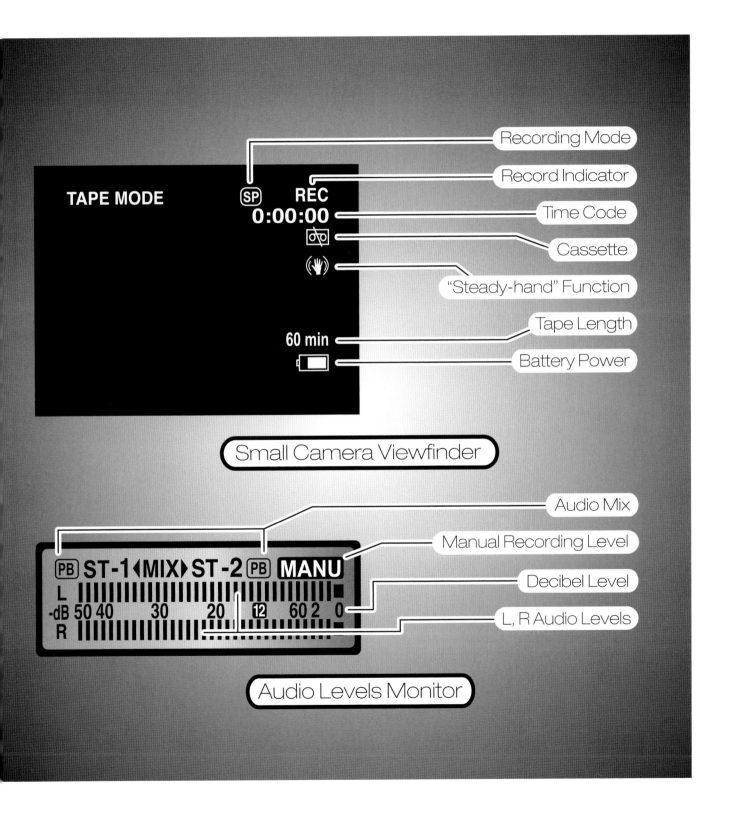

TAPE MODE

(SP) REC
0:00:00

60 min

Recording Mode

Record Indicator

Time Code

Cassette

"Steady-hand" Function

Tape Length

Battery Power

Small Camera Viewfinder

Audio Mix

Manual Recording Level

(PB) ST-1 ‹MIX› ST-2 (PB) **MANU**

L
-dB 50 40 30 20 12 60 2 0
R

Decibel Level

L, R Audio Levels

Audio Levels Monitor

EDIT SOFTWARE AND STORAGE

When you decide to venture beyond simply shooting and editing a story on your new camcorder, you will want to edit scenes together from different events, shorten a lengthy scene, or you may want to add narration or music to your pictures. You have many choices of edit programs for your personal computer. They are called non-linear edit programs and essentially cut and paste your images without cutting the tape. They perform edit functions that only a few years ago would have required a million dollars worth of equipment. Elementary versions of edit software are bundled with the most popular operating systems. Keep in mind that editing on your computer takes up a lot of space on your hard drive, so you may want to invest in some external storage.

Non-Linear Edit Programs

Much like moving sentences around in a word-processing program, editing in a non-linear program is easy. Non-linear programs differ in minor ways—for instance, in the names given to the various sections of the desktop—but all programs share basic similarities. They have a section devoted to the collection of scenes available to the editor. This area is usually known as a "bin" or a "collections bin." A viewing pane displays the scene currently in use. A timeline or storyboard usually fills the bottom third of the desktop. The timeline displays the scenes that the editor has chosen to include in the story. The scenes are shown in order, but they can be mixed and matched to the editor's delight. A running scale at the top of the timeline indicates the length of time the story has run. Separate areas of the timeline are used to add music and titles.

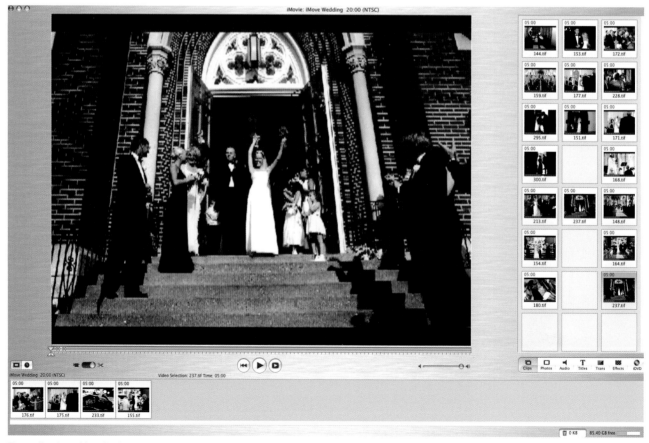

The collections bin, viewing pane, and a portion of the storyboard are shown here.

Higher-End Edit Programs

If you are more adventurous, you may want to investigate more elegant—and expensive— edit programs, such as Avid, Final Cut Pro, Adobe Premiere, Casablanca, and Editrol. Most are software-based and will run on your PC or Mac.

Storing Your Images

Video, even when compressed and digitized, requires lots of disk space. The file sizes are huge—from 3.6 megabytes per second for a digital video camcorder via firewire (high speed) input, to 160 megabytes per second for high-definition video. This means that a simple half-hour school concert, digitized onto your computer, will occupy at least 6.5 gigabytes of disk space. Many computer hard drives will not be able to handle such large files. It's a good idea to purchase an additional hard drive—the largest capacity you can afford. Internal drives work best, but there are good external drives as well. Verify the data transfer speed of any drive you purchase. Some external drives transfer information via firewire and cannot achieve the speed necessary to transfer video to the edit program in "real time." The better-quality drives cost more.

Storing High-Definition Video

High-definition video requires several hard drives connected in a "Redundant Array of Independent Disks (or drives)," or RAID. The RAID drives are synchronized so that video from each drive can be fed into the computer at the same time. This increases by multiples the amount of video information that can be processed. And since high-definition files are huge (more than 288 gigabytes for a simple half-hour program), you really need a RAID to edit them.

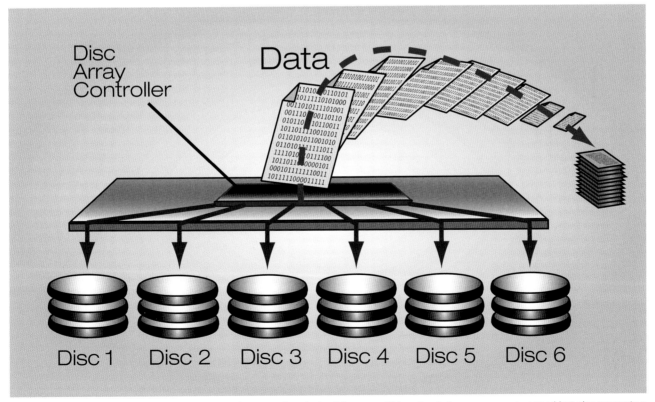

A RAID arrangement of hard drives will segment data over the whole of the array. This not only increases access speed but also prevents a total loss of data from occurring in case the system crashes.

ADDITIONAL EQUIPMENT

When working in the field, you need to be sure your camera bag is stocked with everything necessary to have a successful shoot. Invest in a good bag to protect your camera from shocks and from the elements. You'll also appreciate how it will allow you to keep your equipment and supplies organized.

The Photographer's Gear

BATTERIES

Most camcorders are shipped with a small battery that will run for an hour or so. If you want to avoid the frustration of running out of battery power, you should always carry spare batteries. In this case, bigger is better. A larger battery will run the camera for several hours. Look for a battery that can produce 600–1200 mAh (milliamp hours). Lithium-ion batteries are the best choice; they are lighter, easier to charge, and more reliable than other types of batteries. Some batteries use NiCad (Nickel-Cadmium) cells. NiCads are reliable but lose their charge over time and develop a "memory" if not completely discharged each time they are used—this causes the battery to remember the shorter use time. NimH (Nickel Metal Hydride) batteries offer less power and longer charge times. There are even lead-acid style batteries that don't develop a memory, but they offer a shorter run time.

LENSES AND LENS CLEANER

Don't forget lens tissue and cleaning solution that are specially designed for cleaning lenses. Lightly brush away any obvious particles on the lens surface so you don't mar the lense by grinding in the debris. Use a high-quality tissue that will not scratch the front surface of the lens. Place a few drops of the cleaning solution on the tissue, not the lens. Begin rubbing very gently in the center and continue to rub in ever-widening circles.

FILTERS

The more expensive cameras allow you to place filters in front of the lens. A veritable rainbow of filters is available to alter the image. A must-have is a clear glass or an ultraviolet (UV) filter. The UV filter doesn't affect the color of the image, but it does protect the front element of the lens from nicks and scratches. It's a lot cheaper to replace a cracked filter than cracked lens glass.

RAIN COVER

If you intend to shoot in inclement weather, buy a rain cover. Delicate equipment such as the camcorder does not work well when wet. In fact, just a little moisture in the wrong place can destroy a video camera. In a pinch, grab a trash bag and wrap the camera inside it. Punch a small hole for the lens and one for the viewfinder.

MICROPHONES

A good external microphone will come in handy. The camera-mounted microphones pick up sound in the immediate vicinity—about 2–3 feet from the camera. If you want to record the sound of a performance, for example, you will need a microphone that can be placed much closer to the action. Consider a reasonably priced directional microphone, also known as a shotgun microphone. Don't scrimp on a windscreen: These microphones are notoriously susceptible to wind noise.

STAND LIGHT

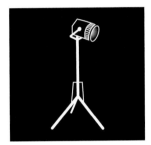

Sometimes you'll need more light than you can get from a camera light; a separate light on its own stand will give you flexibility and extra power. There are many choices of halogen light fixtures that run on electrical current. They range in power from 200–5,000 watts. Somewhere between 200–1,000 is all you'll need.

CAMERA LIGHT

A small battery-powered camera light is a nice addition to your accessory bag. The tiny lights that mount on the camera and operate with power from the camera's battery are underpowered and drain the video camera battery in a hurry. A better choice is a more powerful 12-volt light powered by an external battery. It can be worn on your belt or slung over your shoulder. A camera light should be used only to fill the shadows on a person's face. Don't expect it to light a wide shot in a dark room, but the light will make all the difference in the apparent quality of the facial image. Lights with more punch—that can be plugged into a wall socket—may be a necessary part of your gear at some point as you explore indoor-shooting techniques.

TRIPOD

A good tripod is an important part of any serious photographer's gear. Choose a tripod that can support the camera without jitter. The better, more expensive tripods will have fluid-filled heads. These tripods will allow you to pan and tilt smoothly because the fluid dampens and smooths any residual movement.

HEADPHONES

A good pair of headphones is essential to your kit. Since microphones are so variable, you won't really know what your camera is recording unless you are plugged into your video camera via your headphones.

CHAPTER 2: USING YOUR CAMERA

The new digital video cameras are true marvels. They can capture action, images, and memories that once required hundreds of pounds of equipment. The good news is they have lots of switches and menus to control the image. The bad news is—you guessed it—they have lots of switches and menus. All the more reason to practice with your video camera until you know it well. Next you'll learn how to use your camera with your eyes closed—but you'll want to keep them open.

GETTING TO KNOW YOUR CAMERA

After a little instruction and lots of practice, you should be able to find all of your video camera switches without looking, and know which menu contains each of the vital operations. Think of your camera in the same way a carpenter regards his hammers or a surgeon his scalpel. It's a tool that you use, and it could be any make or model of camera. Some cameras are better than others, some have more features, but they all record an image.

At first the buttons on your camera may seem overwhelming.

After practice and reading the camera's manual, they become familiar.

Take Your Camera with You

Take your camera with you everywhere. When you see a shot, grab the camera and fire away. Having your camera on hand reminds you to think more about pictures, composition, exposure control, and focus. Always keep the batteries charged and a full tape in the camera. Attach one of the batteries to the camera. It is imperative that the camera be ready to shoot at any moment, all the time. Spontaneous events do not wait for the photographer to rummage through a pocket or equipment bag for the battery. Nor do they repeat for the photographer who didn't get it the first time.

It may feel awkward initially, but the more you use your camera, the easier it will be to operate.

Think Like a Photographer

Photographers think in terms of the frame. They see the world in relation to how it would fit inside the box. They mentally compose pictures in everyday life, even if they don't have the camera in their hand. One person might see a dramatic cloud formation, while the photographer will see a shot composed within the confines of the rectangular viewfinder.

Make a box with your thumbs and fingers to form a simulated video frame. Practice visualizing shots within the frame.

The shot magically appears in the improvised window.

Practice isolating elements around you and framing them with your mind's eye. This will hone your ability to compose with the camera.

EXPOSURE CONTROLS

The first stop on the tour of your new camera is exposure control. There are two primary methods of adjusting exposure: aperture and shutter speed. Allow plenty of time to explore the methods of exposure control because one or more will be involved in every scene you shoot. There is a lot to juggle when the camera is in the manual mode; you have to think about aperture and shutter speed all the time. It might be tempting to throw in the towel and switch back to "auto-everything." Don't do it. Be patient and continue to practice. The rewards of truly being able to control your shots will be well worth it.

The camera can do an adequate job in the automatic mode, but the result will lack the finesse a serious storyteller wants. The auto-exposure system has a couple of inadequacies: In automatic mode, the camera reacts to the brightest object in the scene; but a bright light may not be what you want to dominate the image. If the camera is left in automatic mode, the scene will be underexposed because the camera will have adjusted to the brightest part of the image.

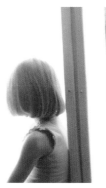

A camera's automatic function cannot help but expose for the brightest area in the frame. Here, the sky takes priority over the people in the shot.

Given a manual adjustment, the camera can be made to expose for a smaller area with more interest.

Set Your Camera to Manual Aperture Mode

To start, find the knobs or menus that offer exposure control. Locate the switch that allows manual control. This switch is usually located on the side of the camera. Once manual control is established, switch to manual aperture control or choose manual aperture in the menu. It may also be called "exposure." Watch the image in the viewfinder as the aperture settings, as indicated by f-stops, change. The picture gets brighter as the aperture is opened and darker as it is closed. Practice adjusting the aperture as your shots change. The faster the aperture can be adjusted smoothly to new conditions, without overcorrecting, the better your images will look.

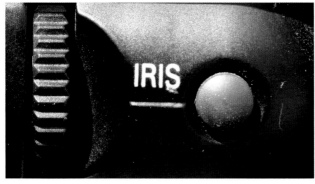
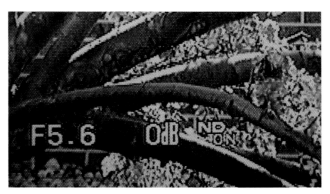

The aperture, or iris, is controlled by the thumb wheel in the lower right.

The aperture numbers are displayed in the viewfinder. In this shot, the aperture is set at f/5.6.

Set Your Camera to Manual Shutter Speed Mode

Next, look for the shutter-speed control, which will also most likely be a menu item. Select shutter speed in the menu and adjust it by turning the wheel in the same way you adjusted the aperture. The shutter in the camera is an electronic version of the shutter in a still or film camera. Its function is to momentarily obstruct light from entering the camera.

The shutter does this in varying steps measured in time from about 1/4 of a second to 1/10,000 of a second. The numbers represent the amount of time light can enter the camera before the shutter closes. A quarter of a second is a relatively long time—long enough that images will blur if the subject is moving. A ten-thousandth of a second is an extremely fast shutter speed. An image recorded at this speed freezes in that instant. Even fans, propellers, and other spinning objects will appear frozen. If you think about it, it makes sense that allowing light to enter the camera for less time means the picture will be darker. As a beginner, you'll adjust exposure with the aperture alone, but there will be times when you may want to control exposure with shutter speed.

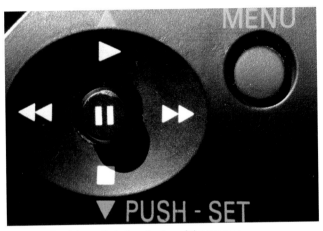

This thumb stick controls the display of the menus.

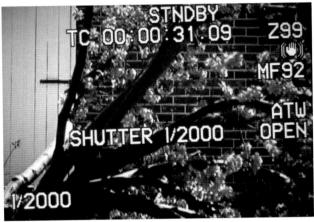

The viewfinder shows the shutter speed is set at 1/2,000 of a second.

Shooting a Portrait in Manual Exposure Mode Using Shutter Speed

A portrait is more pleasing when the subject is in sharp focus and the background is softly out of focus. You can accomplish this by opening the aperture, which shortens the depth of field or the amount of the picture in focus. Opening the aperture can overexpose the picture, so you'll need to increase the shutter speed to allow less light into the camera. This brings the image back to the correct exposure.

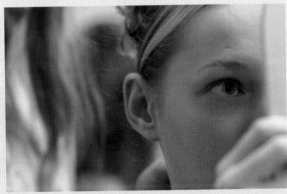

The viewer's attention is drawn to the woman's face because the background is out of focus.

The shutter speed should be increased to compensate for the greater amount of light that a wider aperture will provide.

Understanding Shutter Speed As It Relates to Video

Before you start adjusting shutter speed to affect exposure, you need to be aware of the consequences. It's important to understand that the normal frame rate of a video camera is 30 frames per second; the minimum shutter speed for any single frame is 1/30th of a second. Setting a shutter speed slower than that requires the shutter to remain open longer. The action continues at normal speed, and the image in the frame will tend to blur.

As the shutter speed is increased, the image becomes sharper, but at some point it will start to stutter. This is because the shutter is blocking out major portions of the movement, allowing only tiny bits to be recorded. When the shutter is used at 1/10,000th of a second, fast movements will appear as selections of slides—each slide a brief stop motion of the action. This effect can be used to your advantage in analyzing a rapid movement, like a golf swing.

PRO TIP: Slower Shutter Speeds Slow Everything Down

When shutter speeds are slowed, the automatic functions of the camera are also slowed by a corresponding amount. The automatic aperture will seem stuck in mud when responding to a change in light, and the automatic focus may never be able to find its focus unless the object stops dead still for a while. This is another good reason to turn off the automatic systems and operate the aperture and focus manually.

Shooting at 24 Frames per Second

There's a movement among small-camera aficionados to shoot in what's called 24P, or 24 frames-per-second progressive recording. Motion-picture films have always been shot at 24 full frames per second. When movie cameras were invented, Thomas Edison and others experimented with various rates of filming. They wanted to use as little film as possible, and still have the action look normal. They settled on 24 frames per second. We are so used to watching film shot at this speed that we don't realize that the action is slightly blurrier on film than it would be to the eye. This causes us to subliminally suspend disbelief: the film looks like a movie, not like real life. Video has been engineered at the rate of 30 frames per second, which appears more real. This is why video is well suited for documentary work.

Video cameras can now shoot at 24 frames per second, and many directors of photography choose to shoot at this rate to achieve a filmic look. Unfortunately, shooting at 24P introduces a phenomenon called "jutter," which makes the video look jittery or like the action is stuttering. An option for getting the filmic look at 30fps is to use creative lighting and softening filters.

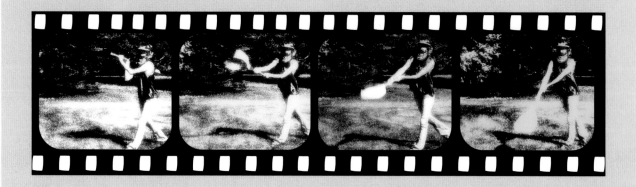

Freeze the Frame

Shooting an airplane propeller in action is a good way to see how shutter speed affects your subject. An airplane propeller shot at 1/60th of a second looks like a disk because the propeller blades moved almost all the way around while the shutter was open. At increased shutter speeds, the propeller seems to slow down until finally stopping at 1/4,000th of a second. The camera is still recording images at 30 frames per second, but each frame is only exposed for the amount of time for which the shutter speed is set. Imagine the videotape pulled along an assembly line. The tape stops for 1/30th of a second, a little shutter opens, and the tape is "exposed." Then the shutter closes, and the tape moves along the assembly line. But sometimes, the little shutter opens for less than a 30th of a second. The tape is still paused in front of the shutter for the whole time, but the shutter opens for only a fraction of that time, then closes, leaving the tape in darkness until it moves along the line.

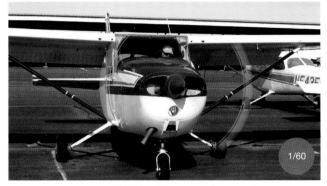

With a shutter speed of 1/60th of a second, the propeller appears to form an almost circular image.

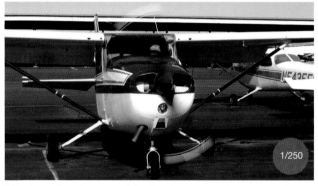

This frame is only exposed for the shutter speed setting of 1/250th of a second, and the propeller is still a blur.

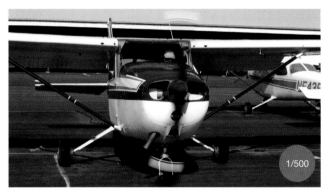

At 1/500th of a second, the moving propeller is finally just visible in the frame.

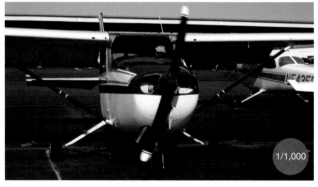

Much more detail is apparent in the frame at a speed of 1/1,000th of a second, although the image is still blurry.

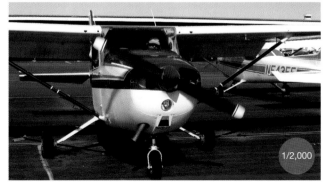

When the shutter speed is set at 1/2,000th of a second, the image is still not sharp—a faint blur implies that movement is still in evidence.

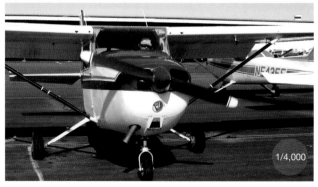

At 1/4,000th of a second, the speed of the shutter makes the propeller in this frame seem frozen in time.

FOCUS

In video, even more than in still photography, focus is a dynamic tool. The subjects of a video story are in motion—sometimes a little, sometimes a lot. The distance between the video camera and the subject is always changing. To keep the subject in focus, you need to be adept at "following focus." This is probably the biggest limitation of consumer-grade camcorders, because focus is adjusted inside the lens electronically and the ability to see focus in the viewfinder is limited. The camera has a manual focus control, but the focus ring is not actually moving the lens. It is sending an electronic signal to the camera to make the adjustment internally. On smaller digital cameras, it takes many turns of the ring to make even the smallest focus adjustment. Fortunately, auto-focus mechanisms are usually pretty good and will find the correct focus most of the time.

Auto versus Manual Focus

Sometimes the auto focus gets confused. Any pattern between you and your subject—a fence, a screen door, or even leaves will cause the auto focus to "hunt" for focus, cycling between minimum and maximum focus. When this happens, shoot from a different angle or with a darker background. In the automatic setting, your camera will focus on what is in the center or most dominant in the frame. The camera decides based on what takes up most of the frame. If you have a person close up, but he only fills up a tiny portion of the side of your frame, the camera will not focus on this person. Sometimes this is what you want, other times not. You can learn to trick auto focus so you can use it to your advantage.

The auto focus had trouble with this shot because of all the lines going in various directions and at different distances from the camera.

The auto focus is focusing on the screen instead of what the photographer is seeing—the world outside.

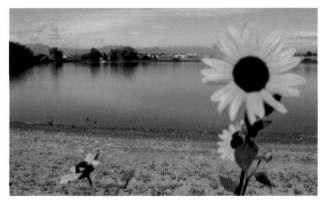

The photographer intended for the flower to be in focus, but the camera's auto focus opted for the dominant center of the frame.

The photographer placed the flower in the dominant part of the frame and it popped into focus. In automatic-focus mode, the camera focuses on the object that is dominant or in the center of the frame.

How to Trick the Focus System

Once you understand auto focus, it's easy to trick it so you can use it to your advantage. Some cameras have a small "auto" button beside the manual focus switch to make it easy to momentarily engage the auto focus.

1 Zoom in tightly on your subject, then temporarily engage the automatic focus.

2 Wait for the camera to focus on the subject.

3 Return the switch to manual focus before zooming out and then shoot your scene.

Creative Focus Control

Creative focus control means telling the camera to focus on a selected item in the video frame, regardless of where in the frame it appears. You can direct the viewer's attention by making the main subject the sharpest part of the frame. To achieve this, the subject needs to be as far away from the background as possible. The camera will focus on the sub-ject, and the background becomes nicely soft and blurry. Also, the background won't compete for attention with your subject. Conversely, if the main subject appears behind an object, like leaves or bushes, separate your subject as much as possible from the foreground.

The camera's aperture is wide open (f/2), and the camera is close to the subject, which creates a very shallow depth of field.

The person's hand and the pencil fish are in sharp focus, while the foliage in the background is so soft it is almost abstract.

DEPTH OF FIELD

Depth of field, simply put, is the distance from front to back in which an image is in focus. Just as in real life, not everything in the photographic world appears in focus at the same time. The photographer needs to know how much of the scene is in focus at any given time. This is called the scene's depth of field. There are times when everything in the frame should be in focus. When shooting uncontrolled action, it is difficult to maintain a sharp focus on an object that is moving randomly. So the photographer might choose to shoot with the wide-angle, or as some might say, "zoomed back all the way." Wide-angle lenses have the shortest focal length, which creates a much larger depth of field so almost everything appears in focus. The range of focus can be calculated for any lens at any f-stop.

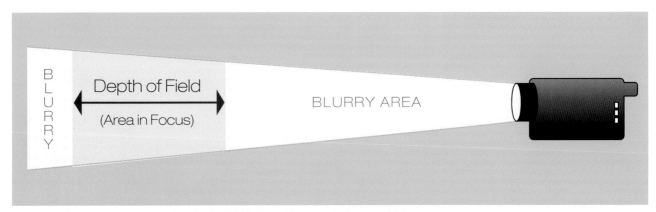

The area in focus in an image is called depth of field. Everything outside that area is blurry.

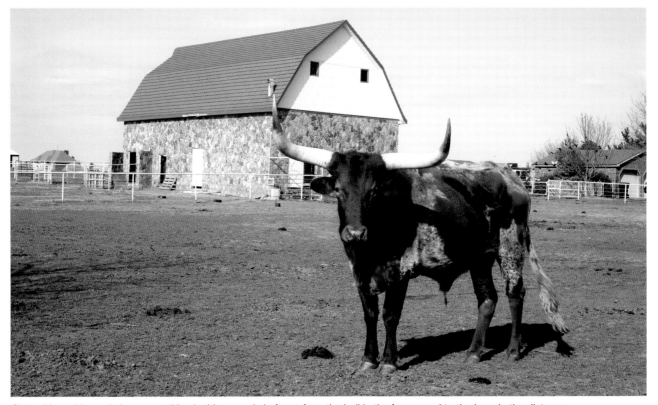

Shot with a wide-angle lens, everything in this scene is in focus from the bull in the foreground to the barn in the distance.

How to Control Depth of Field

There are three ways to control depth of field: focal length, aperture, and distance of the subject from the camera.

The focal length of a lens is, strictly defined, the distance in millimeters from the imaging chip to the rear element of the lens. A wide-angle lens has a very small focal length, and a telephoto lens has a very long one. The distance from the imaging chip to the rear element determines how magnified the subject will be. When the focal length increases, as with a long telephoto lens, the field of view narrows—you see less of the scene in the frame—and the depth of field decreases, so less of your shot is in focus.

The aperture setting also affects the depth of field. A larger aperture number (a small lens opening) yields a greater depth of field, as does the shorter focal length of a wide-angle lens.

So, a wide-angle lens at f/11 would be ideal for the greatest depth of field. Conversely, a telephoto lens at a wide-open aperture (such as f/2), would have the shallowest depth of field, meaning that only things in the foreground of your shot will be in focus. You'll find that it's much harder to focus using a telephoto lens for this reason.

The formula for calculating depth of field explores the relationship of focal length to focal distance. If the subject is closer to the lens, then less of the frame will be in focus. And, conversely, if the subject is farther from the lens, then a greater area, from back to front, will be sharp and in focus. Generally, keep in mind that the depth of field is twice the distance behind a subject in focus as the distance in front of it.

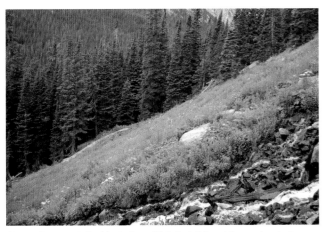

A scenic mountainside is beautiful, but this wide-angle shot conceals its beauty.

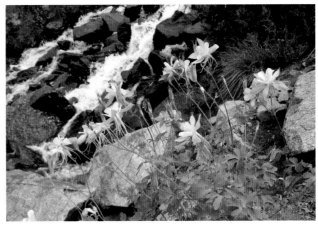

A medium-focal-length shot reveals delicate Columbines sprouting alongside a stream.

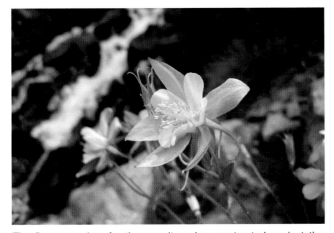

The flower reaches for the sun, its colors contrasted against the deep green of the background is softly out of focus. The focus is determined by the depth of field of the telephoto lens.

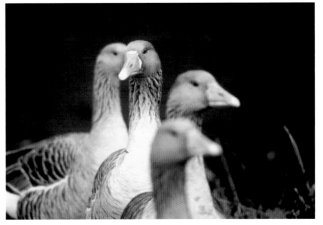

This group of geese grabs attention quickly because the viewer is drawn to the goose in focus. The depth of field in this shot is very shallow, because the geese are relatively close to the lens.

A Scientific Explanation of Depth of Field

When light enters the lens, it is focused to an exact point at the imaging chip. Any part of the image in front of the chip and behind it is out of focus. Even though only one point of focus exists, the point is sufficiently long enough that several items along its path appear to be acceptably sharp.

The smaller opening of a high aperture number creates a cone of light striking the chip that is narrower than the same image at the larger opening of a lower aperture number. The image along the cone is seen as blurry circles of light. If the cone is sufficiently narrow,

the circles are not noticeable. As the cone widens, the circles expand and the image becomes soft and out of focus. This phenomenon is known as "circles of confusion." As the diagrams below show, when the aperture is narrower, the circles stay small much farther in front of and behind the point of focus at the imaging chip. This means that the image along those circles is sharper for a longer distance than it is when the lens is open wider. There are a number of points along the cone where the image is acceptably sharp. This is the depth of field.

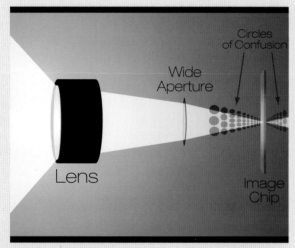

A wide aperture will produce large "circles of confusion."

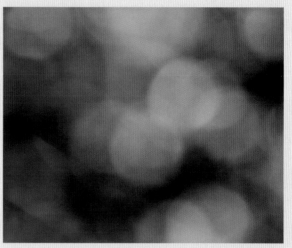

An example of "circles of confusion" in a photographic image.

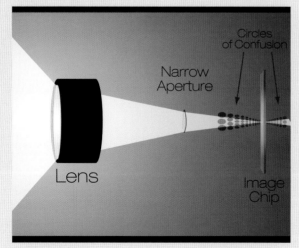

A narrow aperture produces small circles of confusion.

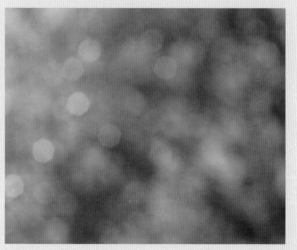

Here the circles of confusion are smaller, due to a narrower aperture, resulting in a picture that is slightly sharper in focus.

Using Depth of Field to Tell a Story

The story below depicts the daily catch at a Denmark harbor. It opens with a wide shot of a fisherman arriving at the dock. Normally a wide shot has the longest depth of field. But in this case, catching him in mid-stride called for a fast shutter speed, which meant that the lens had to be open to its widest aperture. The resulting picture had a depth of field narrower than a normal wide-angle shot.

The medium shot of the fisherman uploading his catch has a large area of focus. The viewer's attention is drawn by the action as he plops down a tray and by his bright orange suit.

An extreme wide shot of the catch reveals the fish and adds the flavor of the harbor in the background. Even though the lens is at a narrow aperture, the depth of field in this photograph is governed by the principle of distance. Since the fish in focus are close to the lens, the depth of field is narrow.

The close-up, shot with the telephoto lens, shows another fisherman happy with the results of his long, cold day. The background is radically out of focus because of the long focal length of the lens; the aperture, set at a wide open setting; and the distance from the subject to the background (which was several hundred feet).

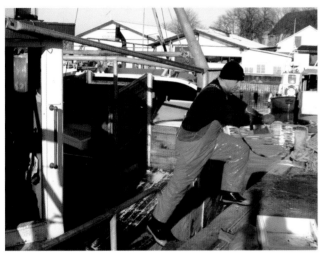

A fast shutter speed was used to catch the fisherman in mid-stride. The aperture needed to be wide open, which narrowed the depth of field.

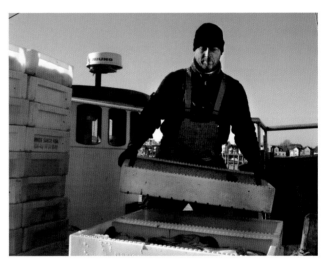

This shot has a large area of focus.

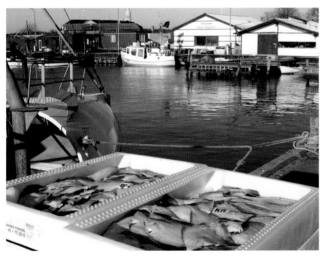

The day's catch in the foreground is accented by the harbor in the background.

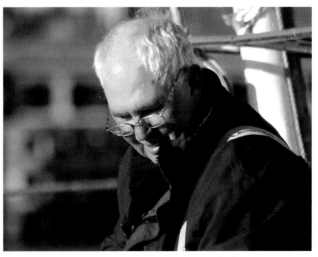

A long focal length, wide-open aperture, and distance between subject and background combine to create a nice portrait with less depth of field.

WHITE BALANCE: A QUICK START

The camera has an automatic mode for determining which colors to assign to objects in the scene. It does this by searching the scene for something white. The camera interpolates all the other colors based on the level of white that it finds. But there is a problem with allowing the automatic mode to choose the color: sometimes it doesn't find white. If it doesn't, it will choose the brightest part of the scene and call it white. This can throw all the colors askew. The automatic white balance setting also creates problems when the camera moves from one color of light to another different color in the scene. The colors will change, and the subject will have a different cast when the scenes are put together.

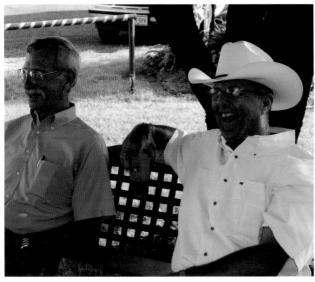

Two men are seated on a bench. The color is askew because the camera hasn't been white balanced.

To adjust the white balance for this scene, zoom in on something white—here, the man's shirt—before any corrections are made.

Push the white-balance button to tell the camera what is white. Here, the shirt color is corrected.

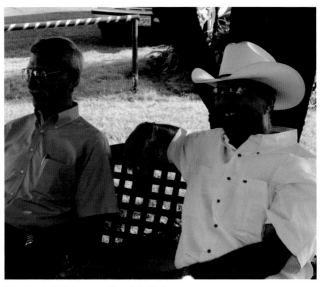

The final shot is correctly white balanced.

RECORDING SOUND WITH YOUR CAMERA

A big part of the video storytelling fun is hearing what's going on, as well as seeing the action. A child's birthday party comes alive with singing, and a soccer game with cheering will make the viewer feel like he's really there. The built-in microphones are great, but you should understand how they work and know their limitations. If your audio needs are more complicated, you can always improve your sound by buying an external microphone.

Audio is recorded in stereo onto the videotape with the sound coming in from a built-in omnidirectional microphone—usually located near the lens. Many people expect the microphone to hear a speech from 10 feet away. It won't. The microphone is designed to record sounds close to the camera and in roughly a semicircular area in front of it. Your camcorder has two microphones, each one recording the same pattern. Still, the camera microphone cannot be expected to distinguish sounds emanating from more than four feet away.

Get Close for Sound

The first rule of thumb when recording audio is to get close. Audio is recorded with the levels set by an automatic gain circuit. Auto gain limits the loudest sounds so they will not overmodulate and distort the sound. It also raises the level of the faintest sounds in an attempt to bring them to a recordable level. Basically, it tries to even out the sounds—the loud sounds are softer, and the soft sounds are louder. And that's probably not exactly what you want. Limited loud sound is a good thing; otherwise the audio will be distorted. But faint sound is usually faint for a reason—it's coming from far away, or someone's whispering—and amplifying it can really change the story you are telling.

Controlling the Audio Manually

On many cameras you can take manual control of the audio, usually by using the menus and the toggle wheel. Audio levels for the left and right channels will be displayed in the viewfinder on the bottom of the screen. All video cameras have two channels, or inputs, for recording audio. Audio strength is measured in decibels or "dB." Try to have the loudest sound peak at about -10 dB. The peak is the highest point the level indicator reaches on the loudest sound. Make sure the audio never exceeds 0 dB, or the sound will distort.

A stereo microphone sends sound to right and left channels.

The viewfinder shows an indicator of audio levels.

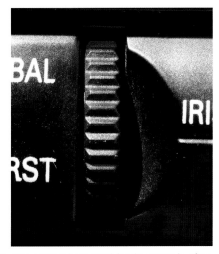

The same wheel used for the menu is often used to control volume.

HANDLING YOUR CAMERA

A steady shot is your goal; one without unnecessary camera movement. You've seen plenty of home videos with lots of shake that make you, the viewer, seasick before they're over. Your subjects will be active, and you must be able to keep up with them. Here are some tricks to help keep the camera from looking like it's bouncing around.

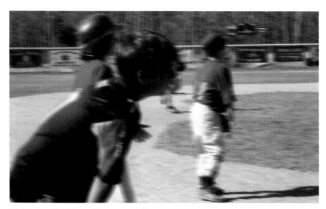

This shot is blurry because of the photographer's unsteady hand.

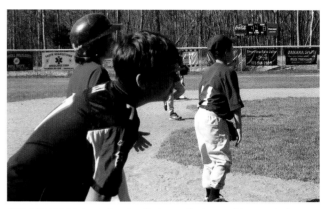

When the camera can be steadied, your footage will be much sharper.

Using a Tripod

Use a tripod when possible. Make sure it's level, so your characters won't appear to be walking downhill as they cross the frame. Some tripods have a leveling bubble, but if yours doesn't, choose a horizontal skyline or the vertical side of a building to level the camera. Lock the set knobs on the tripod, then record your scene. Keep your hands behind your back so you are not tempted to touch the camera and possibly upset the shot.

Choose a tripod that is small and light, but substantial enough to support the camera without shaking or jiggling. Fancier tripods, such as those with a fluid head, will allow you to smoothly follow the action—panning or tilting as needed.

Make sure your tripod is level and the set knobs are locked before you begin shooting.

Remember to avoid leaning on the tripod as you shoot so the camera does not end up shaking or jiggling.

Using a Monopod

A monopod provides a single stable platform from which to shoot. Monopods attach to the bottom of the camera and extend to the floor. They work very well, and don't weigh you down as much as a tripod. You can also make your own monopod. Take a broomstick and insert a 1/4-inch, 20-thread stud into the end, and screw it into the tripod mount of the camera. Be careful because monopods, since they are not balanced like a tripod, have a tendency to promote a side-to-side sway that is not always noticeable until you watch the videotape later.

Handholding the Camera

Using a tripod can often be impractical. Other times, it can feel like an anchor, holding the camera down and keeping you from getting to your shot. In these cases, you will need to handhold your camera.

Developing a good handholding technique takes practice, but it is an essential skill for the video storyteller. The best handheld shots are going to be taken at a wide angle. The smaller digital video cameras don't have changeable lenses, but you can buy an inexpensive wide-angle adaptor for the built-in lens.

Handholding won't work when a telephoto shot is required. As you zoom in, the image becomes much more shaky. Even professionals have trouble handholding a telephoto shot. The best way to get a close-up? Get close up!

Turn Your Body into a Tripod

Practice holding the camera while standing. Your right hand should be snug inside the strap with your fingers relaxed. Your left hand should be cupped beneath the lens. Tuck your elbows into your belly, making two simulated legs of a tripod. Press the camera to your forehead, so your body helps steady the camera and simulates the third leg. Practice breathing from your diaphragm, slowly and evenly. Diaphragm breathing is good because your chest doesn't heave—smoothing and dampening the movement of the upper body—and it creates a steadier picture. Don't grip the camera. Gripping causes the camera to shake. Relax your fingers and let the camera rest in your hands.

Brace Yourself

Steady your shot by bracing against something: a tree, a lamp-post, a doorway, a chair—even the wall. When using a tree or pole, brace your arm against it and lean into it. When using a chair, turn the chair backward and straddle the seat. Place your elbows on the chair back. You can also drop to one knee and rest an elbow on your other knee. This means the camera is lower, but this can make the shot even more interesting. In fact, floor level can also be a good shooting angle and will add a different perspective. Place the camera on the floor, and use a magazine or a book to adjust for the shot.

Brace on the roof or hood of a car. Your elbows become two legs of the tripod, and your head and body become the third.

The elbow is steadied by the knee. Notice the fingers are loosely holding the camera, not gripping it tightly.

How to Walk with the Camera

If walking with the camera is necessary, here are a couple of tips to make the image smoother. Bend at the knees to create a cushion and to enhance stability and agility. March in step with the subject, matching up and down movements to minimize the effect on the picture. It's easy to tell if you're out of step—the subject's head will appear to bounce up and down in the frame as you walk. A quick hop will synchronize your step with the subject's and the head movement will almost disappear. Support the camera away from your head and keep your eyes open, occasionally glancing behind to keep from stumbling. An assistant can help in guiding you backward by tugging you in the direction you should go.

This is a good handholding posture. Walk with your knees bent, holding the camera away from your face.

Notice how the knees are relaxed enough to cushion the impact of walking on the cement.

Handholding When You Really Need a Tripod

I had a memorable assignment where carrying a tripod was impossible. A small volcanic mountain in northern Oregon named Mount St. Helens suddenly became active again in 1980. After months of rumbling, groaning, and seismic activity, the volcano blew with disastrous results. I was assigned by the ABC News show *20/20* to accompany the first search-and-rescue teams to the mountain. We flew aboard National Guard helicopters with military and civilian searchers. After landing in a small clearing, we had to climb over trees that had been toppled like matchsticks by the volcanic blast. I was barely able to scale the huge obstacles with the camera. Carrying a tripod along with all the rest of the gear was impossible. I had to find ways to steady my shots, so I braced against fallen trees. I even braced against my soundman's shoulder for one shot. The searchers, who were not carrying so much equipment, quickly climbed far ahead of us. My only chance for a shot of them was to zoom all the way out to my most telephoto setting. I placed the camera on a fallen tree trunk and fine-tuned the shot by placing rocks under it. The resulting shot was a dramatic example of the task the rescuers faced on the slopes of this demolished paradise. We hiked down to our ejection site and boarded the helicopters for home at the end of an eight-hour adventure. The footage I shot that day became the anchor for a 25-minute documentary on the volcano that appeared on *20/20*.

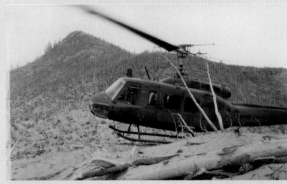
The wide shot shows huge trees scattered like matchsticks.

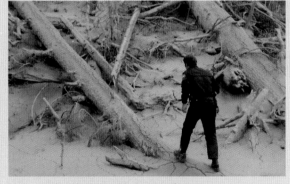
I struggled to keep up with the searchers.

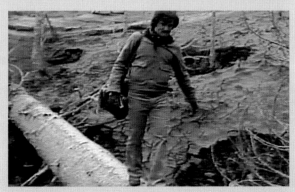
I resorted to using a fallen tree as a brace to hold my camera steady for this telephoto shot.

A wider shot reveals the difficulty presented by the terrain.

PANNING AND ZOOMING

It's easy for the beginner to get distracted by all the things the camera can do and forget about telling the story. Pans, tilts, and zooms are unnatural acts, ones that the human eye cannot and will not duplicate. Try zooming with your eye. Pick any two objects in the room. The eye will do, in effect, a wide shot—one that takes in the two objects and encompasses the entire room. Now concentrate on just one of the objects. The eye will "cut" to the object. It will not zoom. The eye eliminates the unnecessary movement and gets right to its destination. Now look at the second object. Notice that the eye did not pan to get there. It just "cut" to the object. No wasted time, no blurring. Try though you might, you cannot make the eye do pans or zooms. So, don't do them with your video camera either. As with every rule, of course, there are exceptions. Panning is useful when following a moving object, and you may have to zoom when shooting a close-up on a tripod.

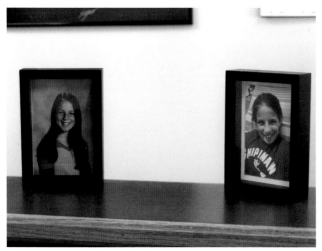

The eye takes in both framed pictures on the counter as a "wide shot."

If you want to see one of the pictures close up, the eye will "cut" to that picture. It won't zoom.

If you want to look at the other picture, again the eye will "cut" there. It does not pan.

This is what it would look like if your eye panned from one picture to the other. If you started seeing like this, you would get dizzy!

When a Pan Is a Good Idea

When the camera is tracking a moving object, it is natural for the camera to follow the object as it passes by. Technically, this is considered a pan, but think of it as just following the action. It's a good idea to lead the moving object; that is, to give it more room on the side of the frame in the direction it's going. Remember to pan smoothly—don't jerk the camera up and down.

The photographer has not allowed any lead room in this shot.

In this shot, the photographer has allowed room on the right, leading the object.

PRO TIP: Let the Buyer Beware

Camera manufacturers add all sorts of special bells and whis tles to their digital camcorders in an effort to entice buyers. Some tout their 40X digital zoom feature on the lens; others offer special effects such as fade-to-black, picture-in-picture, chroma-key, 24-frames-per-second progressive scan recording, and the ability to snap still photos and store them on a memory chip. These features might be useful at some point in the future, but a beginning videographer should try to avoid wandering into this morass. Keep in mind that any effect created in the camera cannot be reversed. The digital zoom feature is a particularly misleading one. The lens is capable of a certain zoom range. The range is plainly identified on the lens. It is expressed in multiples of the widest-angle focal length. A 10X lens with a wide angle of 10 mm would have a maximum telephoto focal length of 100 mm. If the manufacturer of the camera claims it can produce a whopping 40X digital zoom, here is what is happening.

The camera enlarges the image so that the center portion of the picture occupies the entire frame. But it is also enlarging the size of the individual pixels that comprise the picture, and by the time it reaches the touted 40X, each pixel is huge and the image is barely discernable. Do not be fooled by claims of digital zooms. Don't even bother to turn the feature on unless it is needed to create that specific pixelated effect.

The still-photo mode usually produces moderate- to poor-quality images. Digital still cameras have become known by the number of pixels they can create. A good still camera can resolve 5 mega pixels. The still-photo portion of the video camera will be hard-pressed to produce a 2 mega pixel image. It is useful for reference or a very small enlargement but not much else.

PHOTO OPPORTUNITIES

Using natural light and the reflecting qualities of water, the beauty of the outdoors is captured wonderfully.

This may seem like a dim shot that could benefit from some fill light, but if every scene were filled with light, you could never achieve the mood that comes along with shadows, or pools of light that break up a dark area.

Carrying your camera with you at all times enables you to capture many of the photographic opportunities you may encounter.

CHAPTER 3: YOUR CAMERA AND LIGHT

Capturing any image, moving or still, on film or digital, is all about light. In fact, photography literally means "painting with light." So it pays to know a bit about how light works in relation to your camera before you start shooting. Remember, your goal is to use light to create emotion and story. In this chapter, you will learn exactly how to manipulate light to make the best videos possible.

MANIPULATING LIGHT WITH YOUR CAMERA

In photography, you create pictures by manipulating the intensity of the light entering your camera. This is called controlling exposure. In videography, exposure is the amount of light falling on the videotape or memory chip in your camera. Choreographing exposure control is an art, and you will become an artist as you begin to understand the how and why of each exposure control function.

Three Ways to Control Exposure

There are three ways to control exposure: (1) the aperture, (2) the shutter speed, and (3) gain. Of these three, the size of the aperture—also known as the f-stop or the iris—is used most often to control the amount of light and is the easiest of the three to manipulate. Shutter speed is adjusted when the aperture alone cannot handle bright daylight, or when a special effect is desired. And gain is the tool of last resort—when light is too dim and no other means of supplying additional light can be found.

Aperture

The aperture is a diaphragm inside the lens created by interwoven leaves that, when rotated, open and close, getting bigger and smaller to allow light into the video camera.

These settings on your camera are known as f-stops. F-stops are confusing because the numbering system is counter intuitive: A larger f-stop means a smaller aperture, or hole, which lets in less light. A bright sunny day at the beach will require less light and, therefore, an f-stop setting of f/16. In lower light or indoors, it will be necessary to open the aperture to let as much light as possible into the camera by using a setting of f/2. Sometimes you can trust the camera's auto exposure mode, but it's best to take control of the aperture yourself by using the manual mode.

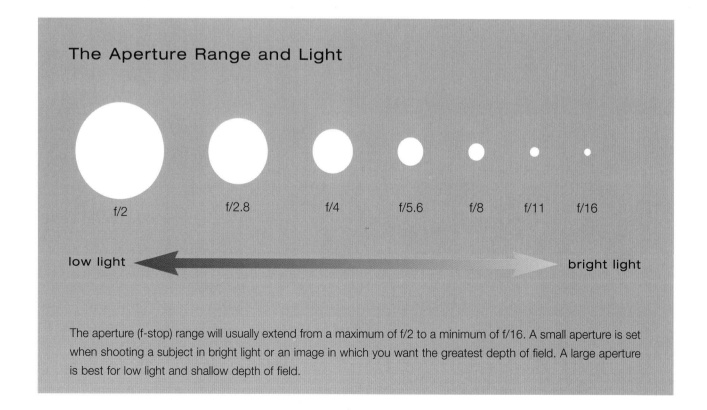

The Aperture Range and Light

f/2 f/2.8 f/4 f/5.6 f/8 f/11 f/16

low light ← → bright light

The aperture (f-stop) range will usually extend from a maximum of f/2 to a minimum of f/16. A small aperture is set when shooting a subject in bright light or an image in which you want the greatest depth of field. A large aperture is best for low light and shallow depth of field.

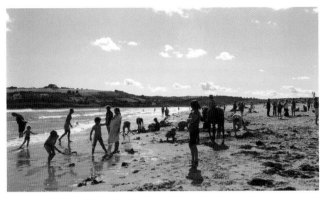

Bright midday at the beach requires less light and an f/16 aperture.

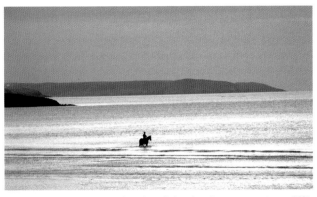

A beach in late afternoon has less light; therefore an aperture of f/8 works best.

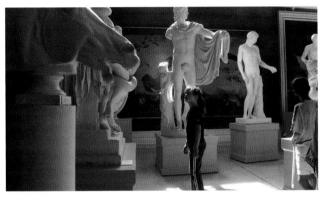

Daylight indoors calls for an aperture of f/5.6.

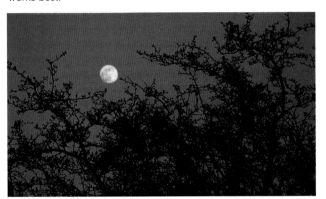

A dusk scene with the moon low in the sky is best shot using a wide-open aperture of f/2.

F-Stops: A Technical Explanation

The f-stop is a number representing the focal length of the lens divided by the lens diameter. So, a 100 mm lens with an f-stop reading of f/2 will have a diameter of 50 mm. The next higher f-stop is f/2.8 with a diameter of 35.7 mm. Now you might ask what possible relationship would f/2.8 have with f/2 in halving the amount of light entering the lens? This is because the "amount" of light relies on the area of the circle the diaphragm creates. The area of a circle is determined by the formula π times radius2. It's important to remember that pi equals approximatly 3.1416 and the radius is one-half of the diameter. So, if we apply the formula for our 100-mm lens set at f/2, the formula will be as follows: $(3.1416) \times (50/2)^2 = 1{,}963.5$ mm^2 (the area of the circle of the aperture at f/2). The same 100-mm lens set at f/2.8 will be calculated by multiplying $(3.1416) \times (35.7/2)^2 = 1{,}000.98$ mm. The area of the aperture opening at f/2.8 is almost exactly one-half of the lens opening at f/2.

Why do we go through the process of creating f-stop numbers? Why not just refer to the actual area of the circle? The photographer could say that he shot a picture at 25 mm and he would be correct, but with which lens? To shoot 25 mm on a 50-mm lens is quite different than 25 mm on a 100-mm lens. The f-stop is needed to provide an "apples to apples" language for lens aperture. An f-stop of f/5.6 is f/5.6 no matter which lens is used.

F-stop = focal length of the lens ÷ lens diameter

Lens diameter = π (or 3.1416) x radius2

Using Zebras to Set Aperture

In the manual mode, achieving the correct exposure is crucial, but it can be difficult. To help, most cameras have a built-in tool called the zebra pattern. The zebras can be turned on or off, and they are adjustable on some cameras. Set the zebra level at 100 percent and the stripes will appear in the viewfinder on any part of the picture that is white. Some photographers like the zebras to appear at levels less than white. For example, they will set the zebra level at 70 percent, which will tell them that lighter skin tones are properly exposed. This may be confusing for the beginner, so it's best to set the zebra level at 100 percent to start. It's also difficult to use the zebras if nothing in the picture is white. Pick the brightest item in the scene. Open the aperture until zebras are seen over that item, and close the aperture an appropriate amount. Determining that appropriate amount is the hardest part of using zebras, and can only be determined by prolonged practice with your camera. When you've gained some experience with your camera, you'll be able to tell in the viewfinder whether your picture is correctly exposed. The zebras can only be seen in the viewfiner or the side monitor. They are not recorded onto the tape.

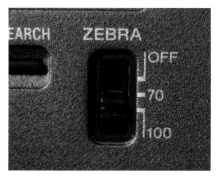

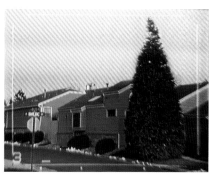

1 The zebras can be set to different levels, but it's best at first to set them at 100 percent. Therefore, when a zebra pattern is seen on any part of the picture, that part is exposed at 100 percent and it should not be exposed any farther.

2 With the setting at 100 percent, open the aperture until the zebras appear on something white in the picture. Open it no farther, and you will have a scene that is correctly exposed.

3 The overcast sky has been chosen as white, and the houses and trees are properly exposed against that bright background.

Gray Scale

Everything related to adjusting exposure is based on the principle that a quantifiable difference in exposure takes a doubling or halving of the amount of light entering the camera. Each f-stop setting, from f/2 to f/16, lets in one half as much light as the previous setting.

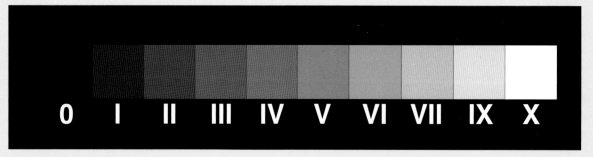

The amount of light reflected by stop IV is twice the amount reflected by stop III.

Auto Exposure: When It Works, When It Doesn't

In auto exposure mode, there are times when the camera misinterprets the scene and gives false zebra readings. But those instances happen rarely and can be overruled by the attentive photographer. The trick to having consistently good exposure throughout your movie is to use manual exposure and faithful employment of the zebra pattern in the viewfinder.

False readings are most likely to occur when the scene contains a brightly lit subject against a dark background. The same problem will exist when the subject is placed against a bright background. The camera will average the light in the scene and try to underexpose the subject.

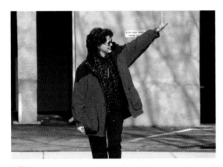

1 In this scene, the woman is properly exposed.

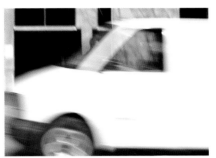

2 When the van crosses the scene, the auto exposure closes down the aperture to let in less light.

3 The van has passed, but the auto exposure takes several frames to readjust, so this shot is underexposed.

How to Trick the Camera into Using the Correct Exposure

The photos below are compelling because the dancer is underexposed and technically too dark to see the details of her face. If the photographer had exposed for the level of light on the near side of her face, the outdoors would have been lost. Alternately, in auto exposure mode, it is likely that the camera would choose to set the aperture according to the bright light behind the dancer. This would cause all detail of the dancer to be lost, making her a silhouette. In this case, neither is correct.

Using manual exposure and zooming in to the brightest part of the scene can help you trick the camera into the correct exposure. Remember that anything overexposed—with video levels in excess of 100 percent—will be void of picture information, and nothing will be recoverable from these portions of the scene. Determining the correct exposure for difficult lighting situations is one of the hardest parts of videography. Try different exposures and see what you like best.

1 Zoom in to a tight spot, filling the frame with the subject to exclude the background.

2 Zoom back out to compose the scene. You must be in manual exposure mode, or your settings will be lost.

How the Aperture Affects Depth of Field

Depth of field is the amount of the scene in focus from front to back that is in focus, and the aperture affects depth of field. A larger f-stop number yields a greater depth of field, as does a shorter focal length—like a wide-angle lens. A wide-angle lens at f/16 would be ideal for the greatest depth of field. Conversely, a telephoto lens at a wide-open aperture of f/2 would have the shallowest depth of field—perhaps only an inch or so. Video cameras, especially digital video cameras with automatic lenses, have a very shallow depth of field when compared to a regular camera. Remember that more things are in focus with a higher f-stop number.

To draw attention to your subject, use a shallow depth of field to blur the unimportant elements. This photo was taken with a wide-angle lens at a wide-open aperture setting.

Depth of Field and People

When photographing people, it can be effective to get rid of a distracting background or foreground by making it blurry. You can create this effect by opening the aperture all the way. This creates a shallow depth of field. Then, when you focus on the subject, it will be clear and crisp against a soft, blurry background or foregound. The non essential elements of the shot won't compete with the subject, and the subject will be the main focus of the viewer's concentration.

A smaller aperture number, such as f/16, results in a greater depth of field. Everything is in focus.

PRO TIP: You Can't Fight a Gray Day

I have flown thousands of miles in helicopters to shoot aerial scenes of city skylines, nuclear submarines, and in this case, the aircraft carrier *John F. Kennedy*. On hazy days, the sea and the sky meld into one. All the colors disappear, and the viewfinder just looks gray. The tendency is to open up the aperture to force more detail into the picture with a brighter exposure. While it is true that a brighter scene will seem to have more information, it is very easy to overexpose the scene and the few highlights that exist will be blown out. If the day is gray, not even the best photographer can make it appear otherwise.

Shutter Speed

Exposure on a digital video camera is generally controlled by the aperture opening or f-stop. But sometimes you will want to change the shutter speed to allow less light into the camera. Imagine the shutter as an eyelid between the lens and the camera. The eyelid opens and closes every few tenths of a second, which interrupts the light intermittently.

Normal shutter speed is 1/60th of a second. There are 30 video frames in every second, so the shutter is open for one-half the time each frame is available for exposure. The camera can adjust shutter speeds in intervals up to 1/10,000 of a second, exposing the frame of light for only that fraction of time. One way to understand the relationship between aperture and shutter speed is to compare the aperture to a water pipe and the shutter speed to a shut-off valve. The aperture is a large or small water pipe, depending on the aperture setting. More water flows when the pipe is big than when it's small. Therefore, a small f-stop number allows more water to flow than a large f-stop number.

Now imagine a shut-off valve attached to the pipe. The valve can be turned on and off at really fast intervals. The valve will work in the same way on any size pipe. More water flows when the valve is open than when it is closed. A fast shutter speed allows less water to flow. A slow shutter speed allows more water to flow.

The big difference between the shut-off valve and the camera shutter is that the camera is doing it all electronically. There isn't a big shutter blade buried inside the camera, spinning madly around. The imaging chip receives or rejects light according to an electronic signal it receives from the video camera.

A slow shutter speed will blur the image.

A fast shutter speed will make action seem sharper, but some movements may seem to stutter.

How Shutter Speed Affects Your Exposure

Shutter speed is used most often to compensate for too much light when just your aperture is not enough. When the sunlight is too bright for the camera to handle, you can increase your shutter speed in small increments to compensate. An increase of 1/250th of a second will usually be fast enough. The relationship between shutter speed and aperture setting, or f-stop, determines exactly how much light is used. If your camera is set to automatic, this balance will be adjusted by the camera. Remember: the faster your shutter speed, the less light that reaches the camera, and the larger your aperture must be set (f/2 is a "wide-open" aperture setting).

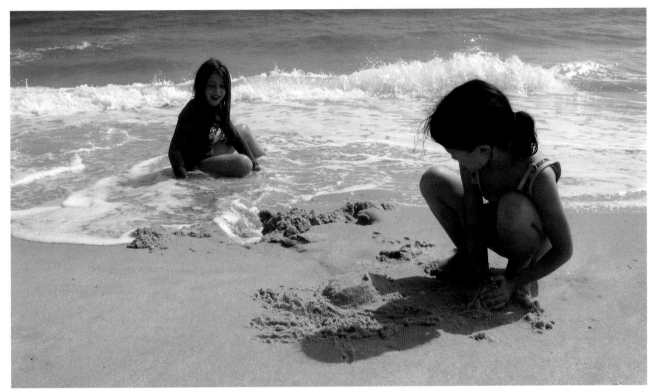

Even with the aperture at its smallest setting, sometimes there's too much light at the beach. So, you'll need to select a faster shutter speed.

How a Digital Camera Sees Light

Digital images are recorded as a file. The computer sees the picture as nothing more than a large text document. It looks at parts of the picture as either on or off. Imagine black as represented in the recorded image file as all zeros, and white recorded as all ones. As the exposure approaches 100 percent, or white, the digital recorder sees all ones, so it doesn't attempt to recover an image from the portions of the picture measuring 100 percent or more. It just says, "I can't do this anymore; I give up." The white areas become white mush, with no detail. In the analog days, with film cameras, the overexposed areas would retain some detail, albeit of poor quality. Not so with digital. This means that every effort must be made to avoid overexposing the picture. It's possible to recover an underexposed picture, but nothing can bring back the overexposed shot.

Gain

The third, and last, method to control exposure is gain. Let's say you want to shoot in very low light. The lens is wide open, the shutter is off, and you still can't get a correct exposure. You can enhance the picture by turning up the gain.

Gain is very much like volume because it is measured and represented as decibels. Turning up the volume of a stereo increases the amount of sound, but it also increases the amount of random noise produced by the electronics.

Try turning up your stereo without music playing. The hissing sound you hear is the unwanted noise generated by the electronics. Similarly, when the gain is turned up in the camera to 9 dB or 18 dB, it brightens the picture, but it also adds video noise, making the picture look grainy. The colors will not be as saturated and the resolution will not be as good. Gain is not always your friend, but it can sometimes get you out of a jam.

PRO TIP: Be Careful with Gain

Gain should be used only when no other means can be found to supply adequate light.

A city skyline shot at night has rich colors when shot at 0 dB gain.

Adding 9 dB of gain brightens the picture, but adds noise or grain.

At 18 dB of gain, the picture is noticeably degraded.

WHITE BALANCE

Once you have set your exposure, your camera needs to be adjusted for the correct color of the scene. Light comes in different colors. The human eye can see only a narrow section of the spectrum of light from near ultraviolet to near infrared. The camera can resolve even fewer colors and with less nuance than the eye. The most common colors encountered are those in daylight, incandescent light, and fluorescent light. All video cameras assume that "normal" light is incandescent light. If you're not shooting in incandescent light, you'll need to adjust your camera.

The Colors of Light

Of the three most common colors, incandescent light is the warmest and reads the most yellow. Fluorescent light is a bit bluer and greener than incandescent. Daylight is the most blue. In the real world of measuring light, daylight is considered to be the most normal light because it contains all the colors of the spectrum. If you pass incandescent or fluorescent light through a prism, you will not obtain a rainbow of colors as you will with daylight. The camera can handle all three types of light, but it has to be told what to do.

This is a good illustration of differences in color temperature. Daylight appears blue, and incandescent lighting appears very yellow.

Understanding Color Temperature

The color of light is expressed as a temperature reading and is measured in degrees Kelvin, or "k." In order to understand white balance and light, it helps to learn about color temperature. Candlelight reads as "cool" and will look slightly blue. The color temperature increases as the light gets brighter. It's interesting to note that overcast days are considered "warm" because they register as slightly red. The portion of the Kelvin spectrum that measures visible light is very small. It begins with infrared temperatures below 500 k and continues through ultraviolet temperatures in excess of 50,000 k. Note that household (incandescent) bulbs have a color temperature of about 3,000 k.

COLOR TEMPERATURE	LIGHT SOURCE
1,000 k	candles, some flashlights
2,000	pre-sunrise
2,500	household bulb, used
3,000	household bulb, most halogen lights
3,000–4,000	sunrise, sunset (without heavy smog or smoke)
4,000–5,000	fluorescent bulbs (cool white)
5,000–5,500	electronic flash
7,000–8,000	sunlight, bright day
8,000–9,000	overcast skies at lower elevations
9,000–11,000	heavy overcast skies, slight shade
11,000–18,000	rain at lower elevations, clear day above 8,000 feet
11,000–18,000	overcast to snowy days above 8,000 feet

How to Adjust Your Camera's White Balance

Find the white balance button on your camera. Now look for something white and zoom in to fill the frame with white. Push the white-balance button and hold it for a few seconds, and the camera will balance to the type of light. Once the camera acknowledges your "white," it adjusts all the other colors accordingly. Remember, it is important to white-balance before you shoot. Most cameras have presets for common lighting conditions, represented by icons: a small sun for daylight, a tube for fluorescent, and a lightbulb for incandescent. Avoid using these settings unless you want a special effect—they are approximations and will never be as accurate as a manual white balance.

When the camera is set for incandescent light, the colors will look normal under incandescent, or tungsten lighting.

If photographed under fluorescent light—without manually resetting the white balance—the picture will look green.

This scene, illuminated by natural daylight, has a blue hue. Daylight, when compared to tungsten lighting, is very blue.

Using a White Balance Card

Always carry a white card with you when shooting, so you can balance every scene to the same "white." Pick up a small, sturdy white paper card at an art supply store or buy a white balance card at a camera store. While you're there, choose a couple of other colors to use, too. Adjusting the white balance can add interest to your scene.

True white balance card.

Warm white balance card.

Slightly warmer white balance card.

1 If you do not have have a white card, find something white in your environment, such as a white bedspread.

2 Before you press the white balance button to calibrate the camera, zoom in all the way to fill the frame.

PRO TIP: Adjusting to Light

It may be necessary to white-balance between each scene because the type and color of light have changed. The only way to know is by becoming aware of the light in your environment. Daylight, outside shade, fluorescent lights, and halide or vapor lights are all different colors. Sometimes the light will be mixed from several sources. Try to figure out which source is dominant and balance for that color.

Using White Balance Creatively

Try using white balance to evoke different moods. If you white balance to a bluish card, your image will be warm. The bluer your card, the warmer your image will be. You can also experiment with the camera presets.

The first step in using white balance creatively is to imagine the shot or scene and decide what mood, and thus, which card you should use.

In this shot, the camera was white balanced using a "warm white," or bluish "white card," producing a warm, nostalgic, happy feel.

Try to relate your tint to the setting. Here the context is nature.

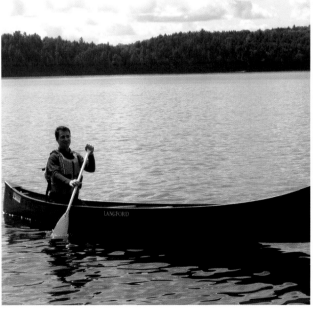

A blue tint was achieved by putting the camera on the incandescent preset and fooling the camera into thinking it was shooting indoors.

LIGHTING YOUR SHOT

Now that you know how to control your exposure and set your white balance, it's time to learn the mechanics of lighting. Film and television studios have always been lit by fixtures using tungsten light. Video cameras were developed to make the best use of tungsten light. Any other light source requires an adjustment to the camera. Halogen lightbulbs were developed about 30 years ago, and they now dominate the lighting fixtures used by professionals. The color of halogen fixtures is only slightly bluer than a household bulb. You can easily mix the light from household bulbs and halogen fixtures without fear of having a problem with the color.

A Simple Three-Light Setup

All lighting theory is based on the three-light setup: a key light, a backlight, and a fill light. The key light is the main light source, defining the direction and intensity of the shot. It is placed about 45 degrees from perpendicular to the camera and slightly higher than eye level.

The fill light softens the effect of the harsh key light and should be placed near the camera and near eye level, or slightly below eye level to fill shadows under heavy eyelids or necklines. For softer light, bounce the fill light off a white card.

The final light, the backlight, is also known as the kicker or the hair light. Ideally, this is placed behind the subject to help separate the subject from the background, and add depth and dimension to the shot.

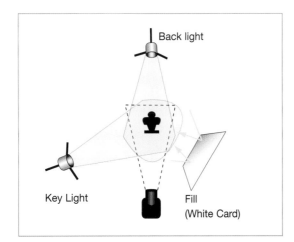

The three-light setup is a 600-watt Fresnel softened by tough-spun fabric; the fill is provided by a small 200-watt Fresnel bounced onto a white card, and the backlight is a 200-watt Fresnel softened with tough-spun fabric.

Fresnel Light

A Fresnel light (pronounced "fre-nel") is a focusable spotlight used in film, television, and theater lighting. Its glass lens with concentric ripples is adjustable from "spot" (for a narrowly focused beam) to "flood" (for a wider beam). Named for its inventor, French physicist Augustin-Jean Fresnel (1788–1827), the lens was originally designed to project beams of light from lighthouses.

The Three-Light Setup—Light by Light

In video storytelling, you want to make the key light look as natural as possible. If the main light source comes from a north window, make the key light soft and diffuse. If the main light source comes in shafts of sunlight, use a hard light fixture with no softening material.

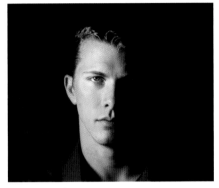

Key light only.

Back light only.

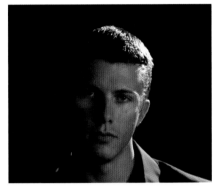

Fill light only.

Understanding Lighting Ratio

Lighting ratio is the difference between the bright side and the dark side of the subject. A 2:1 ratio means the bright side is twice as bright as the dark side. Film and high-definition-television cameras can resolve a ratio of 6:1 or greater. The best video cameras can handle 4:1 or 5:1. Your camcorder may struggle to resolve images with a ratio of 3:1, so remember that scenes lit with extreme differences in light will appear black in the dark areas.

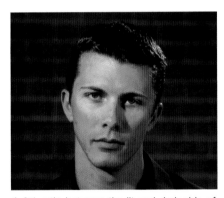

A 2:1 ratio between the lit and dark side of the face.

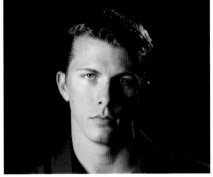

A 3:1 ratio. The dark side is two f-stops darker than the light.

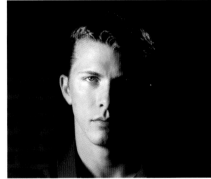

At a 5:1 ratio, the video camera cannot discern any detail in the shadows.

PRO TIP: How to Light People

When lighting a person, you want the backlight to be on the hair and shoulders. Some photographers like to see a little of the light spill onto the cheek. In that case, use a kicker light. Be careful, as sometimes this creates unpleasant shadows from the ear or hair. It's best if the kicker light is soft; it should be a natural spill that looks like it's coming from reflected light. Your goal is to always make the lighting as transparent as possible. If the viewer is noticing the lighting instead of the story, then the videographer has failed in his or her mission.

SOFT LIGHTING

Always look for ways to soften your lighting. Many photographers use fixtures called light banks. A company called Chimera developed the first light bank, or "soft box," and now all light banks are known as chimeras, even though there are dozens of different models on the market. A heat-resistant white fabric is stretched across the front of the light, and black side panels prevent spillage where light is not wanted. They are wonderful but expensive fixtures. Professionals also use large light panels made of grid cloth resembling a soft silk, known as silks. The panels are usually six feet by six feet.

Variations on the Three-Light Setup

Most lighting setups are variations of the basic three-light setup. The key light may be moved closer to the subject or to the other side of the subject. The fill light may be softer or more underneath the face. The backlight may be stronger or colored.

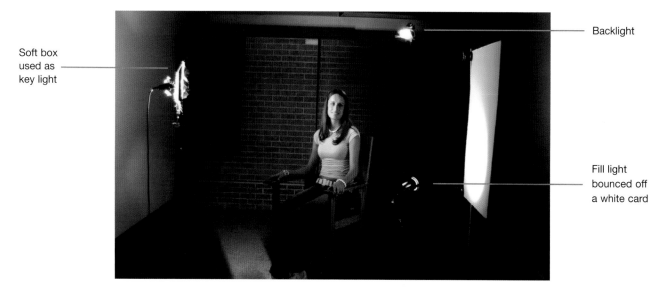

Soft box used as key light

Backlight

Fill light bounced off a white card

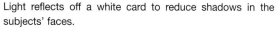

Light reflects off a white card to reduce shadows in the subjects' faces.

The resulting shot achieves the desired soft lighting effect.

Placing Light Boxes

When using soft boxes or light panels, the light source should be placed as close to the subject as possible—at least within an arm's length. Dim the source if the light is overpowering, or "feather" it off by panning it slightly away from the subject. The excess light can be used to fill in the background.

Using a soft box produces a soft, even light.

Soft lighting off to the side softens the edges of this portrait.

Using Wraparound Light

The big, broad light source that the soft box provides has myriad uses when employed close to the subject. Many videographers swear that the light from the box "bends" around the face of the subject, scattering soft light onto the shadow side.

Place the soft box within an arm's length of the subject and remove the fill light. Now the only fill light is the tiny amount reflected from the white card. The light wraps around the face and creates a wonderful soft look that cannot be achieved in any other way. This effect is especially useful to videographers because as the subject moves within the lit area, the face takes on new and surprising looks. And it's so simple—one soft box, a white card, and a kicker light. Soft boxes are expensive, but a similar effect is possible by using a roll of tracing paper from your local art supply store to diffuse the light.

PRO TIP: Paying Attention to the Face

When lighting a scene, pay attention to the subject's face. Backgrounds vary, but the face is where the viewer's attention is drawn. Make it easy for the viewer to concentrate on the face regardless of the surroundings. You may find it works well to light the subject first, and then add the necessary fixtures to illuminate the background. The amount and placement of light will be dictated by the mood you want to achieve. If the subject is lit softly and at a relatively low contrast ratio, then the background should be soft and slightly darker than the subject. If the intent is to create a high-tension, darkly lit scene, use light sparingly on the background and place the lights at cross angles, or from the back, to create strong shadows.

SHOOTING USING NATURAL LIGHT

Natural light is constantly changing in color temperature, direction, and intensity during the year and throughout a single day. Light also varies endlessly because of clouds diffusing, blocking, and reflecting the light. You might shoot a scene in the forest, using the dappled light as it filters through the trees. Or perhaps you'll sit your subject by a window, allowing the daylight to illuminate one side of her face. Study the endless variations of light and shadow, and the moods they evoke.

Shooting Outdoors Using Natural Light

When shooting outside, the same principles of the three-light setup apply. The sun provides the key light. A reflector or white card will add the fill light. Remember to white balance the camera with your card, and then follow the same steps outlined for shooting indoors. Survey the lighting conditions. Do you have bright sunlight, or is the sun obscured by clouds? Is the sun directly overhead—the worst time to shoot—or is it lower in the sky? What is the best direction to face when shooting the event? What, if anything, can be done to supplement the available light? Since the sun is the key light, there is no practical way to provide a backlight.

The Quality of Natural Light Outdoors

You know the light outside is brighter than the light indoors, but you should also understand that outside light is more diffused. The light outside bounces off the many available surfaces and is reflected through the moisture in the air. Overcast days are often best for shooting, because you can explore color and detail without the harsh shadows of a sunny day.

Magic Hour

A well-known maxim of photography is that it's best to shoot either very early in the morning, in the late afternoon, or in the photographer's favorite time—magic hour. Magic hour is the time between sunset and dark, when there is still a little light left in the sky to separate the sky from the foreground, but it is dark enough and blue enough to look like nighttime.

A beach shot during magic hour is eyepleasing.

The Sun

In general, you should shoot with your back to the sun. If you can't, or don't want to, you can turn the subject away from the sun so the sunlight becomes a backlight. Reflect light onto the subject with any reflective material you can find—professional flex-fill reflectors or simple white foam core boards that you can find at an art supply store.

The light is harsh, creating dark shadows.

An assistant holds a reflector to fill the dark shadows.

The subject's face is more evenly lit.

The Color Temperature of Outside Light

The color temperature of natural light changes with the seasons and the time of day. Daylight is rarely pure white, but around noon the light is at its whitest. Sunrise, sunset, and summer light are, in some parts of the world, often more orange or red. And the light at dawn, or in the winter, is closer to blue. The more time you spend outdoors with your camera, the more you will become aware of the different colors of light.

At noon, light is at its whitest.

At sunset, the scene has a yellow tint.

Light at dawn appears very blue.

PRO TIP: Shooting Outdoors

- Shoot early in the day or late in the afternoon.
- Shoot with your back to the sun.
- Make use of reflectors. Close-ups take on added vibrancy when the face is filled with soft light, which makes harsh shadows disappear. Be especially aware of dark eye sockets and areas under the jawline.
- Place a silk between the sun and your subject to diffuse and soften the light. You can create the same effect by blocking direct sun with a white bedsheet or a large roll of tracing paper.
- Avoid bright backgrounds. The subject should always be brighter than the background.

Shooting Indoors Using Natural Light

Natural light indoors is, by its nature, subdued. And light coming in through a window or an open door, is directional, as opposed to diffuse. Imagine that the window or open door is a light and use it to illuminate your subject. Photographing with the window behind you provides even lighting on your subject. Facing the window puts your subject in silhouette. Shooting from the side, parallel to the window, casts light on the window side of the subject, creating interesting shadows on the other side.

Light from the window illuminates the subject evenly.

Facing the window puts your subjects in silhouette.

Light from the side highlights one side of the face.

Cast shadows create an interesting mood.

Using Low Light to Create a Mood

You can use natural low lighting indoors to create an interesting atmosphere. If it's too dark for the camera to see clearly, details are lost and figures are reduced to indistinct forms. The mood created is one of quiet reflection.

Light shining through an old window creates a dimly lit environment.

Low-light, long-exposure blurring adds softness to the image. The mood is peaceful.

PRO TIP: Choosing a Background

Try to avoid white walls. Choose shots with chalkboards, bookcases, or curtains behind the subject. Anything that is darker than the subject will persuade the viewer to focus on the subject and not be distracted by a bright, white wall. High-angle shots work better than low-angle shots. Avoid shooting low-angle shots that look up into fluorescent lights. The viewer's eyes will always go to the brightest object in the frame. Tighter shots work better than wide shots, so stay close to your subject and fill the frame.

Rembrandt Lighting

The famous Dutch artist Rembrandt van Rijn developed a painting style using soft light from the window in his studio. It came to be known as "Rembrandt lighting" because he perfected the classic look of the key light at 45 degrees from the camera and 45 degrees up from the horizontal. Rembrandt lighting creates a soft nose shadow falling on the distant cheek. A soft fill light located near the artist fills in the shadows. Backlight did not occur naturally in his studio, but you can see evidence of his use of backlight in some of his other paintings. The Rembrandt setup is the most commonly used method of lighting.

FILTERS

Filters can be very helpful, and some photographers swear by them. Others are just as happy to leave well enough alone and concentrate on getting the story rather than constantly switching filters or, as is the case with some cameras, fiddling with the filter controls. Scores of filters are available to place in front of the camera lens to improve the scene. Even on a budget, the photographer should attempt to collect a few important filters. A polarizing filter, a softening filter, and a neutral-density filter can help your video look more professional.

Polarizing Filters

A polarizing filter is a good place to start. Light is scattered by the earth's atmosphere, and all the colors become mixed together. A polarizer acts much like venetian blinds for certain light frequencies. It admits only those traveling on a specific path and rejects all the others. Since blue is the most scattered of the frequencies, the polarizer rejects more blue than any other color. The result is a darker, richer blue sky and brighter, richer reds and greens—the colors will be more saturated. Everything seems to take on a Kodachrome look. Polarizers can also help remove reflections from windows and specular highlights from chrome.

Using a Polarizing Filter Against the Sky

1 The polarizing filter is at its best when the sky is pale, and the clouds are evident but indistinct. It will help to bring out the vibrancy of the sky as well as highlight the clouds.

2 When the polarizing filter is used, the sky takes on a brighter color and clouds pop out against the brilliant blue. But with the filter in place, the picture is dark and underexposed by about two f-stops. The unpolarized light—the light traveling in directions perpendicular to the polarizer filter—is blocked. You should then open the camera lens two f-stops to compensate.

3 When the exposure is corrected, the sky is still a more intense blue and the clouds are more distinct against the sky. Two other changes are apparent as well: The greens and reds of the trees are more vibrant, and careful examination will reveal that the shiny specular highlights on the leaves of the closest trees are masked.

Using a Polarizing Filter on Reflections

The polarizing filter is a valuable tool for removing unwanted reflections. The reflected light is unpolarized and therefore, can be removed by a circular polarizing filter. When light enters the filter, it emerges in only one direction. The circular polarizing filter can be rotated, which allows different amounts of unpolarized light to enter.

The glass on this vehicle is a nearly perfect mirror.

As the filter is rotated, the reflections are almost gone. The sky is a little darker, and the colors of the trees are more vibrant.

Why Is the Sky Blue? A Technical Explanation

Ever wonder why the sky is blue? The answer helps to explain the value of the polarizing filter in photography. The light from the sun arrives on Earth direct and unpolarized. That is why the sun appears white if it is viewed directly. The light in the sky appears various shades of blue—from pale blue closer the sun to a wonderful turquoise blue near the horizon on a clear day. The reason the sky is blue, and not red, is that blue is a higher frequency light than red. Red light waves are less prone to scattering because of their longer, larger size. Blue light waves are very short and can bounce around like Ping-Pong balls. So when light enters Earth's atmosphere, the big red waves just plow on through, but the little blue ones bounce around from one air molecule to the next and turn the sky blue.

Blue is darker near the horizon because the light is traveling through more air and blue is being absorbed. This explains why the sunset is such a beautiful red-orange. The sun is viewed through the entire Earth's atmosphere when it is at the horizon and all the blue is absorbed.

Softening Filters

The next filters you might want to try are softening filters. These are especially good for shooting close-ups of people because they soften any harsh lines in the face, and can make a more pleasing portrait of whomever you are filming. You can also use the softening filter to create a romantic or dreamy effect. You don't have to limit this technique to portraits.

Footage showing an unfiltered shot of a woman's face.

A shot of the same woman, but with a softening filter on the lens.

PRO TIP: Soften Your Shot with Panty Hose

A great way to create soft effects is to use stockings. Silk is the best, but they're expensive and hard to find—the drugstore variety will do. Cut a large piece of the stocking and stretch it tightly across the front of the lens. The image is immediately softer. If the stocking is not the sheerest, the softening will become muddy and detail in the picture will be lost. A sheer white stocking is useful for creating the soft look you might see in a dream sequence or a romantic setting. A black net will soften the features of the face and hair, but will not reduce the overall contrast of the scene. Its effect is more subtle and can be used more frequently than the white on flesh colors. A stocking net "filter" will not work well on a wide-angle lens. The pattern of the mesh slowly becomes apparent as the lens is zoomed out to side angle, and the material itself may become visible in certain lighting conditions. Use nets only on telephoto scenes.

Neutral-Density Filters

Another good filter is a graduated neutral-density filter, such as a graduated ND6. This filter is clear at the bottom and slowly obscures to a +2 f-stop reduction at the top. The neutral density does not affect colors. The graduated filter is useful for evening shoots or when there are large disparities in light levels in a scene, such as a very bright sky against a darker landscape. Some cameras have built in neutral-density filters.

Shooting the Sunset with Filters

A sunset can be enhanced by several kinds of filters:

A typical sunset sky shot where the clouds are glowing orange.

With a graduated sunset filter, the effect is gradual—clear at the bottom and slowly becoming red-orange at the top.

A chocolate filter, with its rich dark browns, accentuates warm tones.

As the sunset fades, much can still be captured by using a twilight filter. It is clear at the lower third of the frame where landscapes or buildings are usually placed. Progressing up the frame, a mixture of magentas, reds, blues, and violets signal the arrival of night.

When color is no longer the issue, a nice sky can be aided by the ND6 filter. The neutral quality of the filter does not change the color, but just reduces the intensity of the brighter, higher sky. The filter also enhances the ephemeral wisps of color and tone that cling until surrendering to the night.

LIGHTING ON THE CHEAP

You can make a professional-looking video using inexpensive items. The camera store can be like a candy shop, enticing you to spend every last dollar on new equipment. Save your money and visit your local hardware store instead.

Homemade Silks

You can make your own silks by buying grid cloth in bulk and cutting the material to size. Cheap frames can be made from PVC pipe. Now you have something that resembles the famed soft box. If you don't want to bother with the cloth and pipe, hang a sheet of tracing paper in front of where a key light would normally be placed—about three or four feet behind the paper. Block off light from unwanted areas using the barn doors (built-in panels on either side of the light) on a professional light, or clip some heavy-duty aluminum foil (doubled) to the sides of the light fixture. Make the same adjustments for the fill light.

A homemade tracing-paper "silk" frame is placed in front of two lights.

The tracing paper frame is lit from behind.

Homemade Reflectors

Reflected light is soft and subtle, and will make your shot look more natural. You can reflect light by buying large white cards, or foam core, which is sturdier and will last longer. Prop it up, or hang it from a stand.

Glue some crumpled aluminum foil to the card, and you have a reflector, which is great for filling shadows on a face. Crumple the foil before spreading it out on the board. Spray-on photo adhesive works well for attaching the foil to the board. The gentle ridges and many small surfaces left in the foil will reflect the light smoothly.

A white card is used to reflect fill light (bounce) up onto the subjects face. A silk is held above to soften the sun's rays.

A bounce card does not have to be handheld or placed underneath the subject. This bounce card is clamped to a light stand.

Creating Shadows with Foam Core

You can use foam core to block some of the light and create interesting effects. Use a sharp knife or a box cutter and cut randomly shaped holes in a large piece of foam core. Mix triangular shapes with smooth or circular shapes. Hang it in front of a light and watch the interesting patterns it casts onto a wall. What you've made is a cukaloris, sometimes called a "cookie." The cukaloris was invented by film director Fritz Lang in the silent picture days. The shadow patterns break up a flat wall and give it some texture.

Construct your homemade cookie from cardboard or foam core. Use a sharp knife or box cutter to cut out random shapes.

When you shine light through the cut spaces, you will be able to create interesting shadow patterns on surfaces.

With a little creative use of the knife, you can create a pattern of sunlight streaming through venetian blinds.

When your cookie is placed close to the light source, the pattern is diffuse. The farther away from the light source, the more distinct the pattern becomes.

PRO TIP: Clothespins as Clamps

In Hollywood there is a clamp known as a C-47 clamp—you might know it as a clothespin. And film supply houses sell these at a ridiculous price. Buy them at the grocery store, where you can also find cotton sash cord—both are useful to keep in your lighting kit. Film people also use lots of gator grips—simple clamps from the hardware store.

LIGHTING AND EXPOSURE
DO'S AND DON'TS

DO expose for your subject, rather than letting the camera automatically determine which area of the picture to prioritize.

DON'T assume that the camera will know the particular area you want to expose. Here, the auto exposure chose the brightest area instead of the human face.

DO strike a balance when exposing for mixed lighting. You don't want the shadowed areas to fall into darkness, or the highlights to blow out and lose detail.

DON'T forget that a bright light source can trick your auto-exposure system into underexposing, even if it is not in the center of the frame.

DO make use of natural mixed lighting to highlight a subject, when possible.

DON'T feel compelled to brightly expose every single shot. Sometimes the subject matter will dictate a mood that calls for under or overexposure.

DO expose for the brightest part of the scene if you want a silhouette effect. If you allow any part of the scene to be over-exposed, all picture information will be lost in that area.

(continued)

LIGHTING AND EXPOSURE DO'S AND DON'TS *(continued)*

DO shoot the sunset indirectly, either by capturing the golden light that falls upon the subjects in your frame...

...or by waiting until the brightest part of the sunset has ended and the sky is filled with color.

DO stay aware of casting a shadow that enters the frame. This will draw attention to the camera operator and away from your subject.

DO allow parts of the frame to go completely black if it means the area of interest will be accurately exposed.

DO take advantage of late afternoon sun to create beautifully lit shots.

CHAPTER 4: COMPOSITION

A well-known photographer was attending a dinner party in his honor. The hostess said to him, "You take such great pictures. You must have really good cameras." At the end of the dinner, as dishes were being cleared away, he could not resist saying to her, "You cooked a wonderful dinner. You must have really good pots and pans." Good photography requires much more than good equipment; it requires a good eye. The best photographers can still shoot great photos while using an inexpensive camera.

DEVELOP YOUR EYE

Having a good eye means possessing the ability to see pictures in real life; to isolate the most meaningful parts of a story and put them into a small box that is your picture frame. It's the ability to think "inside the box." Photographers walk around with this picture frame in their minds, always composing a shot from everything they see. You are a photographer now, so you can start doing the same thing. The more you shoot, the more you'll find that you begin to compose your shots naturally. Even if you do not have your camera with you, continue to think as if you are looking through the lens. This will develop your visual sense of composition. The art of capturing nice shots is closely related to training the eye and the mind.

If framed the right way, the geometry of the environment can create very pleasing lines that draw the eye to the subject. The watchful photographer may notice the "frame within a frame" provided by the rectangles formed by the grass and the concrete.

Practice Thinking "Inside the Box"

As mentioned previously, it's a good idea to think like a photographer. Have you seen those documentaries where the director peers through a frame he has formed with his hands? Make a rectangular box with your fingers and practice seeing through it. All of a sudden, real life begins to take on the dimensions of a video image. The frame limits your view and focuses your attention on the subject. This should help you begin to think photographically—to think in terms of "the shot." You can buy the most expensive camcorder and all the accessories, but if you don't see photographically, you will never make great pictures. Like anything else, the best way to learn is to practice; take lots and lots of pictures. And use your brain. Don't just look and shoot. Think and see. Shoot with your mind, your senses, and your heart. Don't be afraid to make mistakes. And never put technique ahead of expression. This way, your pictures will have meaning.

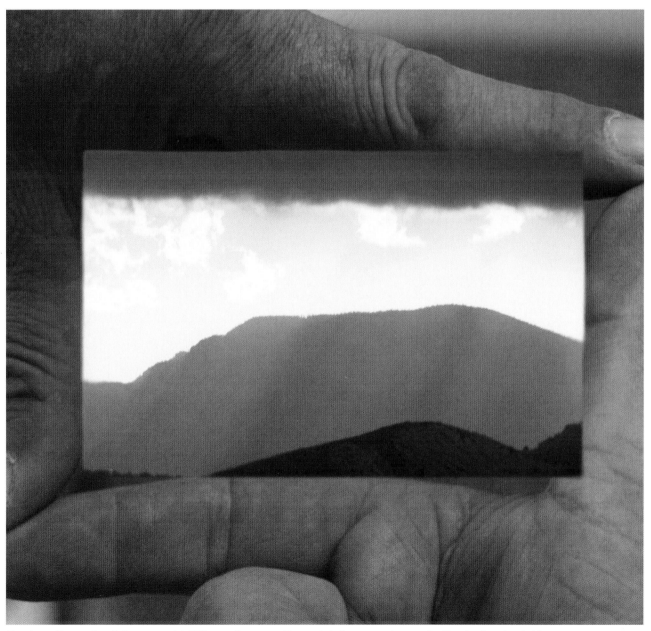

Framing with your hands is very useful. With practice, you will see shots in your environment without using visual aids.

COMPOSING A MOVING OBJECT

Composing a great shot gets tougher when things start to move. To videographers, composition usually means simply keeping something in the frame as it races past. Here are a couple of tips that will help you compose your moving pictures.

Leading the Subject

Learn to "lead" the subject. Move the camera ahead of the subject so there is more room in front of it than behind it. This makes for a more pleasing shot and allows some reaction time to change the rate of camera movement when the subject changes speed or direction. Leading takes a lot of practice, but is fun when you get the hang of it.

1. Leave a good amount of lead room.

2. The motorcycle sped up suddenly, and the photographer needed the room to react.

3. Keep an eye on your subject, or it will disappear out of the frame.

Exit the Frame

Another option for shooting a moving subject is to allow the subject to enter the frame, pass through it, and exit. When editing begins, a shot like this is a gift, as it gives the editor tremendous freedom in assembling the story. When the subject leaves the frame, it can reappear anywhere. This means two disparate parts of the story can be put together by having the subject leave the frame in one shot and enter the frame in the next.

When a person or thing moves across the frame and exits on one side, this is called "wiping the frame." Once this quickly moving team member wipes the frame, the editor can start the next shot in any variety of ways. Always allow your subject to completely exit before ending the shot.

DON'T STAND STILL

Technology has provided us with a small, light camcorder that is easy to move. So, move with the camera. This does not mean walk around while the camera is recording. It means shoot a steady shot, stop, and then move with the camera to a different angle. Shoot and move. Look for unusual angles. High-angle shots provide lots of context, and they can be interesting in terms of shapes and composition. They can also bestow a feeling of smallness upon the subject as the viewer looks down from a high vantage point. Conversely, low-angle shots connote power and strength because the image appears dominant.

This high-angle shot of a running race gives us a new perspective. If the cameraperson were on the same plane as the runners, the individual members would meld into one entity—a crowd of runners. You may want either type of shot, depending on the message you want to convey.

The inclusion of the shadows and a large amount of space tells the viewer something different than if this shot were cropped tightly. Pushing the subjects to one side of the frame and leaving room in this manner communicates a feeling of isolation. Think about mood in your a shot.

THE RULES OF COMPOSITION

The great photographer Edward Weston said, "Consulting rules of composition before taking a photograph is sort of like consulting the rules of gravity before taking a walk." Weston had it right. If you need to pull out the composition rule book when shooting, then you'll invariably miss the shot. The only way to get the shot before the moment disappears is to know what works and what doesn't. And, again, this is something you'll learn only from practice. However, there are some basic rules of composition that you should learn before you know them well enough to go ahead and disregard them.

Rule of Thirds

The first and most basic guideline of composition is the rule of thirds. Imagine placing a grid, like the tic-tac-toe grid, over the scene. Avoid the center of the grid and place objects of interest in the outer squares. Landscapes will have the horizon in either the upper or lower third of the frame, but never across the middle. A person will be offset to one side of the frame. Offsetting images in this manner makes the scene dynamic—adding a feeling of tension and action to the shot. These images will provide context and give a better sense of time and place.

The rule of thirds grid overlays a nighttime street scene. The picture's most important elements are composed in the outer thirds.

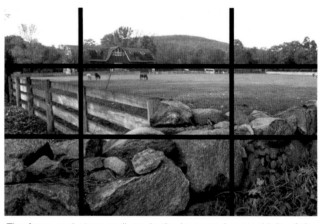

The fence and stone wall are in the lower and outer thirds of the frame, and the horizon is in the upper third.

The statue borders the left third of the frame, while the girls occupy the right two-thirds of the frame.

By not centering your shot, you will often get added interest on the side of the frame.

PRO TIP: Don't Shoot When You Shoot

It is natural to want to center an object in the frame, as if you were looking through a rifle scope. This is actually an unappealing way to shoot a photograph.

The subject is centered in the frame, which makes for a fine but uninteresting image.

When the picture is composed, the image suddenly has more meaning and emotion. Context and a sense of place are provided by revealing a second guitar player and exploring the relationship between the two men.

Three Is Best

As you've seen, the number three plays a large role in composition. Objects compose and balance a photo better when there are three. Three objects also help you fulfull the rule of thirds by keeping the activity or subjects away from the center. So look for ways to build three things into the scene.

The three circus performers balance the shot beautifully.

The three subjects in this photograph balance the picture and focus the viewer's interest on the steer.

Triangles

Triangles are another example of how the number three plays an important role in composition. Triangles and pyramids make interesting shapes in photography because the lines help your eye focus on the important parts of the photograph. Utilize tri-angles in your compositions, and they will be more pleasing and more interesting. Pay attention to your frame, and your surroundings: you will be surprised at how many naturally occurring triangles you will find.

An action shot follows the rule of threes, creating a triangle.

Notice how the triangle imparts power to this shot.

Even when there is empty space, you can use the power of the triangle to draw the viewer's attention to select elements in your shot.

PRO TIP: Look at Great Art

You can learn a lot about composition from the masters. Look at photographs and paintings in books, libraries, and museums. Study great films and see how the directors composed their shots.

Avoid Straight Lines

Straight and level lines work well when shooting horizons and tabletops but not much else. Look for upward angles to emphasize positive movement, downward angles for negative movement. Diagonals often indicate motion, or a dynamic quality that can be used for tension. Lines will draw the eye to the center of attention or in a pattern within the frame. In video composition, they lead the eye toward anticipated action or guide the viewer along as the action unfolds.

This unusual angle draws the eye to the bride getting out of the car.

The viewer's eye is drawn to the subject by the converging lines.

Note the natural diagonal that guides the eye from the upper-right corner, along the arm of the girl, and finally, down the reins she is holding.

All the lines in this dew-covered spiderweb converge on the single strong line running diagonally across the frame.

Fill the Frame

The space inside the frame is the photographer's most precious commodity. It is finite, limited, and every effort must be made to make the best use of that space. Fill the frame. Put as much meaningful information in it as you can, but take care not to clutter your shot. Emptiness can be a message in itself—filling the frame with solitude, serenity, and tranquility.

The objects in the foreground and background fill the frame.

In this case, the scene fills the frame, without being cluttered.

Simplify

Strive for visual simplicity. Shoot scenes that can be easily understood in a glance. Viewers should not have to look twice to understand the shot. The shot should impart a mood more than information. If the shot grabs the viewer's attention, will continue to watch. If it doesn't, you have lost them, probably for the rest of the film.

This picture suggests a wind will come at any moment, blowing the seeds away to parts unknown. Be sure to get close to intimately examine a subject.

The purity of the snowy landscape emphasizes the iconic image of the red barn. Find contrasting elements that highlight one another.

16:9

Have you ever watched a movie on your television and had black bars running across the top and bottom of the screen? Then you already know what shooting in 16:9 is like. An option offered on new model camcorders, 16:9 refers to the relationship of width, to the height of the viewing screen. Early television standards called for a screen that was 4 units wide by 3 units tall, hence the old 4:3 television standard. The 4:3 is slightly wider than a square picture. Imagine a big screen 4 feet wide by 3 feet tall and think of how you might compose a shot to fit within that screen. Now grab one corner of that screen and stretch it out until it is 16 feet wide by 9 feet tall.

It's a huge screen, but it is also a wider space in which to compose a picture. You will notice right away that a single close-up shot works better in the 4:3 aspect ratio because there is precious little space for anything else. That is why television has always been known as the close-up medium. A whole new world has been opened for the videographer with the added width of the 16:9 format. Subjects can be offset to one side of the frame, and something of interest in the background can be placed on the other side of the frame, creating marvelous illusions of depth—giving a real "3-D" feel to the picture.

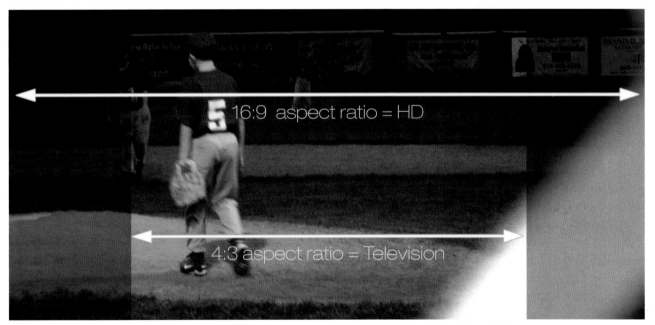

The inner box represents a 4:3 television screen. The outer box shows the additional space offered in a 16:9 format.

When to Shoot in 16:9

The decision to shoot in 16:9 should be made by knowing how and where the piece will be viewed. Different camera manufacturers approach the 16:9 issue in a variety of ways. Some cameras shoot what is known as "native 16:9." This means that the imaging chip is recording a true 16 x 9 image, and if the product is viewed on a television that supports only 4:3 images, the picture will appear "squeezed" and the subjects will look thin and tall. Other cameras create a pseudo 16:9 image by placing a mask over the 4:3 frame that blocks the upper and lower portions of the screen. This produces an image that fits the ratio, but when played on a 4:3 television, the image will be effectively smaller and will have black bars at the top and bottom. This process is known as "letterboxing." The 16:9 format is the wave of the future, and soon the 4:3 format will be as antiquated as black-and-white televisions.

Foreground Interest

Next, your goal is to combine rules of composition, the rule of thirds, the use of three objects, depth of field, and lines to create foreground interest. Foreground interest means that images can be given depth by shooting something in the foreground that relates to something in the background. Shoot with a wide-angle lens and put one subject very close to the lens and in one of the thirds of the outer edge. Put the other subject in the background and in the opposite third. Focus on the near object. The results will be surprising.

Selective focus is important in composing foreground interest. Sometimes the closer object is the important one, and it should be in focus. But there are times when foreground interest simply means some out-of-focus item that helps draw attention to the object in the background. It may be greenery that draws the viewer's eye to a sign or some out-of-focus car lights that frame a car in the background. Foreground interest can change ordinary pictures into compelling ones.

Make foreground interest work for you. The flowers lead the eye to the rest of the neighborhood.

Add depth to your shots or place the subject in a larger context. These close, blurred eggs place us in the physical space.

The foreground interest grabs the viewer's attention. The next shot must keep the viewer watching. Search your surroundings for relevant details.

Imagine how different this shot would be were it to exclude the porch. It is more than a basic landscape shot; it now offers a point of view.

Seek Balance

While considering the rules of composition, always seek balance. Try to put something in each third of the frame that balances with the other third. Look for balance in color, exposure, and intensity. Visualize the shot before picking up the camera. Think of ways to improve the shot. Don't just accept the scene the way it looks initially. Play "what if…" games with the composition. "What if I moved a few feet to the right? What if I placed that lamp a little closer? What if I asked the grandmother to join the grandkids in this shot?" A small shift in perspective can make a world of difference in a shot.

Asymmeterical balance can be very pleasing. Remember the rule of thirds, which tells us the eye likes the frame divided in threes.

You can find a balance between bright areas and colored areas. Both may draw the eye and can have equal weight in the frame.

This composition features a balance between both dark and light, and the child and the dandelions. A follow-up composition is also suggested—a wide shot that captures the seeds spiraling out into the sunlight.

DEPTH OF FIELD AND COMPOSITION

Your choice of lens focal length and depth of field affects composition. When do you use a wide-angle lens and when do you want a telephoto lens? You may know to use a wide-angle lens when you are handholding a shot to keep the picture steady, but wide angles also hold almost everything in focus. There are times when a shot works better when it is focused on a single subject and distractions from other things in the frame are eliminated. This would be a time for the telephoto lens. You would also want a telephoto lens when you want to compress space. For example, in the movies, when a truck seems to almost hit a car but swerves out of the way just in time, this is done with a telephoto lens.

The Wide-Angle Shot

The wide-angle shot involves the viewer in the action. A pastoral scene invites the viewer in for a closer look. The edges are hard and sharp. With a wide-angle lens, the depth of field might be from one foot to infinity.

Use the wide-angle lens when you want to convey a feeling of vastness or overwhelming size or scope. This is ideal for great scenic shots.

The Telephoto Shot

A telephoto lens is good for shooting portraits or for highlighting intimate details or important elements of a story or scene. The background (or foreground, depending on your shot) softens and the eye is directed to the subject of your shot. Remember, with a telephoto lens, focus is extremely critical. The depth of field might be only 3 inches deep. Depending on the lens and how close you are to the subject, it may be even more shallow. Clearly, there is not much room for error with such a range. Make sure the subject, and only the subject, is in focus. Also be aware that small cameras with color viewfinders are extremely hard to focus. Professional cameras have high-resolution black-and-white viewfinders that make focusing much easier, and some of the top-of-the-line consumer cameras now offer high-resolution viewfinders. You can turn the focus ring on the lens forward and backward past the sharpest point a few times to locate your depth of field. If you are familiar with shooting film, know that a film camera shows its focus much more obviously than a video camera. Keep in mind that this is the nature of the mechanisms themselves, and cannot be helped.

Use your telephoto lens, or setting, when you want to highlight a physical, emotional, or narrative detail in your documentary or narrative piece.

LIGHTNIN'-FAST REFLEXES

There is a great line in the film *Little Big Man* that takes place when the character is learning to shoot a pistol. His teacher says it requires "lightnin'-fast reflexes and considerable snake-eyed concentration." Good composition requires the same skills. Getting the camera set correctly and composing the shot before it goes away call for lightnin'-fast reflexes. Seeing the great shot in the first place calls for considerable snake-eyed concentration.

A Quick Review of the Rules of Composition

Develop your eye. Practice composition by examining the environment.

Make the frame and think inside the box.

Watch for the powerful triangle in your arrangements.

Practice the rule of thirds.

Remember the magic of three objects in a frame.

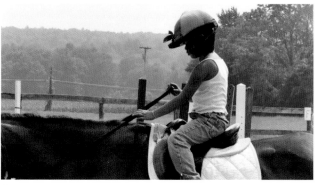

Observe and consciously arrange the lines that make up your shots.

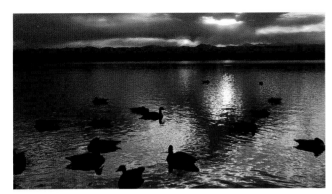

Fill the frame.

Use depth of field to draw attention to particular elements of the shot.

Create foreground interest.

Balance between bright and colored areas in your compositions.

Be ready for what might happen next.

Study stills and paintings by the masters in museums and books.

Leave "lead room" in front of a moving subject.

Use interesting compositions where the subject is not always centered.

COMPOSITION DO'S AND DON'TS

DO look for natural "frame-within-a-frame" arrangements.

DON'T incorporate unnecessary elements or space.

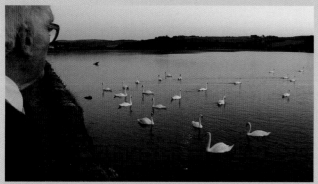

DO put your camera in positions where it can express a point of view.

DON'T put your camera in positions where the image is compromised.

DO take advantage of the natural lines found in your environment.

DON'T include too much distracting background or lines that detract.

DO remain aware of your background.

DON'T allow your background to unintentionally affect your shot.

DO use natural light to enhance your composition.

CHAPTER 5: TELLING A STORY

Since the beginning of time, storytellers have enriched the lives of their families and friends with odes and parables, fables and allegories. Early storytellers pounded icons into a rock face or smudged charcoal onto cave walls. Their mediums have changed through the years, but the message is enduring. In this chapter, you'll learn how to take the shots that tell a good story.

THE STORYTELLER'S TOOLS

Photographer Henri Cartier-Bresson said, "Good visual storytelling is having your brain, your eye, and your heart all in the same line of sight." The art of telling a story begins with the craft of its assembly. Practice your craft and the art will follow. After you have mastered the craft, you can allow your heart to lead you to the best parts of the story.

Beginning a story is an age-old dilemma. Once you have begun your story, how do you proceed? Every story—spoken, written, or visual—is put together in sequences. Remember that you will need dozens of sequences for your beginning, middle, and end. Practice by shooting, and above all, remember, you are telling a story. Don't let technical considerations bog you down and make you forget your purpose.

The Three-Shot Sequence

The first, and most basic, technique that you must master is the simple three-shot sequence. Every visual story is built on combinations of sequences. Sequences are made up of variations on three kinds of shots: wide shots, medium shots, and close-ups. A single shot will often end up on the cutting room floor because it has no context and, therefore, no place in the story. Whether you are controlling the action in the scene, or making a story out of action that is beyond your control, don't think about the single shot. Instead, think of your sequence. The simple three-shot sequence gives you a strong foundation. When you master shooting the sequence, you can start to think about how to tell your story.

The Wide Shot

The wide shot begins the sequence by setting the scene. It answers the questions Where are we? What time is it? What's the weather? Your goal is to make it easy for the viewer to understand the story. A good wide shot of the soccer field, for example, tells the viewer that a soccer game is impending. Of course, rules are made to be broken. Once you master the wide-shot rule, feel free to experiment with other kinds of opening shots. A tantalizing close-up grabs the viewer's attention and holds it until the story is revealed. The wide shot will become the revelation. Sometimes the wide shot is also called the master shot. This occurs when the shot contains essentially all of the action of your scene. The following shots will isolate bits of the action. The master shot is a film term and is most often used when the action is controlled by the photographer.

The Medium Shot

The wide shot is often followed by a medium shot of the same scene or character. The medium shot brings the viewer closer to the action and usually introduces the main character of the story. Medium shots are useful when editing because they generally contain information about your characters and your story. The medium shot can be eliminated easily in many sequences, and the scene can be cut directly from the wide shot to the close-up. But what happens when the action in the close-up doesn't match the action in the wide shot? The medium shot is the only way to edit the scenes together. Always shoot the medium shot—the only time you'll need it desperately is the time you didn't get it.

The wide shot sets the scene—a mountainside meadow. The viewer is transported to a wonderful place and is ready and waiting for the next shot.

A medium shot shows the viewer a walking trail—hewn from the mountainside and protected from erosion by logs placed across as steps.

The Close-Up Shot

The close-up is the anchor of the sequence, so pay careful attention to the introductory scenes. If your wide and medium shots are good, they set the viewer up for the payoff when the close-up appears. Preferably, your close-up should be of one thing or person—a single shot. For added impact, move the camera in to isolate part of your subject. Remember, this shot will present itself as important, so make sure it's warranted.

The close-up: A small swatch of color alongside the trail, and the viewer discovers he is not alone. A butterfly is attracted to the sweet nectar.

The extreme close-up: The camera gets even closer, and the viewer gets to enjoy watching not one but two butterflies.

The Cutaway

After the close-up, the camera pulls back for a reestablishing wide shot, or it cuts away from the action for a reaction shot, also known as a cutaway. The cutaway is an often neglected, but important, part of the sequence. In physics, Newton's Law states that for every action, there is an equal and opposite reaction. In storytelling, for every action, there is indeed a reaction: it may not be equal or opposite, but it will be there.

The viewer will expect to see the reaction, and it will help you tell your story. When putting two sequences together, it is often the cutaway that bridges the gap between the scenes. When two medium shots of the same subject are edited together, it will appear to make the subject "jump" from one location to the next. A cutaway inserted between the two scenes smooths the transition.

Point-of-View Shots

The point-of-view shot shows the story from an unusual angle and shows the viewer something he might not have seen before. In this shot, you change the point of view of the camera. Let's say you're telling the story of a little boy on his first day of school. So far you've told the story through an unseen narrator watching the boy. In the point-of-view shot, you let the viewer see things through the little boy's point of view. Or you might let the camera take the point of view of the boy's book bag. Either way, this shot makes the viewer a part of the action, as shown in the following sequence as well.

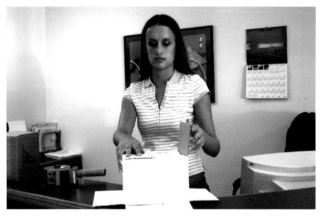

1. The opening shot shows a young woman assembling a box.

2. Next is a medium shot where the viewers see her taping the bottom of the box.

3. The sealing of the box is completed in a close-up.

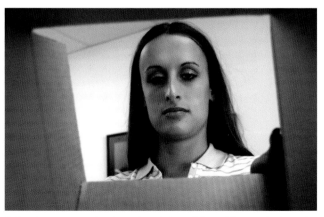

4. Let the camera take the point of view of the subject or the item the subject is using (a box ready to be packed).

Transitions

The simple sequence, taken to the next step, incorporates transitions. These are shots designed to seamlessly and cleverly move the story from one place to another. Whether you end your sequence with a point-of-view shot, a close-up, or another shot you like, it's a good idea to anticipate where in the story the sequence will be used. Look for a shot that will aid the transition from one scene to the next. If, for example, someone walks through the frame, from left to right, a good follow-up scene could show someone else entering the frame from the left. Good transitions are smooth and don't jar the viewer's concentration. In fact, the best transitions are invisible to the viewer. You are limited only by your imagination in creating clever transitions. Watch for actions that might repeat themselves from one scene to the next. If a truck or bus passes between the subject and the camera, look for a way to get a similar shot in the next location—a shot with your subject obscured by a moving object. Then edit the scenes together at the moment when the subject is obscured. This will transition the shots from one location to the next with a little bit of surprise.

5. In this case, the special-angle (or point-of-view) shot as she closes the box serves as an introduction to a transition.

6. Look for a shot that will aid the transition from one scene to the next. Here, a close-up shows the completed box being pushed out of the frame.

7. A close-up of the box, this time in the driver's hand, transitions the viewer away from the young woman and to another location.

8. The closing shot cuts to a wide-angle shot of the driver carrying the box away.

Putting the Elements Together

In this sequence, the couple is loading sports equipment into a car.

1. The photographer starts with a master shot, which shows all the elements of the scene.

2. The scene can then be edited by using the master shot as the wide shot of any sequence. Medium shots and close-ups are matched and cut in.

3. A close-up shows the remote control unlocking the hatch.

4. The woman's reflection in the glass is an excellent transition to the next shot.

5. A medium shot reestablishes the setting as the hatch springs open.

6. The woman enters the frame with her equipment and begins loading the back of the car.

7. The next shot—the cutaway to the man's face—is an important transition shot to the next frame.

8. The man in the background of this close-up moves the viewer along in the car-loading process.

9. It is followed by a close-up of the same equipment being placed in the car.

10. In this close-up, the man helps load the bats and clubs. We know him because he was introduced in the cutaway.

11. In another close-up, the clubs are put away, and the job of loading the car is complete.

12. A point-of-view shot is a creative way to signal that the story is over. It is the closing shot.

THE ELEMENTS OF A STORY

The elements that make spoken stories worth telling are the same elements that make video stories worth watching. These stories often have intriguing titles and engaging opening phrases or scenes. They follow with building and releasing tension, or surprising the audience with an unexpected ending. They all have a beginning, middle, and end. Filming an entire baseball game or school play is not telling a story; it's recording an event. Showing backstage preparations, focusing on a single player and his experience, or highlighting the suspense and resolution in a scene—those are the building blocks of storytelling. The best stories are told simply and communicate on different levels. Edward R. Murrow, the veteran CBS correspondent, said that he tried to craft his reports so he would not insult the prime minister's intelligence, but if the scullery maid were listening from the kitchen, she would also be fascinated. In other words, the best stories have the widest appeal.

Every Story Has an Arc

The beginning of your story should set the time and place, the mood, and the characters. It must interest and grab the attention of your audience. Your job as the storyteller is to involve the viewer with the first scene. The middle of the story should introduce the characters or amplify the event, and narrow the focus of the story to its essence. A more complicated story will require additional sequences to flesh out the beginning. The characters must be defined. Who is the main focus of interest? Some movies spend the first hour defining the story. At some point, the beginning neatly segues into the middle of the story. Think of the middle as the stuff the viewer can sink his teeth into. It may be a building of tension, a comparison and contrast, a juxtaposition of different points of view, or a surprise. If you think hard about how to tell your story, you'll likely get the viewer thinking as well.

This is an ideal opening shot. It is provocative and sets the place and time. In this case, it whets the viewer's appetite for what is sure to be an interesting video story.

Tension and Release

The director Alfred Hitchcock explained the elements of a good story this way: Two men seated at a restaurant having a discussion is a dull story. If there is a briefcase on the floor between them, the story gets more interesting. If the briefcase contains a bomb, then the story has meat. If only one of the men knows the briefcase contains a bomb, then the meat gets tasty. There are a dozen variations on this story construction. What if both men know about the bomb, but only one man knows that both are aware? What if one man has defused the bomb but hasn't told the second man? The choices are limitless. Hitchcock's theme sets the stage for a good story. It creates tension, and it builds that tension. The inevitable end to such a story is a great release. Tension and release can be accomplished in a simple Christmas morning story or in a more complicated series of events.

Compare and Contrast

Comparing one item to another is also a good technique to build the middle of a story. Classic fairy tales are full of these comparisons—the good Cinderella as compared to her evil stepsisters springs to mind. Perhaps the lay-up technique of one basketball player is different from the method of another player. Comparing the two would be instructional. Contrasting the excellent fast-break ability of one team with the laid-back approach of another could also be worthwhile. Your story about local pollution will be enhanced by shots of birds in their endangered habitat. Simultaneous stories are also useful when comparing people, events, or things. The stories may be happening side by side or a continent apart, separated by years, but the stories must have a common theme that ties them together—and one that resolves itself in the final act.

The Closing Shot

The closing shot is the most important shot in your story. Since it's the last thing the viewer sees, it's likely to be the scene he or she remembers best. So use this shot to tell the viewer the story is over. But also use it to make an impact, to evoke emotion, and to solidify the point you are trying to make. On the news program *60 Minutes*, for example, the stories always end with a piece of dialogue from within the story. This snippet of sound is likely to be a provocative statement, and one that the viewer may well remember and discuss with his or her colleagues the next morning.

The sunset is the old standby closing shot because it signals better than any other shot that the day is over.

Surprise

Surprise is perhaps the most valuable storytelling gift. John Larson and photographer Mark Morache of Seattle, Washington, told a great video story full of surprises. They visited a small town in eastern Washington that had only one main street. If you blink while driving through town, you might miss it. Everyone knows everyone, and nothing out of the ordinary ever happens. So it was a shock to the residents when a "visitor" from the big city came to town—a parking meter. This parking meter suddenly appeared on the main street. It was the only meter in a thousand square miles. The camera team decided that the best way to tell this story was to build surprise by first showing all that is predictable in the town and then revealing something no one could have predicted. The story was so well crafted that the viewer began to expect the next surprise. If you can come up with a surprise or two in your stories, it will make them that much better.

1. The first shot is an establishing shot that shows the viewer a small town with one main street.

2. The cook in the local diner knows everyone's breakfast by heart.

3. She starts cooking their orders before they arrive.

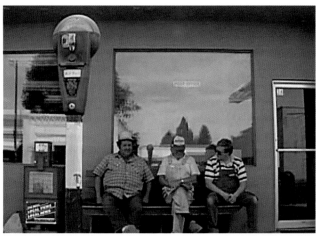

4. So, it came as shock to the residents when a "visitor" from the big city—a parking meter—came to town. This was the first surprise in the story.

5. The next surprise came when the viewer discovered that the parking meter could be moved.

6. Townspeople took turns putting the meter in front of each other's cars.

7. Motorists grumbled when they found the expired meter in front of their car.

8. The price was only a nickel, so some people went along with the joke and paid the money.

9. The townspeople realized it was all in fun, and besides, reported the filmmakers, complaints to the mayor would not have done any good.

10. The mayor confessed to having started the whole thing. He's already planning his next gag—a portable fireplug.

A Day in the Life of an Editor

I once shot an assignment about Norris Alfred, a newspaper editor who printed his weekly paper on a historic Babcock press, which required him to snap single sheets of paper onto the printer table to be rolled against the lead type, or slug and spit out the back end of the machine. I realized that each page was produced the same way. Each action was repeated over and over. I shot a wide shot of the complete action and then broke it down into its component parts with intricate close-ups of the old press heaving, rolling, and flopping out the pages. I included close-ups of the editor's hands flipping the sheets of newsprint and cutaways of his face intently keeping time with the print board as it flipped back and forth. I did not document each page being printed, but I told the story of the paper being published. The action was beyond my control, but it was easy to break down into repeated actions because it happened in one place. I didn't have to chase it around the room.

Mr. Alfred was a lifelong bachelor who, at the age of 70, found a family when he hired his Linotype operator, a single mother with a four-year-old son. Little Timmy terrorized the office on his small tricycle, careening among the table legs, in and out of the Linotype machines, and over the toes of employees. My task was to recognize any repeated actions and then place the camera in the right position to capture them from different angles and at different focal lengths. Timmy learned the alphabet by naming the letters the editor handed him from the Linotype table above. He sat on the floor shouting out "A!" when handed that letter. The paper office resounded with Timmy's voice, "J, N, and B!"

I watched this remarkable scene for only a couple of seconds, but long enough to see the repeated action, and then set about shooting all the component scenes. I grabbed a wide shot that included Timmy on the floor and his mom at the machine above. I moved in for a medium shot of a letter being handed down to him, and then moved closer for a close-up of his angelic face shouting out the letter and a close-up of that letter. Then I shot upward for a cutaway shot of the editor looking down at him affirming his correct recognition of the letter. The action kept repeating until Timmy, tired of the lesson, returned to his trike for another session of terror around the office. I planned for several point-of-view shots. In one, the camera is down low with Timmy, looking up at the editor. In another, we see the newspaper delivery boy from the angle of his red wagon full of papers.

It took an hour or so to get all the shots necessary to complete the sequences. I spent much more time with Timmy on the floor than I did with the printing press, but the effort was worth it. The sequences were pure gold when the story of the editor and his adopted family was complete.

1. Norris prints his paper on a nineteenth-century Babcock printing press into which he feeds the paper one sheet at a time.

2. Norris helps Timmy learn his alphabet with the slugs—the lead letters—from the typesetting machine.

3. Norris failed the only journalism class he ever took.

4. In 1979, he was nominated for a Pulitzer Prize for his editorial on the presidential campaign.

5. But nothing makes him happier than catching Timmy when he jumps from the pressboard of the old press.

6. Norris finally finds a family.

UNCONTROLLED ACTION

Controlled action rarely happens in real life unless you're making a movie. When shooting the real world, or uncontrolled action, you must grasp for ways to create sequences when the action is completely beyond your control—and you don't know what is going to happen next.

Repeated Action

When planning to shoot, it's a good idea to approach your scene without the camera for the first few minutes. Observe the action, noticing the moments when elements of the action are repeated. When you begin to shoot, those repeated actions are the moments when you can shoot from a different angle and distance to obtain wide shots, medium shots, and close-ups containing essentially the same action. Capturing repeated action is the equivalent of the master shot in an uncontrolled environment. Some scenes have more repeated action than others, but almost every event has actions that are

repeated somewhere. Remember that your job is to tell a story, not document every action. Not every play in the football game needs to be shot from the same location. Some plays may be sacrificed so the photographer can grab close-ups of the quarterback calling the play or the center snapping the ball. You may capture the coach reacting in a cutaway or shoot another cutaway of the cheerleaders or fans in the stands. The trick is to make sure you get the important plays and shoot your cutaways when you think the play isn't going to produce a game-winning touchdown.

1. A few minutes spent watching Norris flip the pages into the old printing press revealed actions that repeated themselves every few minutes.

2. The close-up in this sequence followed his actions as he manually flipped each piece of paper into the press.

3. A low-angle shot combined Norris's action with that of the press.

4. A close-up of the pounding press transitioned the story to the next scene.

5. Norris needed to readjust the type mid-printing. Pounding the type in place ensured that the ink would be evenly distributed.

6. Changing a paragraph meant replacing heavy sections of lead type in the rail.

Be Patient

A little serenity is necessary to get the right shot. Think about the shot you need and wait patiently for it to happen. Be ready for it, with your camera set at the proper exposure and focal length, and powered up. When the time comes, roll the tape and get the long-awaited shot. If you miss it, don't be discouraged; just get ready for the next one.

1. A quick look at Timmy racing around the press room revealed a predictable route. The photographer only had to set up the camera and wait for Timmy to return.

2. Timmy's Mom, Barb, was the Linotype operator. While his mom set the type, Timmy worked the room. The photographer waited patiently until Timmy approached his mom.

3. Sticking with a story, and sometimes even waiting until it's time to turn out the lights, can make the piece. In this case, Timmy and Norris had their own way of doing it.

Shoot and Move

Don't stand in one spot and attempt several shots. Zooming in on a subject is not an acceptable alternative to walking closer for a real close-up shot. Shoot the scene and then move the camera for the next shot.

1. Although this story took place in a small setting, there were still many choices of locations and angles from which to shoot. Here, Norris lifts Timmy up so he can turn out the light. It's his favorite part of the day.

2. Another important person in Norris' work life was Alvinna, the paper folder, who was full of unique and sage advice. Norris could fold his papers with a machine, but he said, "There's nothing entertaining about a folding machine."

3. Norris addressed his newspapers by hand. When the list got too large and his hand too tired, he raised the price of the paper, which reduced his mailing list.

4. At the end of a long day, the photographer moved outside to get this shot of Norris through the window. The photographer completed this sequence with a wide-angle shot of the deserted small-town street.

5. When shooting a story, try to think about what happens next to keep your piece interesting and tell the whole story. In this case, the newspapers were delivered by a boy with a red wagon—an old-fashioned delivery method.

6. Remember that your story is about a person, and people have many interests. Norris was a birder. The photographer followed Norris to Platte River at the end of the day, his favorite spot for watching Nebraska's feathered fowl.

Anticipate the Action

Here's an exercise for when you're not shooting. Try to predict which way the car in front of you will turn. Watching the driver's head motion will offer clues. Imagine where the camera should be placed to get the shot. Watch the crow flying overhead and pick out the clues that will help tell which direction he will turn. This will help when you are shooting the next ballet recital and you are trying to predict which way the ballerina will leap.

Learn to anticipate action in the frame. What hand will he catch with?

When the girl kicks, will you follow the ball or stay with the player?

A STORY FROM THE FIELD

Look for Unusual Angles

During an assignment on the USS *John F. Kennedy*, I shot aircraft as they were catapulting off the deck and landing, hooking onto the arresting cable. I paid close attention to the repeated action of the crew as they readied each jet for launch. They did it the same way every time. I caught one launch in a wide shot, and then broke up the action into its individual sequences for close-up concentration. Once I had all my sequences on tape, I looked for unusual angles. I got as close as I dared to the engines in the afterburner just before launch—blue and red flames roaring into a blast shield that protected the sailors behind it. I climbed to a place the sailors call the "vultures bough," a walkway about 40 feet above the flight deck that offers an excellent view of all the action below. I mounted a small camera on the forward-most tip of the carrier deck, where a jet passed directly over the lens. I was not allowed to be there with the camera, because I would have, in all likelihood, been blown right off the bow of the ship when the jet was launched. But I was happy to risk the camera's life, instead of mine. I always look for unusual angles, but I get the bread-and-butter scenes first. I make sure I have all the shots for the sequence on tape before I spend a lot of time mounting cameras or climbing for those surprise shots.

Even in a story with uncontrolled action, where the photographer is not choreographing the scenes, surprise is possible. While the viewer watched my sequences of sailors on the flight deck working among aircraft launching and capturing, a voice explained, "The first time I walked onto the flight deck I knew I wasn't in Kansas anymore. I was afraid of being run over by a jet, of being sucked into the engine, or of being burned alive by the exhaust...." The camera then cut to the man's face, shining with excitement. He exclaimed, "It's great!"

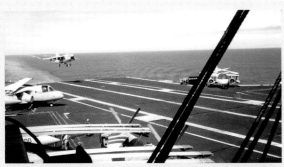

1. I chose the vulture's bow, a walkway that extends above the flight deck for an establishing shot.

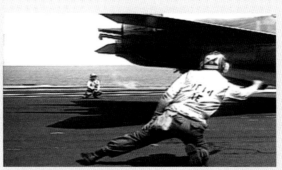

2. I moved closer onto the flight deck to experience same point of view as this crewman.

3. I shot the fog to both establish that beauty could exist even here, but also to show that it could create a dangerous situation.

4. Here I used a match cut from the close-up to reveal an aircraft emerging from the fog.

5. I looked for close-ups that would be "story-telling shots." The pilot's salute reflects the discipline necessary on carrier deck.

6. The photographer placed himself and his camera in a risky position to get an interesting angle of the aircraft launching.

7. Here I mounted the camera on the deck.

8. The crew gathered beneath the flight deck to rehash their day. I recorded their conversation and used it as sound under the pictures.

SHOOT FOR THE EDIT

Good photographers always shoot for the edit. They know the scenes that are necessary to assemble a story. And they take special care to shoot them so the editor—in this case, you—has them available. The best photographers are great editors. The editing process is inherently the core of storytelling. It is where sequences are finally assembled. It is where decisions are made about whether to use the medium shot or just go directly to the close-up. Similarly, the best editors are good photographers. They may not necessarily know all of the functions of the buttons on the camera, but they have an innate sense of where to put the camera to get a great sequence.

Screen Direction

Be sure to establish screen direction—the path the action is taking—and follow it faithfully. A consistent screen direction is important because it allows the viewer to watch the story without being confused about where the subject is headed.

There are several things to consider when choosing a screen direction. Which side offers the most room to move easily and gather your sequences? Which side has a large window? It's a good idea to shoot with the bright light from the window to your back. If there's no window, which side offers the best background behind the subjects? If there's going to be movement, which side favors the cleanest entry and exit? For exam-

ple, if two characters are talking to each other, make sure they keep looking in the same direction relative to each other—one should look to screen left and the other to screen right. If your subject runs toward screen right in the first shot, he must move to screen right in the second shot. Otherwise, he would appear to have reversed course in mid-stride.

A good way to make sure you are keeping your screen direction straight is to watch where your subjects' noses are pointed. Keep each subject in its own direction, and remember, objects have "noses," too—the pool cues need to keep pointing the same way as the shooters.

1. The man making the shot is looking to the right.

2. The photographer makes sure his opponent shoots to the left.

3. This example shows the subject facing the camera while the action heads in a different direction.

4. Even pool cues have screen direction. Here the direction is to the left.

Assembling Sequences

Your individual shots are always stronger when they are combined with the other scenes. The sequence provides context. It offers perspective. It gives power and meaning. When shooting, plan ahead to avoid a jump cut, or two scenes that jar the viewer by jumping from one location to another.

Make sure that the action in each scene overlaps the action in the previous scene, giving yourself enough choices later when you make the cut. The action should flow naturally. When the action involves movement from one location to another, allow the subject to move out of the frame, then begin the next scene before the subject enters the frame. This gives you, the editor, several choices. You can allow the subject to leave the frame in one location and cut to the second location with the subject in place, or you can allow the subject to enter the frame in the second location.

Professional editors would be likely to cut on the action, or while the subject is moving. The cut might be a match cut from a wide shot to a close-up, or it might be leaving and entering the frame with the cut just before the subject completely leaves the frame, or just after he enters the frame in the second location.

1. The photographer establishes time and place with nighttime skyline shot of the city.

2. A medium shot of the pool hall lets the viewer know where the action is about to take place.

3. The photographer introduces his main characters with a wide shot of the pool table which sets the mood for the game.

4. The balls break.

5. A match cut from the previous shot to a closeup of the ball falling into the pocket advances the story.

6. The cutaway to the woman's reaction completes the sequence.

CHAPTER 6: CAPTURING SOUND
AND PICTURES

You don't have to write your own screenplay to tell visual stories. Everywhere around you a script is being written as people go about their daily lives. And if you watch and listen, you will find an angle that captivates you. Sometimes sound makes the story. The ticking of a grandfather clock, the click of a camera shutter, or the hum of tires rolling over a metal-grate bridge can tell a part of the story that the visuals alone wouldn't convey. Open your ears as well as your eyes every day, and you will begin to see and hear things you'll want to capture on tape.

CAPTURING PICTURES AS THEY HAPPEN

For director Alfred Hitchcock, the shooting and editing of his films were perfunctory. All of his creativity was used in the writing of the script, and he planned his films so meticulously that each scene was carefully researched, rehearsed, and reviewed before the cameras rolled. Chances are you do not have, or even want, that kind of control over your projects. The shooting of a story is often where the most creative storytelling takes place—things happen that you didn't expect. There will be events that interest, surprise, or amuse you and will do the same for your viewer. In some cases, pure creation occurs in the edit, and in others, the edit is the fulfillment of a creative shooting process.

Editing in the Camera

You can choose to edit in the camera, which means making your choices as you shoot so no additional editing is required. Editing in the camera requires an extraordinary amount of concentration because the process makes no allowance for repeating a scene or even running a scene too long or short. Each scene must be photographed in the right order and to the proper length before the next scene begins. You cannot rearrange the scenes after shooting. Editing in the camera is a good way to start thinking like a video storyteller and to hone your creative skills. Whether you choose to edit in the camera or on your computer, it's a good idea to plan your shoot.

A STORY FROM THE FIELD

Shooting Amid the Ash

Editing in the camera became much more than an exercise when I covered the eruption of Mount St. Helens. We were lifted up to the site of an old silver mine where three miners had been working when the mountain erupted. The mine was less than a quarter of a mile from the volcano crater, and the damage to the mining camp and the huge surrounding trees was beyond belief.

The volcano had belched cubic miles of ash, which is a sinister substance around videotape recorders. The ash has the consistency of finely ground flour and the grinding capability of sandpaper. If even the smallest dusting of ash got onto the video-recording heads of the videotape recorder, it would grind the delicate heads down to nothing in a matter of minutes. The ash is also electrically conductive, which means it will short any electrical circuit it touches. We had to protect the recorder by sealing it inside a plastic bag. The bag shielded the machine adequately, but it also prevented us from changing videotapes when one ran out.

I knew that I had to shoot my entire story, from landing on the mountain to being retrieved by the helicopter, on one 20-minute-long tape. The entire assignment, and lots of money, rode on my ability to construct a story as I shot it. I had to edit in the camera. I relied on many years of experience working at a local television station, where, because of time constraints, I had to edit stories in the camera every day. I began, as I always do, with a wide shot to establish the scene. Then I followed with a medium shot, then close-ups. I remembered that each shot had to advance the story a little farther. I was very conscious of how long each scene ran. I counted under my breath, "a thousand-one, a thousand-two, a thousand-three." I never let a shot run longer than three seconds unless I felt an editorial imperative to exceed that. Some of the dramatic shots of the rescue dog, Hawser, locating the bodies of the victims, I let run until the action was complete.

My timing was pretty good, too, because I ran out of tape on the final shot of the helicopter lifting off. ABC ran a 25-minute report that occupied the first half of the *20/20* broadcast that Friday night. Eight minutes of the report came from the tape I shot on the mountain. That means that almost one half of every scene that I shot was used on the air—a phenomenal shooting ratio.

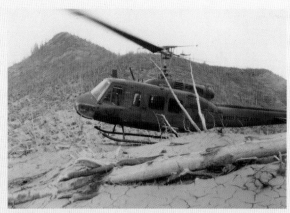

1. I opened my story with the helicopter searching for a place to land. I amplified the sense of destruction by showing the fallen trees in the background.

2. The rest of the search team arrives by helicopter. I chose to put the remains of Mt. St. Helens in the background as the helicopter found a tenuous landing spot.

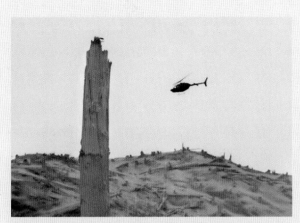

3. The searchers slipped as they climbed over trees. I was slipping too, but tried to stay close to get the shot.

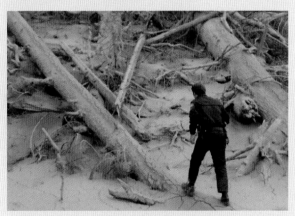

4. I had to struggle through the same crusty ash to get a close- up of the searcher's feet.

5. Rescuers used a search dog named Hawser in an attempt to find the missing miners whose cabin was leveled by the blast. I tried to keep up because I knew that finding the miners would be the key dramatic point of my story.

6. National Guard pilots flew us away from the scene at the end of the day. We narrowly missed being trapped on the mountain overnight. The volcano erupted for a second time, covering the area with a meter of ash. The shot over the pilots' shoulder provides context to the enormity of the damage that went on for miles.

NINE STEPS TO HELP YOU ORGANIZE YOUR SHOOT

Here is a nine-step procedure for shooting your story. Keeping these key steps in mind, and in order, will help you organize your piece so when you get to the editing stage, you will have everything you need.

Step 1: Survey

If you are at the scene of an event already in motion, you will be forced to grab your camera and begin shooting immediately. If you have the time, it's a good idea to survey the scene without the camera and ask yourself some questions: What kind of light is available—indoor fluorescent light or outdoor afternoon sunlight? Do you need to use additional lights, and if so, where are the electrical outlets? How many extension cords do you need? Which screen direction will you choose,:in other words, which side will you consistently shoot from so the piece will make sense?

A quick survey of the empty studio gives the photographer a good sense of the lighting conditions—it's brightly lit with incandescent fixtures. He will white balance his camera before the talent arrives.

As the talent gets ready, the photographer makes use of an available light fixture to create a different mood in the dressing room.

Step 2: Commit

Once you've determined your type of light and screen direction, move on to an assessment of the story. What is the story about? This often requires some serious thought. It's important to understand as much of the story as possible before turning on the camera. Spend time gathering information and discussing the event with the people involved. Then write a single-sentence synopsis of the story—a "commitment statement." This sentence forces you to focus your efforts and commit to a course of action. Make sure it's a sentence that summarizes the complete story. Just saying that you want "to show a soccer game" is not enough. It's better to say, "Ellie excelled at scoring goals at today's soccer match." If the elements necessary to tell a story are present in the synopsis, it will provide a guiding light for you as you shoot the scenes.

Chris Conn Profile

Commitment: Chris works hard to deliver a quality performance

You may think that merely making a commitment in your head is enough, but it really helps to write it down.

The next shot illustrates our commitment right away. It shows that Chris works hard even when rehearsing backstage.

Step 3: Scene List

What shots do you need to tell the best visual story? It's a good idea to make a checklist of all your shots before you pick up the camera. Then you can mark off each shot, and important scenes will not be forgotten. The big scenes are easy to remember. It's the little ones—the transition shots and the cut- aways—that are all too easy to forget. Write the title of your story and your commitment statement at the top of your checklist. If you list your shots in the order they will occur, no additional editing may be needed. If you move ahead chrono- logically, your story will make sense.

You should not only write the scene list on paper but also check off each scene as you shoot it. This way you won't forget any important scenes. You may think it won't happen to you, but it will.

Each shot advances the story. Here Chris attaches a wireless micro- phone to his lapel.

Step 4: Open

The two most important scenes are the opening shot and the closing shot. It is crucial to involve the viewer in the story from the very beginning. P. T. Barnum understood this concept when he told his circus performers, "First you must get them into the tent."

If the story begins with a tepid, confusing scene that does nothing to elicit emotion, the viewer is likely to lose interest immediately. However, your opening scene does not need to be spectacular. Often a simple wide shot establishing time, place, and situation is best. Such a shot is comforting to the viewer because it allows him to discern the basic facts with- out a lot of work. Or if you like, you can get clever with a close- up or a weird angle to grab the viewer's attention.

A story can have several openings. In this case, the story takes a turn when Chris arrives on the set to begin his program. This is the opening shot for his television audience.

A new character is introduced. Dawn is the teleprompter operator. She will put Chris's lines up on a screen so he can see them from the stage.

Step 5: Sequences

The scenes after the opening shot should follow the natural progression of the event as faithfully as possible. As you shoot each sequence, keep in mind its place in the story. Plan transition shots to move your subjects from place to place without disturbing the flow of the piece. Transitions are an art unto themselves. They can be as varied as the imagination. The most commonly used transition allows the subject to walk into and out of the frame. Once the frame is clear of the action, a cut can be made to anywhere, and the viewer will accept it. That is your goal.

Chris begins reading through his lines on the teleprompter.

As Chris reads, Dawn scrolls the script down the screen.

Step 6: Pace

It is impossible to dictate a set of rules to govern the pace of a story. The event sets the pace. A leisurely stroll through the park has a completely different pace than a hotly contested basketball game. When editing in the camera, a good rule of thumb is to allow a scene to run about three seconds and stop recording. That is not a hard and fast rule—some scenes don't deserve three seconds and others demand much more time.

Chris is a lively show host who uses lots of gestures and a big smile to entertain his audience.

The pace of the story is quickened with faster cuts and shorter scenes to reflect his frenetic energy while on air.

PRO TIP: Transitions

Many effective transitions can be done in the camera. Most camcorders have an "effects" mode that will produce a fade to black and fade up from black. The fade is a popular transition. It connotes the passage of time, the visual equivalent of saying "later that same day...". The swish-pan transition requires practice. The concept is to rapidly swish-pan the camera off the subject, then swish-pan onto something in the next scene. Timing is important. If done too early, it might eliminate parts of a valuable sound bite. If done too late, it will create an awkward pause.

Step 7: Sound

Keep your ears open for any naturally occurring sound that you might be able to use as a transition. A door opening, a shouted greeting, the sound of typing on a keyboard are all potential transition sounds. As you shoot the story, listen for a good moment to use a natural sound, and when you've recorded enough of it, stop the camera to make your edit.

Step 8: Adapt

Adapt and improvise. Use your prewritten scenario as a guideline. Don't be afraid to deviate from the shot list when something unplanned happens. Go with the flow, and develop the sequences as they present themselves.

If repeated action presents itself, you'll see it as an excellent opportunity to edit in the camera. Record the action on a wide shot, then stop recording when the action completes its cycle. Change camera positions and then record the same action on a close-up, beginning recording when the action starts.

Chris discovers a mistake in the script. He asks Dawn to repair it at her teleprompter station.

Luckily, the photographer has been following Dawn's story as well and is ready to include this impromptu part of the show in his video.

Step 9: Close

The closing shot is the single most important part of the story. It is the visual image the viewer will remember the most, and it needs to accomplish several tasks. It needs to communicate clearly that the story is over and complete. It needs to show the consequences of actions in the story. It needs to cement the film's emotional message, and it must be a powerful, well-composed image—one that will remain with the viewer long after the story is presented.

Chris is grateful for Dawn's help in making a smooth show. He thanks her on his way out.

A shot of Chris walking out the door helps the photographer conclude his story by providing release from the tension created in the earlier scenes and sending the message that the show is over.

CAPTURING SOUND AS IT HAPPENS

When telling a story, sound is frequently just as important as the picture. Sound can be the glue that binds together various parts of your piece. It sometimes provides excellent transitions from one location to another. The recorded sound is often the only source of audio in some documentaries when there is no narrator and no script. It adds immediacy to the event, bringing the viewers into the story and allowing them to experience the event along with the photographer. It may be a yell of exultation upon winning an event or a soft sob of disappointment from someone on the losing team. It might be an under-the-breath comment from the subject or a shout from across the room. The best audio, like the best pictures, is recorded when the photographer and the camcorder are as close to the subject as possible. When you are close, you are more intimate with your subject, and so are your viewers.

Pay Attention to Sound

Always remember to pay close attention to surrounding sounds when shooting. Sometimes a great piece of sound occurs when it is least expected. Push the record button, even if the picture is not composed. Later, when you are editing, lay that sound under some other pictures. It may make a great transition.

The playful sound of these girls could be used as background sound for a video about children or could begin before the picture as a transition.

The Interview

The interview is a valuable tool in storytelling. Bits of interview answers can be inserted under video to help assemble your story. Remember to isolate the interviewee as much as possible from any interfering sounds. When the audio is played under the pictures, any competing sound will be immediately evident and distracting. Choose a quiet place for the interview. Inside a house is a better choice than in a yard. Unexpected noises outside, such as airplanes overhead or cars passing by, can ruin a choice piece of interview sound.

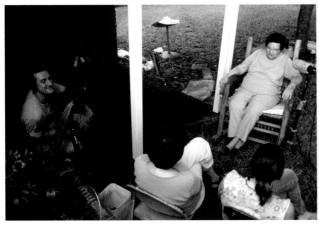

This interview was conducted outside because the early evening light was just right, but the photographer risked being interrupted by planes, trains, or automobiles.

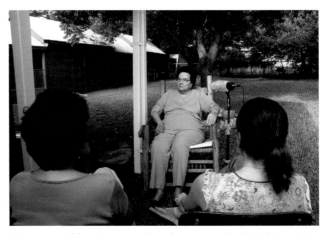

It is a good idea to put a microphone near the interviewer, even though the interviewer's questions are rarely used.

Built-in Microphones

On many video shoots, the sound is not handled by a sound recordist. Good sound is an afterthought. Often, the only microphone available is the one mounted on the camera—the "on-board" mic—which has its advantages and its disadvantages. The microphone on the camera is usually a condenser omnidirectional microphone. They are less sensitive than more expensive microphones and are more likely to perform poorly under unusual circumstances, such as high noise volumes, high wind, and other undesirable situations. It is good for recording speech from no farther than three or four feet away. Beyond that distance, the voices will get lost in the ambient sound.

The on-board mic, while convenient, is not suited for many applications, especially outdoors, or when the camera is not near the subject.

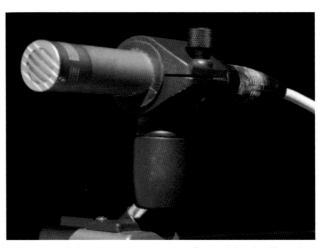

A shotgun mic has a very narrow cone of sound that it will receive, making it ideal for excluding most extraneous and unwanted noise.

TYPES OF MICROPHONES

The serious photographer has many microphone options. The microphone is comparable to the photographer's lens. The lens is only as good as the glass inside it, and the best lenses are those with the highest-quality and most expensive glass. Likewise, different types of microphones will offer a variety of recording characteristics that affect the tone and range of the recording. The many choices are presented by the kind of response patterns they produce or how they "hear."

Omnidirectional

One of the most common response patterns is the omni. The microphone picks up sound in a 360-degree arc, a full circle. This is noted as 0° and is the region in front of the camera. The notation 180° refers to the rear of the camera. And 270° and 90° apply to the sides. All areas pick up sound equally. The front area, or 0°, is also called on-axis. Any sound coming from any other direction is called off-axis. With an omni-directional microphone, any sound behind the microphone will be heard with the same volume and sensitivity as sound coming from the front. An omnidirectional micro-phone is useful if two people standing an equal distance from the microphone are speaking. However, you shouldn't expect voices from more than a few feet away to be heard distinctly.

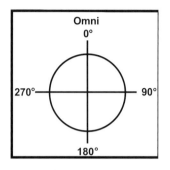

There are two kinds of omni microphones: transducer and condenser. Transducer microphones are "dynamic"—they are not powered by a battery or other power source. Instead, power is created by vibrating air particles caused by the sound, which in turn cause the diaphragm inside the microphone to vibrate and generate a small electric pulse that is sent to the camera and recorded as sound. Dynamic microphones are not very sensitive and may not pick up low sounds well, but they also are not likely to dis-tort the sound. Condenser microphones are powered by an external power source, such as a battery, power supply, or a mixer. A condenser microphone can create a more accurate recording and will pick up low-volume sound that dynamic microphones often miss. However, it will also accurately record all the noise in the room as well, something you may or may not want.

Cardioid

The cardioid response pattern is aptly named because it resembles the shape of a heart. These microphones record full sound in front of the microphone and, to a lesser degree, from the sides. Toward the rear of the microphone, the volume—or response—is diminished. This pattern works best in a situation where an off-axis signal from behind the camera needs to be diminished. For example, when record-ing a trumpet player in a band, a cardioid microphone will dampen the sound of the adjacent trombone.

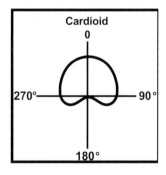

Super-Cardioid

The super-cardioid microphone is very much like the cardioid with a few changes. The front lobe becomes more directional. In other words, the sounds from the sides shrink even more. This also creates a small back lobe so that it lets in a bit of off-axis sound. Be careful that you don't record something from the rear that you don't want. The super-cardioid is good for recording vocals because it concentrates on the voice closest to the front of the camera.

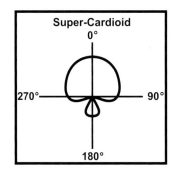

Hyper-Cardioid

Hyper-cardioid microphones are essentially narrower, more directed cardioid microphones. They reject even more sound from the sides. The front lobe is more directional, and the back lobe is more pronounced. This pattern is good when you want to pick up more of the environment in which you are recording. For instance, when recording a choir in a concert hall, you would aim the microphone at the choir. At the same time, the microphone will pick up just a little ambient sound that is reflecting back from the rear of the auditorium.

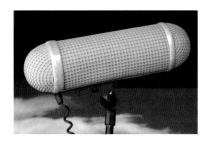

Shotgun

Shotgun microphones are the most directional and often the most expensive. Shotguns are designed to be very focused—rejecting most of the sound coming from the sides—making them ideal for recording from long distances. They are standard in almost all professional production situations. They can be far enough away to be out of the frame and still deliver high-quality sound and reject unwanted sounds from the side and rear. They are placed very close to the subject. These microphones are a good choice for conducting an interview. They lack a strong presence because they don't pick up much ambient sound.

Lavaliere

Lavaliere microphones ("Lav mics") are also a good choice for interviews. Lavaliere microphones were originally designed to hang around the performer's neck like a necklace. (Lavallière is a French word meaning a pendant worn around the neck.) Contemporary models are smaller than the point of a pencil. They are designed to emphasize speech from barely a foot away and hear sound as it resonates from the chest. Therefore, the best placement for a lavaliere is on the subject's shirt—attached with a clip. The microphone can usually be hidden behind a lapel or under a fold.

Wireless radio transmitters can be attached to the lavaliere. The radio signal is transmitted to a receiver that attaches to the camera or to a mixer that feeds the camera. Using a wireless system eliminates the cable that attaches the subject to camera; therefore, giving the subject more freedom to move. The camera is also free to move about and take a wider variety of shots.

OTHER SOUND EQUIPMENT

Headphones

Headphones are a necessity. They are the only way the photographer can really hear what is being recorded. The ambient room sound may be perfectly understandable when heard by the human ear, but the camera is hearing something entirely different. It is recording sound generated by the microphone attached to the camera. Most camcorders accept the standard mini-stereo plug on normal stereo headphones. Be aware, however, that camcorders are not known for producing a lot of sound volume in the headphones—this is a common complaint.

A small and relatively inexpensive pair of headphones is sufficient for most uses. This pair has cushioning, which adds comfort.

A more expensive pair may have softer, bigger pads for added comfort, but probably doesn't have many other practical features.

Two Channels of Audio

All camcorders have two channels of audio recording at all times, but the middle- and higher-level cameras allow you to record two different things at once. When you can, it's a good idea to use two different kinds of microphones on every shoot. A shotgun microphone on one channel and a wireless lavaliere on the other work well. Place the wireless mic on your central subject or performer. Use the shotgun mic to give seamless coverage of any sounds in the immediate vicinity of the camera. The wireless mic offers constant contact with your subject.

Here the subject, getting ready for his television show, attaches a wireless microphone to his shirt.

In this interview setup, a shotgun mic is used to pick up sound from and around the subject.

Recording Music

Recording music is a special challenge. The professionals use dozens of specialized microphones to record a song. All the microphones are fed into a mixer and adjusted for the best possible level before the actual recording takes place. It is impossible to achieve the same results with a single microphone on a camcorder, but there are ways to make it work. Place the microphone closest to the weakest sound being recorded. This is often the voice of a singer or an acoustic instrument that is battling to be heard above the electric instruments or a loud drum set. The louder sounds will be heard by the microphone just fine, and so will the weakest sound if the microphone is very close. If all the sounds of the musical performance are of roughly equal level, place the microphone about midway in the room, directly in front of the performers, so that it is roughly equidistant from each performer. The performance may be mixed by someone in the band or at the venue. It is possible to plug into an output of his mixer if you use the appropriate plug. It is a good idea to assemble a variety of adaptor plugs.

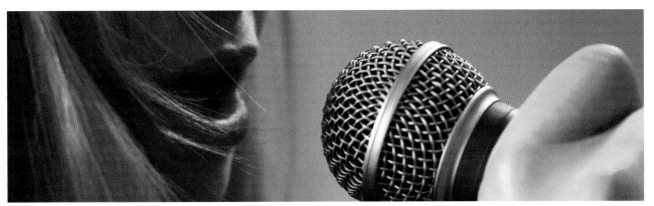

Ideally, the videographer would plug into the mixing board to record the sound directly from the musician's microphones. This would eliminate any room noise, as well as provide a very strong signal, which translates to better sound. However, this will not always be possible.

XLR Plug

The XLR is the standard plug for professional recording. Only the middle- or higher-level cameras will accept it. It has three pins and is used to produce a balanced signal. A balanced signal provides higher-quality audio with lens interference.

Stereo Pin Plug

The stereo pin plug is popular on camcorders. It carries audio signals on two connectors and a ground on the third one. It is an unbalanced signal.

RCA Plug

The RCA, or UHF, plug is used to carry analog audio and video signals into the camcorder. There may be three plugs in a wiring harness included with the camcorder. The plugs will be colored red, white, and yellow. The red and white plugs carry audio, and the yellow plug carries video.

Audio Gain

Camcorders offer automatic gain control (AGC) on the audio circuits. The AGC is much more reliable than the automatic aperture. It is, therefore, safe to depend on the automatic gain to control the audio level in many circumstances. But there are times when automatic gain control is not a good idea. AGC attempts to seek a level for all sounds, whether soft or loud, and record them alike. The subtleties of a softly spoken word may be lost when the AGC boosts the level too much. A burst of exclamation will be dampened to meet the same level as all the other sounds, losing some of its energy. Automatic gain control is useful when most of the sound is at the same level, or when you are just too busy with all the other operations of the camcorder to adjust the audio level. However, make an attempt to use the manual level control when possible.

How Audio Is Measured

Audio is measured in decibels and is displayed as "dB." A decibel is a unit of measurement of the audio signal strength. The meter used to display audio levels is called a "Vu" meter; Vu being short for "Volume Unit." The benchmark audio level is 0 dB. The standard for setting this benchmark level is a 1,000-hertz tone. Once the benchmark is set, the audio being recorded is compared to it. Levels less than 0 dB are referred to as "-dB numbers." Levels above 0 are called "+dB numbers." A good recording level would be -10 dB. A bad one would be +5 dB. Never exceed 0 dB in digital recording. The concept is similar to overexposing your video: The camera is unable to record video levels above 100 percent, and all the details in those areas are lost. Any audio exceeding 0 dB will lose detail and clarity: It will distort. It is preferable to check the sound in a situation and set the audio gain so that nothing exceeds -10 dB. If there is an unexpected loud noise, it will likely reach the microphone and not exceed the 0 dB maximum.

The signal on the Vu meter reads at the optimal level of 0 dB.

It is acceptable if the signal sometimes peaks into the red area.

When the meter stays in the red area, your signal is distorted.

A STORY FROM THE FIELD

The Family Photographer

I am not sure what I expected to find when I went to Trinidad, Colorado, to tell the story of Glen Aultman, a photographer who'd been plying the family trade for 70 years. What I found was a time warp back to the turn of the century, when photos were made in a studio lit by carbon arc lamps and shot onto huge 8 x 10 negatives with an antique view camera. Aultman shot portraits the same way his father did 70 years before. The images were black and white. Glen colored them himself with crayons and pencils. He preferred using his imagination. Aultman's studio was a remarkably quiet place. The only sounds heard were small and very specific: the ticktock of the old grandfather clock on the wall and the pop and hum of the carbon arc lamp as the electric current jumped across the gap between the electrodes. I decided to use these sounds as an integral part of my story. They seemed to define him. There was the click of the shutter when he squeezed the bulb after waiting for his subject to appear "just right" in the frame. And there was his music: Huge LP discs of symphonic and operatic masterpieces played on an old wind-up Victrola record player. Aultman chose his music to match the mood, and he set about his daily chores in the same way each day, year after year.

Veteran photographer Glen Aultman.

The sound of the carbon lamps lighting the studio becomes an integral part of the story.

Glen squeezes the bulb to click the camera shutter.

Coloring photos by hand with crayons and pencils enables Glen to use his imagination.

CHAPTER 7: BUILDING YOUR STORY

Good stories well told do not necessarily have to be made in Hollywood. Events in your everyday life provide wonderful storytelling opportunities. The following examples should inspire you to look at your life and think about the tales you want to tell. Weddings and vacations create strong family memories. The challenge for the photographer is to chronicle the event in a way that's true to those memories. Sporting events and parties are full of action and emotion. The storyteller is challenged to capture the action and carry that emotion throughout the video. Here you'll find guidance on storytelling and shooting techniques to help you record the day-to-day and special occasions that make your life unique.

SHOOTING A WEDDING

You may be asked to shoot a friend's wedding with your new video camera. Weddings are great opportunities to tell a story. The event is uncontrolled, but all weddings follow a certain pattern. You can anticipate what's about to happen if you think on your feet. This photographer did an excellent job of placing his camera in the right place at the right time. You feel like you are there, know the bride and groom, and can feel the emotion of their special day. The photographer chose a very specific style to use in telling the story: He developed parallel stories of the bride and groom preparing for the wedding. All of the pictures of the groom are in black and white, and the photos of the bride were treated with sepia tone. The difference in textures served to separate the two stories as they developed alongside each other. When the wedding began and the couple came together, he reintroduced color into the pictures, which helps to symbolize their union.

1. The wedding story begins, as most weddings begin for the bride, with a date at the hairdresser. This story opens with a wide shot that establishes the place and time.

2. A medium shot brings the viewer closer. This is an excellent example of the use of the rule of thirds as the bride's head is in the right third of the frame.

3. A close-up of Sarah reveals the pensive bride examining her new hairstyle.

4. Now it is time to begin intercutting pictures of the groom, Bret, to begin telling his parallel story. A wide shot shows him greeting his mother, and establishes the place as a hotel room.

5. The story returns to Sarah arriving at the hotel. The maid of honor, Rebecca, has a unique way of closing the car door. The photographer got this great shot by being prepared.

6. Bret seems to be having trouble with his bow tie. His father makes the first tying attempt.

7. Sarah, in a medium shot, is discovered applying her makeup with help from Rebecca.

8. The photographer cuts to a close-up to complete the sequence and bring the viewer in to get to know Sarah better.

9. Bret's travails continue; this time his best man, Geoff, attempts to tie the bow tie. This medium shot match cuts to the next shot.

10. A wide shot over the shoulder reveals their reflection in a mirror. This is another nice example of the rule of thirds in action.

11. The wide shot is used to reestablish Sarah's location as she continues with her dressing.

12. The photographer match cuts to a medium shot of Sarah and Rebecca.

13. Success at last!

14. One can only imagine the thoughts racing through Sarah's head as the wedding approaches. The photographer shoots an excellent close-up that captures her deep in thought.

15. The groomsmen perform the ritual of decorating the getaway car. It's a good idea to get the traditional shots that people expect—like tossing the bouquet.

16. A wide shot shows Sarah and Rebecca arriving at the church. Returning to a wide shot, such as this one, establishes a new place.

17. Bret and Sarah's parallel stories come closer together as the interwoven action merges in front of the church.

18. Finishing touches include something borrowed, in this case, a necklace from bridesmaid Sonia. Observant viewers will notice the decorated getaway car in the upper left corner.

19. Geoff puts the finishing touches on the car.

20. It is time. Sarah heads inside. This is the transition shot that takes us to the main event: the wedding.

21. Bret's story transitions to the church when his mother is escorted to her seat.

22. A wide shot establishes all of the groom's party preparing for the big moment—now only seconds away.

23. The photographer transitions to color as the ceremony begins. The junior bridesmaids are first down the aisle.

24. The photographer cuts to a wide shot of the magnificent church with light streaming in through the windows. He had noted this in a preparatory visit earlier and was prepared for this light.

25. The story is advanced with a shot of the ring bearer, who appears to be near collapse with fright. This kind of emotion in an image will stick with the viewers.

26. Finally, the bridal march begins as Sarah and her father make their way to the altar. Notice how each shot, regardless of its composition, advances the story.

27. A match cut to a close-up confirms the happiness of the bride and the pride of the father. This shot enhances the emotional impact of this dramatic moment.

28. A cutaway of the family watching from the pews serves as a transition to the next image. Cutaways advance the story. Here the viewer is reminded that the bride's family is present.

29. The wide shot establishes all the characters of the story together for the first time.

30. A match cut to the close-up affirms the emotion everyone feels at this moment.

31. It is a good time to reestablish time and place and the photographer takes advantage of the next few minutes to climb to the top of the balcony for a breathtaking wide shot.

32. The priest conducting the ceremony is revealed with arms outspread in a medium shot. The viewer is also listening to his words as he addresses the couple.

33. A match cut brings the viewer closer to the priest and the couple. The match cut allowed the photographer to edit the priest's remarks to create a shorter, more pointed version.

34. Emotions overflow as the vows are exchanged. Sarah can no longer hold back the tears and the photographer responds. An event such as this requires quick thinking and the ability to adapt.

35. The photographer notices the family sharing Sarah's tears, and he quickly includes a cutaway to amplify the emotion.

36. A scene should run as long as the emotional content dictates. Bret and Sarah exchanging their vows runs longer than any other scene in this piece. A medium shot brings the viewer closer to the action.

37. The vows have been exchanged, and the story is nearing its end. The photographer has already planned his closing sequence.

38. Immediately following the kiss, the photographer rushes down the aisle to place himself in a good position to capture the bride and groom leaving the church.

39. The emotion builds to a peak as the photographer shoots close-ups of family members congratulating the couple.

40. The getaway car becomes a cutaway to the couple and the anticipation of their departure.

41. The photographer uses a soft effects filter to make use of natural light streaming through the front door of the church.

42. This soft effects filter also enhances the bright highlights on Sarah's veil.

43. The closing shot to the story epitomizes the wedding's euphoric feeling and will stay with the viewer after the video is over.

SHOOTING A SPORTING EVENT

The author had a chance to put his storytelling techniques to good use when his daughter played in a championship soccer game. The challenge was to tell a story about the events without attempting to chronicle every movement of the ball and every goal scored. The game, like all sporting events, is an uncontrolled event but with predictable, repeated actions. If you look for opportunities to shoot sequences using the repeated actions, it's easy to capture the emotion of the event without having to record every minute. Knowing the game is essential to anticipating the important moments. In soccer, momentum is the key. Shots on the goal most often follow a drive down the field. Close-ups are important to capturing emotion and also to making the viewer feel connected to the action. Getting good close-ups in a fast-moving event such as soccer, is extremely difficult. Try to use as small an aperture as possible—that is, a higher f-stop number—because it will give you greater depth of field and thereby help keep everything in focus. Keep in mind that much of the emotion occurs on the sidelines when families and team members on the bench react to the game. You will also have the opportunity to create more drama and emotion in your edit with your use of cuts and music.

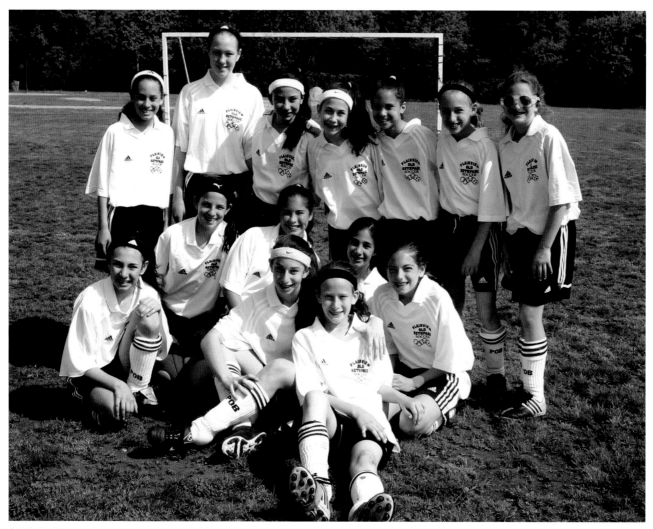

1. It's the big game—the semifinals for the championship. For the team photo, the photographer gets in as close as possible, while making sure to get the team in the frame. A great opener, this picture conveys that the Fighting Tigers are ready to play.

2. Coach Tony gives serious instructions to his team about the dangerous opponents they face today. Don't be afraid to shoot people's backs. This different point of view can add interest.

3. The next shot is a close-up on the coach as we continue to hear his pep talk: "The opponents are fast and physical; expect a lot of body contact and shoving. And most of all, have fun."

4. The camera quickly turns to a shot of the referee as he whistles the ball into play. A good photographer always anticipates what will happen next.

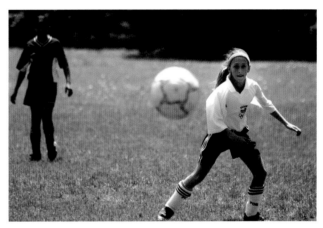

5. The ball comes fast. A fast shutter speed makes the player seem frozen in time, but the slight blur of the ball gives a sense of movement. Dramatic music is faded in.

6. Lots of quick scenes set the frantic pace. The scenes are short, but they are cut on the action when possible. They should not be routinely edited to the same specific length to fit the beat of the music.

7. A close-up of the fans captures efforts at mental telepathy and old-fashioned vocal encouragement, which is easier to capture with a microphone.

8. A close-up introduces Catherine, the playmaker. The photographer has prepared by learning each girl's name and her strengths. It helps him anticipate the play of the team.

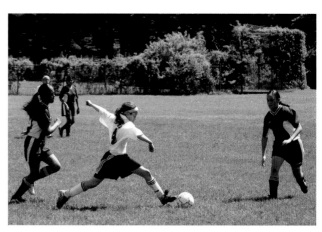

9. Here he follows Catherine as she prepares to feed the ball to Sarah.

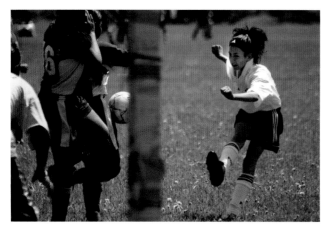

10. A player gets off a blistering shot on the goal, but it is blocked. Her frustration is evident in the close-up. Subtle expressions can be captured if the photographer attempts tighter shots.

11. It's a hot day, and even the four-legged spectators need refreshment. A good photographer is always on the lookout for fun shots to make the story more interesting.

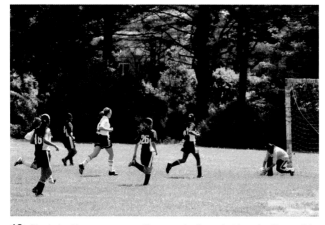

12. Back to the game—another goal attempt. You don't need to chronicle every moment, but you should capture the goals. Here, the photographer was ready, but the player didn't score.

13. The photographer returns immediately to the close-up, this time catching the worry on a father's face.

14. The game gets physical. Coach Tony had warned the girls this might happen. The photographer knew to anticipate it and he caught this dramatic moment.

15. A player goes down. The music breaks into a tense, single note, and the pace of the edit slows abruptly. The viewer can worry along with the parents.

16. Another player, Chelsea, also needs help. The shot lingers as the viewer waits to see if the injury is serious. The single dramatic musical note continues, mixed with the murmurs of the crowd.

17. Coach Tony rescues Chelsea, who is having trouble walking, and the viewer hears applause from the crowd.

18. The photographer knows the parents will be worried, so he hurries to grab a close-up of their reaction. Soccer etiquette dictates that parents not run onto the field if a child is injured.

19. Play resumes and so does the musical score. Both teams are giving it all they've got.

20. A penalty shot is called and the photographer chooses to concentrate on a close-up of the ball.

21. Then, he quickly pans the camera and zooms to a wider shot as Ellie throws her body in front of the ball to block it.

22. Sarah picks up on the rebound, battling through two opponents. The photographer senses the electricity in the air as the momentum of the game changes.

23. They play with abandon. The photographer catches the crucial turning point in the match because he pays attention to everything going on around him.

24. Ellie's team scores and wins. The photographer is slightly out of position and has to shoot a telephoto shot from across the field. No one can anticipate every play in a game as fluid as soccer.

25. The photographer gets close enough to the fans to record their enthusiastic reaction.

26. High fives are exchanged all around. This is a moment the photographer doesn't want to miss.

27. Ellie and her teammates are congratulated. They will now play for the championship.

28. The photographer was searching for a strong closing shot when the girls gathered for a team cheer: It's the perfect ending. Luck can play a role in getting the good shots, but most of the time the photographer makes his own luck by being prepared and paying close attention.

SHOOTING A BIRTHDAY PARTY

Like weddings, birthday parties have a structure—you know what to expect, from the cake to the presents. At this party for the soccer team's goalie, the author observed the frenetic activity in the backyard and wanted to capture that emotion as the thread of his story. It was a hot summer day and the party guests were reveling in water play. The girls should have been tired, since they'd just played an intense soccer game, but their energy was boundless. There was a lot of fast action—the girls were racing back and forth very close to the camera. A faster shutter speed was needed to keep the pictures from blurring. The sound was easy to record since the girls were loud enough to be heard from blocks away.

The photographer needed to monitor the audio level closely because as the girls ran past the camera, they created large spikes on the sound meter. When the meter peaked at maximum level, or 0 dB, he lowered the volume control. The photographer wanted to capture a raucous party, but he didn't want the sound to be distorted and distract the viewer.

1. The story opens on a backyard basketball game. It's the soccer team at the goalie's birthday party.

2. The girls should be tired, but they're still playing and making lots of noise. Sound is going to play a major role in this story.

3. The goalie, Mallory, is also the birthday girl. This close-up captures her satisfaction and happiness.

4. A series of quick, action-filled shots of a "Beamo" game sets the pace for the party.

5. Some fast-paced music is added to enhance the party fun.

6. The photographer will attempt in the edit to cut the scenes on the musical beat.

7. Changing scenes on the beat enhances both the music and the picture. This close-up completes the Beamo sequence and transitions to the rest of the party.

8. The pace on the swings is a bit slower, so the scenes will run longer, and the music will slow down to keep pace.

9. Close-ups reveal a subject's true emotion.

10. The parents attempt to control the party with a water-balloon toss. A wide shot establishes this new activity.

11. A match cut to the close-up sets up a transition to the chaos that follows.

12. It's obvious the parents have lost control of this party. The photographer gets up high for a shot that captures the feeling.

13. The photographer adds context by placing sneakers in the foreground.

14. He stays committed to revealing action through wide shots.

15. A close-up of a girl at the top of the slide is used to transition away from the water fight.

16. The scene cuts to a wide shot as a girl slips down the slide and onto an improvised water slide, actually a plastic tarp, but it does the job just fine.

17. The music accents the howls of laughter during a succession of quickly cut scenes of the girls on the water slide.

18. A quick cutaway melds together the two action shots.

19. Laughs turn into shivers and towels are suddenly in short supply. A close-up tells the story of blue lips and goose bumps.

20. A sequence of shots, beginning with a wide shot, tells the story of Coach Tony, who becomes a hairdresser as he tries to dry all those long manes of hair.

21. Mallory's mom serves the birthday cake. The photographer makes sure he knows when the cake will be served so he will be in position to get the shot.

22. Mallory, the birthday girl, is pleased—a happy ending.

SHOOTING A FAMILY VACATION

Family vacations make excellent video stories. There is action, excitement, and fun, and the story has a built-in beginning, middle and end. Make the commitment to shoot your story in the simplest manner possible. Commit to shooting only with available light. Commit to shooting handheld. Take the bare minimum of equipment, but be a little generous with battery power because you never know when you'll have time to recharge.

Shoot the vacation action with a commitment to create a special sequence or two at each event. Don't go crazy trying to document every little thing that the family does. Just grab some nice sequences; then put the camera down and have some fun. Keep your camcorder on standby—it will power up faster this way. Sequences will convey your story better than single shots, and give you more options in the edit room. Finally, be on the lookout for a strong emotional closing shot. The obvious ending shot is arriving home, but you can challenge yourself to find something unpredictable.

1. The family is off on an adventure to Vietnam. The story begins with a wide shot of the girls preparing to board the airplane, then fades to black.

2. The scene fades up from black to discover the family in Vietnam visiting a rice field. They are awed by all of the workers in the fields planting and caring for the rice crop by hand.

3. Bicycles are the dominant form of transportation. The rice field sequence concludes with a shot of a worker on a bicycle.

4. The tourists get a chance to visit the ancient Chinese Temple of Hoi An. The photographer establishes the scene with a wide shot of the family arriving through the front archway.

5. A medium shot from below shows the brightly colored decorations on the temple.

6. This close-up reveals a detail of the elaborate temple roof.

7. The quick-thinking photographer grabs a shot of a Vietnamese woman carrying fruit and vegetables to the market. It proves to be a great cutaway and transition to the next event.

8. The girls visit a silk factory in Hoi An. The wide shot establishes the location and shows a seamstress working on a silk garment.

9. A medium shot reveals workers using needles threaded with silk to create detailed embroidery pieces.

10. A close-up shows the worker's technique for sewing the thin silk strands into the delicate patterns.

11. The family travels from place to place on unique bicycle contraptions called cyclos. It is a cheap fare and lots of fun.

12. The photographer uses the cyclo trip to transition to the next location.

13. The family travels to Da Nang where they find a unique rest and relaxation location. The wide shot shows hammocks hanging from the trunks of trees.

14. In the medium shot the photographer shows one of the girls enjoying a quiet moment under the canopy of tree branches.

15. The foliage filters the harsh Vietnamese sun, making the hammocks a relaxing place, and a great place to grab a close-up.

16. On the beach, shade is provided by thatched-roof beach umbrellas. The photographer takes care to get the family into the pictures. People, not locations, will make this video story memorable.

17. This soft strip of sand near Da Nang, Vietnam is known to Americans as "China Beach."

18. The beach was made infamous during the Vietnam War, but this family is interested in enjoying the cool sand underfoot. The photographer takes advantage of beautiful late afternoon sunlight.

19. It is the last day of their trip and as the last rays of sun disappear, the photographer grabs a wide shot of Mom and the girls.

20. Then the photographer moves in for the close-up. Everyone is tired but happy and full of memories.

21. The photographer could choose from a couple of good closing shots: The girls celebrating the end of their trip on the beach or mom and the girls together on the beach.

22. But the light in this scene was too beautiful to turn down. A shot of the girls washing the beach sand from their feet in the unique Vietnamese way is a poetic end to the story.

STORYTELLING REVIEW

When constructing a basic story, it helps to remember these four words: Hey! You. See. And So. "Hey" is the opening of the story, the part that grabs the viewer's attention. "You" personalizes the story. "See" is where you give your details. "So" reveals the consequences. Every story is different, but it should follow these basic guidelines. The stories previously shown, a wedding, a soccer game, a birthday party, and a vacation are real-world examples of putting the nine-step shooting procedure into action. All of the events demanded preparation before picking up the camera, as well as a great deal of thought about how to structure the story. Elements such as screen direction, lighting conditions, and time of day all played important roles in these stories.

❶ Survey

The photographer who shot the wedding needed to know the lighting conditions he would face both in the preparations for the wedding and during the ceremony. He figured out where he could place himself and his camera, which would establish a screen direction for his story.

In the soccer game, the photographer needed to find out where his daughter's team would be on the sidelines. He also noted where the sun would be during the time of the game. And he checked the local weather forecast so he would be ready if it rained.

❷ Commit

The wedding photographer committed to a story plan that was both ambitious and intimate. It served as a road map for him as the day unfolded.

At the soccer game, the photographer committed to a plan of building the emotion of the game through close-ups of the players and fans.

On the vacation, the photographer created a story full of human emotion—not just a travel log.

❸ Scene List

The photographers developed scene lists in their heads—not on paper. But it's a good idea for you to write down a list of shots you need to tell your story. It serves two purposes: It is a checklist to make sure you don't forget important shots such as cutaways and it forces you to think about your story plan from beginning to end. In addition to getting the shots, the wedding photographer caught the emotions in the faces of the bride and groom.

The soccer photographer concentrated on close-ups of sweaty, frustrated players and water-drinking dogs on the sidelines to build the emotion of the story.

❹ Open

The wedding photographer opened his story in a logical place—the early preparations—with the bride having her hair done and the groom wrestling with his tuxedo.

The soccer photographer began with a team photo, a shot that set the scene, established the place and time of day, and invited the viewer into the story.

The photographer built action and excitement at the birthday party by using an energetic basketball game as his first scene.

Even vacation stories need a starting point; this trip started with an exciting plane ride for the whole family.

⑤ Sequences

Good photographers remember that a video is not made of single shots, but of sequences of shots. Each shot in the sequence advances the story. On the previous pages you saw a couple of shots in a sequence, but most of the time, single photographs represented sequences. You might not have seen every cutaway, wide shot, or close-up in these stories. When reviewing a single photograph in this chapter, try to imagine a three-shot sequence.

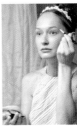

⑥ Pace

A wedding is a slow moving, but fluid event that requires long scenes to allow the viewer time to absorb the information. The only exception is during the preparations for the wedding. The photographer intercut scenes of the groom's dilemma in getting his bow tie on straight with scenes of the bride getting dressed. Once in the chapel, the pace slowed significantly.

 Soccer, on the other hand, is a fast-moving game and the action set the pace for the video. The photographer kept his commitment to building the emotion of the game by shooting close-ups of both the players and the fans.

⑦ Sound

In a wedding, the vows are the most important sounds. Have at least one microphone close to the trio. Most professional wedding photographers use small, wireless microphones. You can also use long microphone cables. Test the microphone before each event. Record as much music as possible so you can lay the music underneath the ceremony.

 At the soccer game, the photographer placed a wireless microphone on the coach so he could record the coach's instructions to the team. Crowd reactions were picked up on a shotgun microphone mounted on the camera. The birthday party was full of exciting sounds recorded with a shotgun microphone. The squealing girls enhanced the spirit of the story.

⑧ Adapt

The wedding took an emotional turn when the vows were exchanged. The photographer quickly adapted to include a shot of the tearful mother.

 The soccer game contained its own brand of drama. When an injured player was carried off the field, the photographer moved into position to follow the story. The birthday party was planned as a relatively sedate and controlled backyard party. But things took a wild turn when a water-balloon fight erupted and the photographer adapted on the fly to cover the fast-moving events.

⑨ Close

A strong closing shot is essential to telling a good story. The wedding photographer chose a triumphant moment when bride and groom emerged from the church, with arms raised in jubilation. He froze the image to reinforce it in the viewer's mind.

 The soccer game ended with the players leaving the field in good spirits. The photographer opted for a different kind of closing shot in his vacation story. The girls on the beach with arms uplifted would have worked, but the girls washing the sand from their feet had symbolic impact—that the day was over and they couldn't take the beach sand with them.

CHAPTER 8: SHOOTING A PERSONAL PROFILE

Have you ever thought about making a video about the life of someone close to you? Many video enthusiasts are preserving memories of their special loved ones by creating video profiles. These films can be treasures for children and grandchildren to view many years from now when their grandparents or great aunts and uncles have passed on. Here's how to log your tapes to keep track of your shots, find the thread to carry your story, create an outline, and finally, write a script that will prepare your footage for editing.

SHOOT YOUR SUBJECT

You've spent a lot of time learning how to use your camera to its best advantage and and how to create sequences. Now it's time to test your storytelling ability. The real world is the perfect venue. Once you've decided on a subject to profile, you need to determine the best time to shoot. The time to shoot refers to a number of things: It can refer to when your subject is available; when the weather is best if you are shooting outdoors; and most importantly, what actions are available to shoot. Keep in mind that the more active your subject, the more interesting the images. For instance, a person sitting alone in a chair talking to the camera will not be as interesting as a person riding a bike, walking in the woods, or visiting with family. The visual material may determine the best way to tell your story; in other words, it may become the thread that ties the story together. Or the thread may lie within the interview. It is your task to find the thread and use it to construct your story. Here are the steps you should take to use your best storytelling material:

1. Find the Thread that Tells Your Story

Maybe you had a story idea when you started shooting, or maybe it occured to you later, but a good personal profile has a strong theme running throughout the piece. It's not enough to simply interview your subject; his or her words and actions need to have context. Just as a novel needs a good plot, your personal profile needs to tell a strong story. A good example is the story of the old newspaper editor working on his antique press. This piece started out as a simple profile of the man and his work. While shooting, the little boy emerged as a key character in the editor's life, and the piece expanded into a poignant profile of a man who finally found a family. Reunions are good opportunities to talk about the past, and watching an artist at work is a good time to talk about the artist's passions. Part of the art of storytelling is finding the thread that connects all the various and sometimes seemingly unrelated facts and events. It's these things that will eventually comprise your story.

2. Create an Outline

Once you've found the thread of your story, it's time to write an outline. Your outline doesn't have to be long or complicated, but it does have to touch on the major points that are crucial to your story. Your outline can can be arranged like the table of contents of a book, and it will help you begin to organize your available footage into a profile. Major points become headings with a designation of capital A, B, or C. Supporting points will be headings with the numerals 1, 2, and 3.

3. The Interview

The story is best told in your subject's own voice, which is why the interview is such an important piece of the profile. Choose a quiet place where nothing will interfere with the subject's concentration and other sounds will not compete with his or her words. Shoot the interview in a shot tight enough to see the subject's facial expressions—sometimes thoughts can be read in the eyes. Always ask questions that cannot be answered with a yes or a no. For instance, instead of asking "Dad, was the war a terrible time?" ask, "Dad, would you tell me about your experience in the army?" Remember that personal emotions are integral to telling an interesting story. Find a way to open the door to your subject's inner thoughts. You want to know what happened, but more than that, you want to know how he or she felt about it.

4. Sequences and Sound

After you've completed your interview, you will shoot and gather everything else you need to tell the story. This includes sequences, as many as you can get, of your profile subject doing as many active things as possible. At home, the kitchen is a good place because lots of things, besides cooking, happen there. It's frequently the place where people gather for conversation. Listen carefully for any naturally occurring sounds on your tapes that can be used to further your story. Listen for bits of conversation, birds chirping, horns honking, dogs barking, or maybe a clever quip from your subject as he or she walks past the camera. These naturally occurring sounds can also be used independent of their video images to move your story from place to place. For instance, a train in the distance can signal a transition to a person leaving on a trip.

5. After the Shoot

After you shoot your footage, it's time to log your tapes. It is difficult to remember every scene and its location on the tapes if you don't write it down. The larger cameras have time codes that record onto the tape as you shoot. View your footage, either in the camera or on a larger screen, and note each scene and its time code. When you're finished logging all your tapes, you will have a list—tape by tape—of every scene you shot. It's easy to get confused at this point. Remember to make your descriptions unique so they will jog your memory when you review your tape log. Also, since you'll have multiple tapes, keep your descriptions short so you can visualize the scene with just a glance at the log.

6. Log Your Interview

The best way to find the choice bits of the interview is to write up the complete transcript of the subject's words. Use the time codes to note the location of these sound bites, so you can find the segments later. If you don't have the time to do a complete transcription, at least log the interview with the first few words of the best parts to serve as reminders.

7. Tape-Log Shorthand

It's not necessary to write out a full scene description. Develop a shorthand that works for you. Here are some suggestions: Abbreviate the shots with *WS for wide shot, MS for medium shot, CU for close-up shot,* and *CA for cutaway.* You might want to use the number two for a two-shot, or a scene with two people; and the number three for a three-shot, and so on. *Point-of-view shots can be* abbreviated as *POV. SOT stands for sound on tape,* which can be the interview or any other piece of naturally occurring sound that is on your tape. Use *OF* for *out of focus, ECU* for *extreme close-up,* and *NATS* for any *naturally occurring sound* other than the interview. Also, it's a good idea to note screen direction with small arrows (< or >) pointing the same way as the subject.

Tape-Log
Shorthand Key:

WS	Wide Shot	**SOT**	Sound-on-tape (Interview or other full sound)
MS	Medium Shot	**Narr**	Narration
CU	Close-up	**NATS**	Natural Sound
C/A	Cutaway	**Under**	Sound or music softer than the Narration
VO	Voiceover		

Time Codes

Many camcorders record and display time codes, a numbering system that assigns a unique number to each video frame recorded. The time is displayed in hours, minutes, seconds, and frames. A passage, called a sound bite, might start at 01:14:25:27. The bite started 1 hour, 14 minutes, and 25 seconds into the tape and it was the 27th frame. Time code is based on the clock, so the maximum number it can display is 23:59:59:29. Notice that the last number, which represents the individual video frame, only goes to 29 frames. That is because each second of video contains 30 unique frames. On the 30th frame the counter advances one second and the frame counter resets to :01.

Many camcorders do not offer time codes, but they will count, usually in minutes and seconds, as the tape progresses. The time counter is not as accurate as the time code, but it will be very helpful in locating scenes. It is important to rewind the tape to the beginning and reset the counter before attempting to find a scene on the tape. The counter only knows distance from the beginning of the tape.

8. Write a Script

When creating a personal profile, it is best to write your script after you have shot—using your outline as your guide. The script is a scene-by-scene summary of your shots that will help you decide how to edit. Scripts generally have two columns: video and audio. Write a brief description of the scene and type of shot in the video column. Be sure to add the time code from your tape log. In the audio column, transcribe the words or sounds. Keep in mind that you want your story to flow smoothly from location to location or subject to subject. Continuity is important. Jumping from place to place without a clear transition, or introducing too many characters at once will confuse your viewers. You need a clear concept of how to tell the story. Will your story have a linear timeline—taking the viewer through an entire day or event with the subject? Or will it be a series of flashbacks as your subject remembers his life's experiences? This is a good time to think about how one location or subject will transition to the next scene. Sometimes words or sounds can help with transitions.

The success of your piece will have a lot to do with how much you prepare. Production without pre-production equals poor production. Here the author checks the composition of his shot.

A PERSONAL PROFILE OF MY MOTHER

The subject: Lillie Seal Brandon

I decided to use my mother in a real-life example of a video profile. I am embarrassed to admit that I have been in the video business for almost 40 years and have never shot a video profile of anyone in my own family. The opportunity came when Mom prepared to travel home for her family reunion. I flew down to Texas to accompany her and tell her story using the event as my vehicle.

I arrived late Friday afternoon. I had planned to spend early Friday afternoon shooting Mom going about her daily routine, but the airlines had canceled my morning flight and I arrived late. So I was forced to go directly into the interview because the light was waning and I wanted to film in her beautiful backyard. My sister, Beverly, met me at Mom's house and we began the interview. Mom was full of stories. She had been saving them up since I told her of my plans. The stories came flooding out, sometimes all at once, and sometimes segueing from one story into another without warning. We had to stop frequently to remind her of a story she didn't finish and bring her back into focus. It was a two-hour interview that took us past sunset. The only thing I could shoot that evening was Mom having dinner with Beverly and Beverly's daughter and son-in-law.

Bright and early Saturday morning we left for Childress, a small town in northwest Texas near where Mom grew up. Childress is the traditional site for the Seal family reunion. Many of Mom's relatives still live in or near Childress.

I attempted a couple of brief interviews with her on the four-hour drive. We talked about the countryside, what life was like in northwest Texas in the 1920s and '30s, and about the importance of rain in her life. It showered on us as we drove, so when the windshield wipers came on we discussed rain

and how dryland farmers—farmers with no irrigation systems—depended on the rain. I limited the interviews in the car to a couple of questions and answers on each subject. I knew they were important subjects and the noise of the car prevented a comfortable conversation. I would return to the topics later when conditions were better.

When we arrived at the reunion, Mom was out of the car and into the meeting hall before I could get my camera gear assembled. I was forced to grab shots as I could. Mom worked the room, hugging each person and seeking an update on his or her life. I finally got my act together and shot conversations among family members and interviews with Mom's brothers and sisters.

The traditional barbecue "dinner" was served not long after noon. In Texas there are three meals each day: breakfast, dinner, and supper. Lunch is something eaten by folks up North.

Early Sunday morning, shortly after sunrise, Mom and her sisters traveled the 15 miles out into the country to visit the old homesite and their parents' graves.

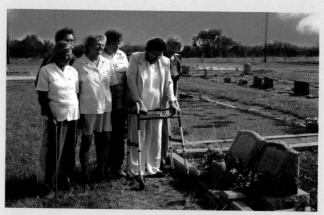
Lillie and her five sisters visit their parents' grave site.

It was an opportunity to spark a conversation about life in the country, so I got them started and never had to ask a second question. They talked without pause for the entire trip. I shot a lot of the conversation, and grabbed point-of-view shots through the windshield as we drove. The POV shots would be useful as cutaways when cutting this sequence.

The old homesite is nothing more than an old dilapidated windmill that once provided water for Grandpa's livestock, and an old peach tree he planted about 50 years ago. The railroad boxcar that the sisters called home is gone. I shot pictures of

an old boxcar I spotted alongside the road on the drive home, and would use it to represent their boxcar. Those who could walk the short distance from the road to the homesite rummaged through the shards of a lifetime left scattered on the ground. Mom couldn't walk that far, so we placed a chair by the road and she reflected on her childhood. It was quiet. Only a mockingbird's litany of calls and the buzz of an occasional cicada broke the stillness. I turned on the camcorder and just let her think out loud.

The sisters piled back in for the short drive to the cemetery and a visit to the headstones of W. P. and Eula Seal. Grandpa Seal was a sharecropper who managed to save enough money for a down payment on a farm in early 1935. He made payments on the loan once a year, when the crops came in, and he paid as much as he could. In the bad years when crops were poor, Grandpa would have to forego the whole payment. He would try to make up the difference in the good years. But in the '30s the bad years far outnumbered the good ones. Mom remembers the time almost 40 years later when "Papa" finally paid off the place.

But Mom also remembered better times: when "Mama" fixed her trademark biscuits every morning along with sausage or ham from a hog Papa had slaughtered; when the girls slept three to a bed in an old shack attached to the boxcar. The two boys slept in the boxcar with Grandma and Grandpa. The bedroom was one half of the boxcar. The other half was the kitchen where Grandma cooked on a woodstove. Electricity was a luxury not yet affordable to the Seal family. Neither was running water, so

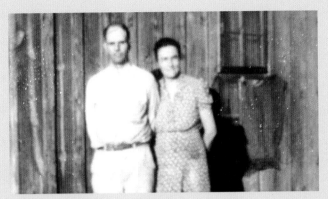
Grandma and Grandpa in front of the boxcar.

drinking and bathing water came from a cistern that collected precious rainwater runoff from the roof of the boxcar. In especially dry times, Grandpa would hitch the horses to the wagon and travel a day's ride round trip to haul water in a tank attached to the wagon. The restroom was an outhouse; they called it a privy. Mom and her sisters laughed at the myth of the rattlesnake that lived under the outhouse seat, waiting to bite the unsuspecting visitor.

There were a few more things to shoot, but the video was essentially "in the can" when we returned to town.

I flew home the next day with all of my tapes, some still photographs, and a disk of borrowed photographs that my relatives compiled on a computer during the weekend. It was time to take account of my resources for this piece and put them in some kind of order.

Putting It All Together

I had the following items for the video profile. My job was to find a way to put them together to make the best use of the materials and, consequently, to tell the best story:

• A lengthy interview with Mom conducted by Beverly and me.

• Pictures of Mom having dinner with Beverly and her daughter and son-in-law.

• Video of Mom at church.

• Video of the family reunion with Mom greeting her family, having conversations, and enjoying a barbecue dinner.

• A visit to the old homesite by Mom and her sisters, followed by a visit to the grave site of their parents.

• Interviews with Mom's siblings offering stories, some of them funny, about things that happened when they were kids.

• Old photos of Mom as a child, her parents, siblings, my father, and other important people in her life.

• Old film of mom's sister, Minnie Lee.

LOG YOUR TAPES

Logging your tapes is necessary to keep you organized, but the process can also help you to find the all-important thread that will tie your story together. Spend a few evenings after work playing your tapes and taking notes on the interviews. Don't feel as if you have to transcribe the interviews verbatim. A key sentence to jog your memory will do. Jot down the time code of your favorite passages, and note the type of shot by using the tape log shorthand:

Mom Profile Tape Log

This is the tape log for the Mom profile.

Tape #7

TIME CODE	SCENE DESCRIPTION
1:06	WS, MS, sisters looking at headstones
1:20	CU, sisters looking at headstone
2:21	CU, Mom at grave
2:45	WS, over shoulder of sisters
3:30	CU, headstones, Eula and W. P.
5:10	WS, sisters in truck leaving cemetery
5:20	SOT, Mom, "House site all grown over..."
5:30	"Shouldn't be a sad trip, should be a happy trip..."

This helped me to plan my sequences. I also tried to include in the description who was in the shot, so I can easily search for shots of a particular person. If I had the luxury of time, I would transcribe all of the interviews. It is easier to cut and paste pieces of different interviews together on paper than it is while viewing them on the screen. But this piece couldn't wait because I had many other things demanding my attention. So I paraphrased the sections of the interviews that I thought I would use in the story.

Mom presented me with a particular challenge because she would begin a story, then digress. I would bring her back on subject, hoping to splice the two parts together so they would make sense.

As I listened to the interviews, a story thread began to emerge. At first it was only subliminal. I try to let the story tell me how it should be told. I avoid preconceived plans because the material might not support them. It will not be immediately evident if I have made a mistake in my story plan. It might not show up until I am well into the edit. At that point it is harder to abandon the plan and start over. No one wants to throw away hours of work.

CREATE AN OUTLINE

Your high school English teacher probably emphasized the importance of creating an outline for your reports before you began writing. The same rules apply for shooting a story. The outline is your road map. It lists the major pathways you will travel as you create your story. It may not, and probably won't, include the many interesting things you might see beside the path. Use the outline to guide your way, but don't etch it into stone as if it were a tablet from the mountain. It is a dynamic instrument.

Begin your outline with a rough guess about the flow of the story. It doesn't have to be exact at this stage. It almost surely will change, but you have to begin somewhere.

Determine what would be the best way to introduce the reader to your story. I started with an idea that I hoped would grab the viewer's attention. I wanted to compare Mom when she was young to Mom as she is now. There are plenty of differences, but the subtle little similarities struck me, and I hoped the viewer would pick up on them as well.

Mom Profile Outline

Typically when I'm working, it's only after I have logged all of the tapes and listed all of the still photographs that I will allow myself to begin assembling story parts according to the thread I have found. I will attempt a rough outline.

A. OPEN

1. Compare a young Mom with the current Mom.
2. Introduce her family with stills and film.
 a. Provide a sense of place and time for both the current footage and old photos.
 b. Create an understanding of her early life as a child of a poor farmer.

B. WHO IS SHE?

1. Document Mom's values and beliefs.
2. Photograph her at church with friends.
 a. Use the sound of her describing her religious beliefs and how her life is centered on the church.

C. ON THE ROAD

1. The trip to the family reunion becomes a trip back in time as Mom visits family and remembers her childhood.
 a. Use the drive as the thread to bring the viewer along as Mom describes what life was like as a kid settling in an old railroad boxcar that became home.
 b. The drive through a rain shower can be used as a transition to Mom's love of rain.
2. Explain why rain is so special to people who live in rural Texas.

D. AT THE REUNION

1. Mom visits with her family and each brother and sister is introduced to the viewer.
2. Her brother and sisters tell humorous stories about their childhood.
 a. Use old photos where appropriate.
 b. Finish with Dan's emotional sound bite.

E. SUNDAY MORNING

1. Mom and her sisters drive to the old homesite and talk along the way about old times.
2. Tell dust bowl stories, use old stills, use film to illustrate.
3. Visit ruins of old homesite; then visit cemetery where her parents are buried.
 a. Mom talks about her parents and we glimpse her ethical values at the same time.
4. Introduce Dad as Mom talks about her married life and describes Dad.

F. CLOSE

1. Mom summarizes her life as we see pictures of her kids and grandchildren.
2. Fade-to-black.

WRITE A SCRIPT

Once you have a completed outline, you can begin smoothing the story into a more traditional form, called the script. Scriptwriting has its own set of rules. These rules exist for the same reason certain rules apply to construction blueprints. The script uses a universal language. Anyone can understand it and actually sit down and edit the story from the instructions it contains. The script is divided into two columns. The left column is devoted to video instructions and information. A description of the desired scene will be included here, preferably with a time-code reference to the scene's location.

The right column contains the story's audio information. It tells the editor to look for either narration or sound from the interview, or a piece of natural sound. Music can be introduced at any time, and it is noted in the audio column. Every piece of sound has a time-code number so the editor can easily locate it. All instructions are written clearly and precisely so confusion is eliminated.

A good editor will be able to take the photographer's vision of the story and improve on it with new and better transitions and effects where necessary. A good editor can point to the parts of the script that are vague, superfluous, or just don't fit.

Script of Mom Profile

I chose to tell the story through my sister Beverly's eyes. I wrote the piece in her voice, and had her narrate the piece for me. Notice that the page is divided into two sections for audio and video. Audio is traditionally given the right side of the page and video the left side. Sometimes the directions are very specific. The audio directions might include a verbatim transcript of the interview. On other scripts, the audio directions might simply say, "She talks about growing up on the farm." The video section might only say, "Sequence of her driving to the family reunion." It helps to be as specific as possible about which audio and video scenes are wanted. When projects grow in length, as this one obviously has, it is easy to forget what you had in mind when you become immersed in the technical concerns of digitizing and organizing an edit project.

The script for the profile of my mother looks like this:

Script: Lillie Seal Brandon, Personal Profile

VIDEO	AUDIO
Fade up on a close-up of Mom in a photo of when she was a young woman. Slowly dissolve to close-up of her on interview set looking into the distance.	**Narration:** *Her name is Lillie Anise Seal Brandon. She is a Seal by birth, a Brandon by choice. She is 85 years old, her mind is sharp, and she has many stories to tell.*
Mom on camera, cut to stills of each sibling as she names them, and other photos that fit.	**Tape #1 24:50** "They called me Dick. I don't know why. Uncle Mutt was named Opal Ernest. Minnie was Snooks or Minnie Nook." **Edit to: Tape #2 36:10** "There's Mutt and Fern. . ." She names all her brothers and sisters in order.

VIDEO	AUDIO
Continue with stills of a young Mom and family.	**Narration:** *Two words are all that are necessary to describe my mom: family and church. Everything in her life revolves around her family and her faith in God.*
Mom leaving for church. Tape #8.	3:05 "We have the best country in the world to live in. Our forefathers who came for freedom of religion, so they could worship God like they want to, and I think it's just a great, great privilege."
Mom arrives at church. (Still frame of the exterior of church, followed by Mom entering church, and into Sunday-school classroom.)	Sound under from Tape #8 32:00 (choir singing) SOT Tape #8 :45 "It's such a pleasure to go to church because you see your second family…your church family. You have your own family and then your church family. It's a part of your life, too." 1:30 "…and it's got some lovely people in it and I'm thankful that I've got 'em." 2:38 "…If I don't get to go to church, I miss it all week." 5:05 "…The Lord, He protects me. Sometimes at night I ask the Lord to have my angel watch over me so I can rest, so I give 'em something to do, my angels something to do."

The script has more bits of shorthand. SOT, for instance, means sound on tape. It refers to a piece of sound, either from an interview, or a piece of natural sound that the viewer should hear up full. Under, tells the editor to turn down the volume of the sound so that something else can be heard more clearly. A common instruction might be: SOT UP FULL, music, CD #14, track 11, 2:08:30 for 30 sec., then under Narr.

An editor should be able to read a script and live it as if he or she were watching the video.

VIDEO	AUDIO
Transition with windshield wiper. Tape #3 36:37.	**SOT: wiper sound**
Transition to over shoulder driving in rain sequence. Tape #3 34:00–40:00.	**Narration:** *There are some things that aren't important in Mom's life. She doesn't go to the movies and she doesn't have a clue about the latest Hollywood stars. But one thing that is included in almost every conversation we have is how much, or little, rain has fallen. Rain is important, because in west Texas, rain is life.*
Rolling farm shots. Tape #5 11:40–16:25.	**Narration:** *These are dryland farms. There are no irrigation wells. The only water the crops get comes from the sky. The difference between wealth and welfare is a few inches of rain.*

VIDEO	AUDIO
Various rain shots from driving sequence on Tape #3 continued and storm clouds and rain on wood. Tape #7 32:00–42:00.	**Sound under Tape #1:** "I love the rain. I don't know, I lived in the desert so long…to have rain is like having something from heaven coming down."
Mom on camera—CU.	**SOT Tape #3 38:30** "When it began to rain, we had to get the little chickens and turkeys…so we would pick'em up and we'd wrap 'em in blankets and bring 'em in the house.
Pictures of Texas plains in the rain. Tape #7 32:00–42:00.	**Sound under Tape #5 5:17** "We had gutters around the boxcar and dug a well."
Mom on camera—CU. Tape #5 28:20.	"You know, it is so dry out here. We mostly got rain in the spring, like now, and maybe some in the fall and that's about all the rain we got. We had a cistern for well water; for drinking water, we had a cistern that we dug, and it run off the top of the house into that cistern."
Rain pictures continued.	**Sound under Tape #5 5:20** "We had rain water, made the best tea…"
Mom silent, looking into distance. Tape #3 approximately 12:00…then rain on pan. Tape #3 29:30.	**Narration:** *Rain was comforting. Rain meant they could buy new shoes. Rain gave the Seal family peace. It meant they could sleep well at night. When Mom moved from the farm and the boxcar with the tin roof, she put a bucket outside her bedroom window to catch the rain from the roof. The sound of rain on metal meant good, peaceful, restful sleep…*

VIDEO	AUDIO
Mom sound under—WS. Tape #1 4:39.	"After it rained on the soil, it's an odor that's just the best-smelling perfume you ever smelled…I guess everybody that had to do without it a lot in their life do; they do love it, I guess."
Driving shots of Beverly. Tape #3 34:00–40:00.	Narration: *We are driving to Childress in northwest Texas to meet Mom's family at the annual reunion. She hopes to see five of her six surviving sisters and one brother. Her older brother, Mutt, died earlier this year.*
Mom on camera. Tape #4 5:20 followed by shots of arrival at meeting hall.	"I expect to see Nell and Sonja…Sue's not coming. 'Course there will be Hallie and Dan. I started to say Mutt, but I don't guess he'll be here this year. That is a habit, isn't it? Like Mama used to call all our names before she called the right one…she'd say Mutt, Fern, Dan, Lillie, Sue, Nell 'till she hit the right one."
Transition to inside meeting room. Tape #4 9:50. Mom hugs Sonja. CU on Minnie Lee. Carolyn hugs Mom. Nell at table with Otis. Cut to Nell and Otis in photo when they were young. WS of room.	Narration: *That is sister Sonja…* *And sister Minnie Lee, and niece Carolyn and her mother, Sister Nell, and Nell's husband, Otis, who looks a little different than this early photo.* *Mom meets her family in Childress at the annual reunion. Everyone is older and grayer but full of stories to tell.*

PERSONAL PROFILE: LILLIE SEAL BRANDON

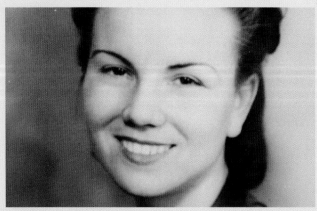

1. Fade up—Close-Up (CU)—Still of Mom in an old photo. Narration: *Her name is Lillie Anise Seal Brandon. She is a Seal by birth, a Brandon by choice. She is 85 years old, her mind is sharp, and she has many stories to tell.*

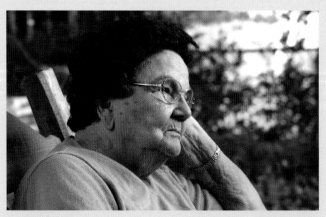

2. Slowly dissolve to CU—day—exterior (ext.) Mom today. Narration: *All of us can learn lessons about life from her stories. All of us can benefit from her wisdom. All of us are enriched by her goodness.*

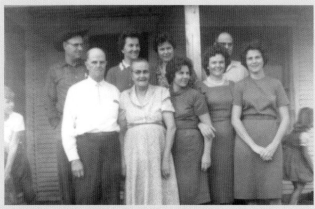

3. Medium Shot (MS)—Still of young Mom and family. Narration: *Two words are all that are necessary to describe my mom: family and church. Everything in her life revolves around her family and her faith in God.*

4. Wide Shot (WS)—Church. Narration: *We have the best country in the world to live in. Our forefathers came for freedom of religion, so they could worship God like they want to, and I think it's just a great privilege.*

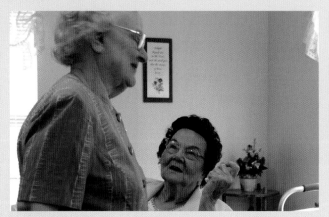

5. MS—Interior (int.) Church—Sound on Tape (SOT) *"It's such a pleasure to go to church because you see your church family. You have your own family and then your church family. It's a part of your life, too."*

6. WS—Church. Congregation sings. Narration: *The church is Mom's second family.*

WS *Wide Shot* — **MS** *Medium Shot* — **CU** *Close-up* — **C/A** *Cutaway* — **SOT** *Sound-on-tape* — **Narr** *Narration* — **NATS** *Natural Sound* — **Under** *Sound softer than Narration* — **VO** *Voiceover*

7. WS—Texas grain elevators. Narration: *We are off to the annual Seal family reunion where most of Mom's brothers and sisters will gather. My name is Beverly. I am her daughter. On this journey, I will learn more about her and her life on the red Texas soil.*

8. Still—Papa and Mama. *"Papa bought 100 acres. It had a little shacky house on it, and then they moved in a boxcar. They bought that boxcar for $50."*

9. Still—Boxcar. *"Us girls slept in the first part of the little old house. Papa and Mama and the boys slept in one end of the boxcar and the other end was our kitchen."*

10. WS—Countryside on the way to the reunion. *"We had a woodstove that was the cookstove and we had a woodstove in the part of the house where us girls slept."*

11. Still—Grandma in the kitchen. *"She loved that woodstove, and everything seemed like to me tasted better on it. You had the oven to make them biscuits and Mama could make them biscuits . . ."*

12. CU—Still—Mom as a younger woman. *"Those biscuits would rise and just brown like everything. She'd cook breakfast and us kids was in the other part of the house and she'd bang on the wall. We knew it was time to get up."*

INCORPORATING STILL PHOTOS

Adding still photographs to your family profile not only adds interest and depth, but it is a good way to archive your old family snapshots and portraits. The photographs of Grandma in the boxcar kitchen were in an old shoebox (as were all the still photos in the Mom profile). Before you begin the process of copying your photos onto video, you will want to organize them by placing them roughly in the order in which they will appear in your story.

How to Add Still Photos to Your Profile

Copying still photographs requires a combination of science and art. With the right equipment and some practice, however, you will be doing it like a pro.

1. Place the camera and the print stand in an area that is free of shadows that might obstruct the photograph. An evenly lit corner of a room is often a good bet. If you don't have sufficient natural light, such as that coming through a north window, you may need to place a light fixture near the photographs. In this example, the light from a swag lamp placed directly over the photograph table provides soft, even illumination.

2. Find a way to mount the video camera as vertically as possible, so that the lens is pointed straight down. This is harder than you might think, because traditional tripods will not allow the camera to decline to a vertical position.

There are a couple of ways to solve this problem. The first is to clamp the tripod onto something, such as a stepladder, so that the tripod is tilted, but safe from falling to the floor. A slightly more elegant solution is to mount an articulated arm—available at any camera supply store—onto a plate that is clamped to the ladder. The arm bends at the elbow and at the wrist, and with a little experimentation, you can angle for just the right position. A pan-and-tilt head is also helpful.

Any necessary moves can be accomplished more smoothly by slowly moving the table on which the photograph is mounted, especially if the table is on wheels. The camera zooming slowly into a photograph can add a nice touch, but any contact with the camera is likely to cause noticeable vibrations. A handy solution is a remote zoom control that is placed away from the camera.

3. Allow your makeshift studio to remain as is while you are shooting your profile. Other photos may be needed. Perhaps a relative remembers a special shot that should be included in the story. It is a lot easier to return to the photo table and shoot another still photograph when the studio is already assembled. When you begin editing your story, you may discover that you need a slightly different angle on a particular photo. It is easier to return to your studio than it is to hunt down the ladder and the clamps to set everything up again.

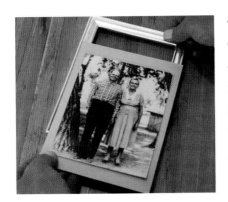

4. If you think you may need to shoot areas of the table in addition to the photograph, choose the background you want and place it on the table. It might be a plain piece of colored poster board or an attractive piece of fabric. Avoid backgrounds that are too bright or colorful. The background should not distract from the photograph. A muted, darker shade usually works best—perhaps a medium gray or blue, or even a black velvet fabric. In this example, the photographer will not shoot beyond the edges of the photograph, so the photograph table does not need any attention.

5. If the photograph is in a frame, remove it. The glass of the frame will create unwanted reflections. The photograph itself will reflect light, especially if it is a glossy print, so watch for reflections in the viewfinder of the camera. You may not see the reflection when you are standing beside the camera, so be sure to check the view through the lens. The edges of most photographs will tend to curl away from the table. Tape the corners down to ensure that the photograph will remain flat on the surface.

6. Develop a shooting pattern that will offer you maximum choices in the edit room. Shoot each photograph in a sequence. Begin with a wide shot, then a medium shot, and then a close-up. Get these basics first; then experiment with slow zooms, or perhaps a pan across the image. Rather than panning the camera, try pulling the photograph table slowly and smoothly past the lens. Make sure you start and stop smoothly as well, because you may need to use the beginning or end of the movement in your story. Give yourself plenty of options because scripts change and things always look different in the edit. You will thank yourself for having these shot choices later.

PERSONAL PROFILE: LILLIE SEAL BRANDON
(continued)

13. Still—Girls and horse. *"We had no lights, no electric lights. We had lamps and sometimes we'd run low on oil, you know, for the lamps, and no telephone."*

14. Still—Mom's father. *"Our sewer system was a little two-hole outhouse. We didn't have no running water. We had to draw the water out of the well, you know, out of the cistern, and if we run low on that we hauled from a tank in barrels . . ."*

15. Still—Mom's parents with baby. *"Life wasn't easy, but one thing about it, we always had Mama and Papa. We didn't have much else but we had each other. We could all feel safe at night."*

16. Still—Recent photo of Mom's siblings. *Narration: Mom is one of 10 children. The joke was that Grandma Seal had to name each child, eldest first, in order to get to the name of the one she wanted.*

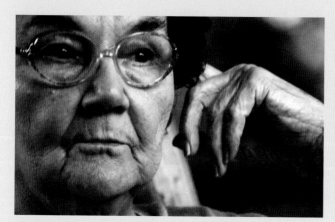

17. CU—Mom on camera. SOT: *(Mom names all the kids.)*

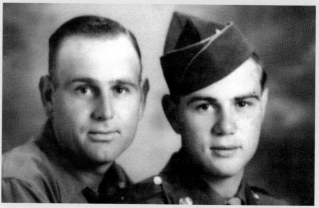

18. Transition to stills of each kid. SOT: *"There's Mutt (on left, younger brother Dan on right). His name was Opal Ernest. They named him after a girl. You know, I couldn't understand that. It's just like naming a boy 'Sue.'"*

WS *Wide Shot* — **MS** *Medium Shot* — **CU** *Close-up* — **C/A** *Cutaway* — **SOT** *Sound-on-tape* — **Narr** *Narration* — **NATS** *Natural Sound* — **Under** *Sound softer than Narration* — **VO** *Voiceover*

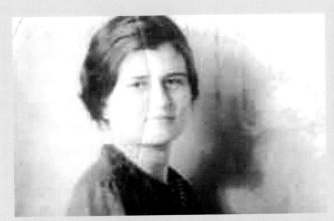

19. Still—Fern. *"Then there's Fern. She was two years younger than him. And then there comes me."*

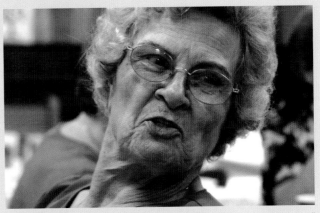

20. CU—SOT: *"And then two years after that, Minnie Lee was born."*

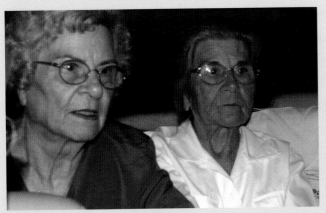

21. MS—SOT: *"Then two years after Minnie, Lila was born (on right). . ."*

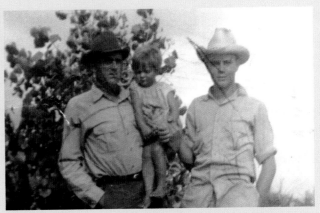

22. STILL—Mutt, Dan and Child—SOT: *"And two years after Lila, Dan was born. Then two years after that Nell was born . . ."*

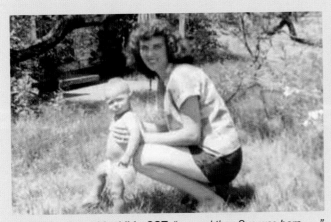

23. STILL—Sue with child—SOT: *". . . and then Sue was born . . ."*

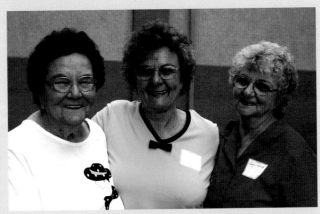

24. MS—SOT: *"It was three years between Sue and Hallie. They were kinda slowing down on the system, I guess. It was five years and they had Sonja, and that was the caboose."*

PERSONAL PROFILE: LILLIE SEAL BRANDON
(continued)

25. Transition to driving in rain sequence. Narration: *Mom doesn't go to the movies and she would not have a clue about the latest Hollywood stars. But one thing that is included in almost every conversation we have is how much, or little, rain has fallen.*

26. Rolling farm shots. Narration: *Rain is important, because in west Texas, rain is life. These are dryland farms. There are no irrigation wells. The only water the crops get comes from the sky. The difference between wealth and welfare is a few inches of rain.*

27. WS—Rain on the fields. SOT: *"I love the rain. I don't know, I lived in the desert, so long . . . to have rain is like having something from heaven coming down."*

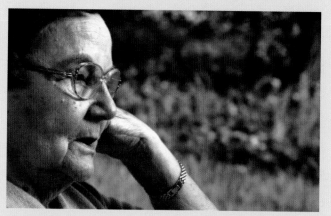

28. CU—Mom on camera—Interview: *"When it began to rain we had to get the little chickens and turkeys . . . so we would pick 'em up and we'd wrap 'em in blankets and bring 'em in the house."*

29. WS—More rain. SOT: *"We had gutters around the boxcar and dug a well. You know, it was so dry out here."*

30. WS—Interview: *"We had a cistern for well water; for drinking water, we had a cistern that we dug, and it run off the top of the house into that cistern. We had rain water, it made the best tea."*

WS *Wide Shot* — **MS** *Medium Shot* — **CU** *Close-up* — **C/A** *Cutaway* — **SOT** *Sound-on-tape* — **Narr** *Narration* — **NATS** *Natural Sound* — **Under** *Sound softer than Narration* — **VO** *Voiceover*

31. WS—Interview: *"We mostly got rain in the spring, like now and maybe some in the fall and that's about all the rain we got. After it rained on the soil, it's an odor that's just the best-smelling perfume you ever smelled."*

32. CU—Narration: *Rain was comforting. Rain meant they could buy new shoes. Rain gave the Seal family peace. It meant they could sleep well at night.*

33. WS—Old Boxcar. SOT. Narration: *When Mom moved from the farm and the boxcar with the tin roof, she put a bucket outside her bedroom window to catch the rain from the roof. The sound of rain on metal meant good, peaceful, restful sleep.*

34. Still—Early image of sister Nell and husband Otis. Narration: *Mom meets her family in Childress at the annual reunion. Everyone is older and grayer but full of stories to tell.*

35. CU—Sister Nell now. Nell SOT: *"We had an old Model T car. Lillie and my other sister got in and was going to go somewhere, and of course, I had to tag along everywhere they went. So I sneaked in behind the seats, and laid down real low so they wouldn't know I was there."*

36. CU—Sister Nell. Nell SOT: *"We had a neighbor that drove really, really fast and his name was Junior Jones, and we went up over the hill and she said, 'I'm gonna turn this corner like Junior Jones and she turned the corner real fast and off in the ditch we went.'"*

THE INTERVIEW

The interviews with sister Nell and all the interviews in the Mom profile form the foundation of a good video story. It must be approached with lots of preparation and some thought. A successful interview will produce lots of information about your subject, but it will also frame the emotional content of the profile and involve the viewer in the story of this person's life. It is a bit of a psychological exercise that must be conducted with sensitivity and empathy.

Here are a few suggestions that will improve your interviews:

- **Never make a big deal about setting up the interview.** Don't fuss about moving furniture around and stringing cables. Go about your job quickly and with a sense of confidence. Carry on a casual conversation as you set up the equipment, talking about anything but the interview. Discuss the weather, the price of corn, whatever. Avoid talking about your equipment, such as how much your camera costs. Don't ask any of your important questions because the first answer is frequently a good one, but it doesn't exist if the camera wasn't rolling. Keep the conversation going and finish setting up the equipment.

- **Choose a quiet place for the interview.** Distractions such as barking dogs and honking horns will surely kill the mood you have been working so hard to create. Light your subject softly but dramatically. Remember that the interview will appear on the video longer than any other shot, so it needs to be interesting, well lit, and appropriate to the emotion you are seeking.

- **Compose the interview in a tight shot.** The viewer will become better acquainted with your subject and share in the emotion of the stories.

- **Do your homework.** Have at least a working knowledge of your subject's life, interests, career, and the events in his or her life.

- **Always ask a question that cannot be answered with a yes or no.** Your questions should be designed to require some thought.

- **Think of the interview as a conversation.** Don't worry that your voice might be heard on the tape. It can be removed in the edit. If you engage your subject in a lively conversation, he or she will be more inclined to forget the camera. Instead of asking "Do you think we have a chance of rain?" try, "Looks like rain…" Give your subject plenty of time to answer.

My friend Bob Dotson, an NBC News correspondent, has interviewed thousands of people in his career. Bob has developed three rules for interviews that work well for him. I follow his example, and they work for me, too. Bob's rules are:

1. **The rule of threes.** Bob says people will answer a question three times. They will give you the answer they think you want to hear; then they will try to explain it, and if you give them time to stop and think, they will give you the little gem of an answer.

2. **Fill the silence.** Dotson is a believer in silence, both in his writing and in his interview technique. When the subject finishes the second stage of the answer, Dotson merely sits and waits, saying nothing. Folks are naturally inclined to fill the void, he says, and they want to be helpful. Often they will come up with a more revealing answer.

3. **The non-question question.** Find a common thread that will connect you to your subject and use it to begin the conversation. You might notice that he is painting his house. You can begin your conversation with, "I painted my house last year. It was a big job." Let the conversation flow and gradually work the subject around to your interview. Let's say the person you are interviewing was a fireman. You could start the interview with, "My father was a fireman, too. He told me

some hair-raising stories." People will give a part of themselves to you in your interview, but only if you give a part of yourself to them. Don't try faking it, because they will be able to tell right away.

- **Ask for descriptions and emotional responses.** Avoid the obvious easy questions like, "How did you feel about the news that the war had ended?" You might try something like, "I know you were really happy when you got the news." Listen to the response. It will lead you to your next question.

- **Use the five W's.** Information gathered in the interview can be put to good use when you write your script. Use the best sound bites from the interview, but then use the rest of the information as the framework of the script. Use the storytellers' list of requirements: Who? What? When? Where? Why? And the non-W requirement: How?

- **Be patient.** Many people, especially older folks, require a little time to compose their thoughts. Ask a question, or propose a story idea; then give the person plenty of time to answer. Listen to what they say. Many times a follow-up question will elicit more information. Have a prepared list of questions, or better yet, a list of bullet points to discuss. But don't be distracted from the answer by looking for your next question. Older people sometimes lose their train of thought. Their stories take unusual turns and you may need to gently nudge them back to the point of the thought. Make sure all the characters in their stories are identified. Not everyone will know "Old Jack" is really their distant uncle Jack. Ask if there are any sensitive family issues that should be avoided.

Sometimes an interview may need to take place over a period of time. You may not be able to finish it in one sitting. But keep in mind the wonderful flexibility you have with today's equipment. If you can afford a wireless microphone, by all means get one. If you can't buy one, you may be able to rent one. Put the microphone on your central character and leave it on the person for the entire shoot. Eavesdrop on his or her conversations as the day progresses and be ready to roll your camera at any moment. You may be able to catch some little snippet of sound that will make your story memorable.

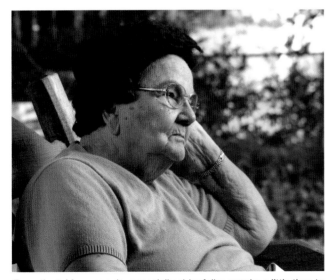

Be patient. Many people, especially older folks, require a little time to compose their thoughts.

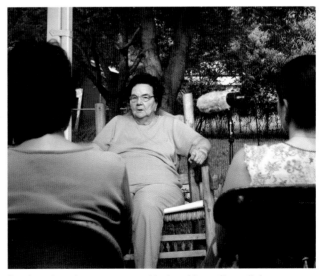

Put the microphone on your subject and leave it on all day.

PERSONAL PROFILE: LILLIE SEAL BRANDON
(continued)

37. Old film footage of Minnie Lee. Narration: *Minnie Lee is closest in age to Mom and they have a special relationship.*

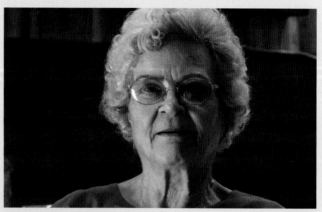

38. SOT—Minnie Lee now. SOT up full: *"She used to do our hair and when she got ready for us to turn our head she'd do this." (Minnie Lee tugs on her hair.)*

39. Edit to Minnie—SOT cont.: *"We had a lot of good times together, Lil and I. We were really close. She used to take me dancing with her when I was about 13. We even came up here to Childress to the Elks Club and danced."*

40. CU—Brother Dan. Narration: *But it was Dan who surprised us the most. Strong, handsome, silent, stoic Dan who never let anyone know his feelings.*

41. Dan SOT. *"I had four sisters older than me and four younger and I learned pretty quick just to do what they said and stay out of the way. But they always kinda petted me, them girls did. I don't know why . . ." (Dan's eyes tear up.)*

42. CU—Shows emotion. Sound under. Narration: *Dan didn't say much else. He really didn't have to, because what he didn't say spoke volumes.*

WS *Wide Shot* — **MS** *Medium Shot* — **CU** *Close-up* — **C/A** *Cutaway* — **SOT** *Sound-on-tape* — **Narr** *Narration* — **NATS** *Natural Sound* — **Under** *Sound softer than Narration* — **VO** *Voiceover*

43. Family gathers for photos. Narration: *The girls always had plenty to say.*

44. Nell SOT: *"When I was young they used to tell us if you eat chicken gizzards, you would grow big boobs, and man, I really wanted them. So every Sunday we had fried chicken and I'd eat the gizzard. I think it worked pretty good." (Camera tilts down to her chest.) (Big laugh.)*

45. Transition stills of boxcar kitchen. Narration: *Nell was lucky to get a gizzard, with 11 people crowding around that table in the old boxcar.*

46. Minnie Lee SOT: *"When it was dinnertime, there was a huge table and all the kids would gather around there, and let's see, on the back side of the table there was a bench and there was Fern and two or three of the little kids, and then there was Lillie on that end."*

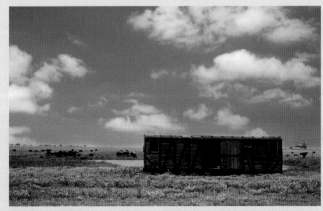

47. Old boxcar with cattle in background SOT (cont.): *"Papa on the end of the table and Mama on the other end, and Mutt and Dan on the other side. And Lila and I had to get our plate and eat over at the little table by ourselves. It could have been worse. We always had plenty of food."*

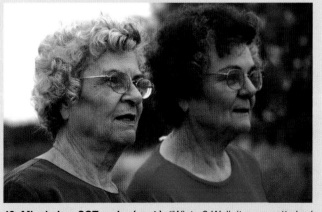

48. Minnie Lee SOT under (cont.): *"Winter? Well, it was pretty bad sometimes, in our little room where we slept. I guess it was warm enough, nobody ever got frostbite, and I don't know how we ever made it but we did."*

PERSONAL PROFILE: LILLIE SEAL BRANDON
(continued)

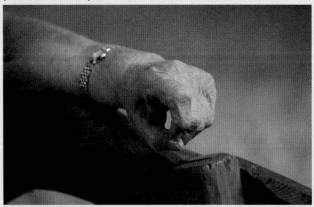

49. Minnie—SOT cont.: *"Sometimes the snow would sift through the cracks in the walls. Wake up with snow on your floor. That old Sue used to get up and make our fire every morning. She was just a little kid, but she would have that fire going for us . . . and I liked that."*

50. CU—Mom. Minnie Lee—SOT: *"Lillie and Nell and Lila slept in one bed. Fern and Sue and I slept in the other bed, two beds in that room. That was pretty good. We always had plenty of cover."*

51. Mom—SOT: *"How often did we take a bath? About once a week."*

52. CU—Mom's hand. SOT: *"We had to get big buckets and set them on the stove to get the water warm. We had some old No. 2 tubs that we did laundry in, so we'd bring them in the house and get our water hot."*

53. Minnie Lee—SOT: *"Whoever carried the water into the tub and heated it, that's the one that got to take the first bath. And the rest of us had to follow. Bathe in the same water. Wouldn't that be good now? We'd die now wouldn't we? (She laughs) Oh, yes!"*

54. WS—Out of truck window. Narration: *It is sunrise Sunday morning and the sisters are headed out to see the old homesite and the cemetery where their parents are buried.*

WS *Wide Shot —* **MS** *Medium Shot —* **CU** *Close-up —* **C/A** *Cutaway —* **SOT** *Sound-on-tape —* **Narr** *Narration —* **NATS** *Natural Sound —* **Under** *Sound softer than Narration —* **VO** *Voiceover*

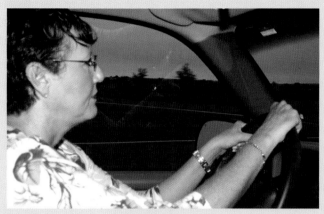

55. MS. Narration: *They drive through red Texas clay punctuated by green fields. It has been raining and the crops are good.*

56. CU—Int.—car. Narration: *It is hard to imagine these fields when the Seal girls lived here.*

57. Approaching dust storm. Narration: *It was the thirties, and years of drought had left the land parched. Then the winds came.*

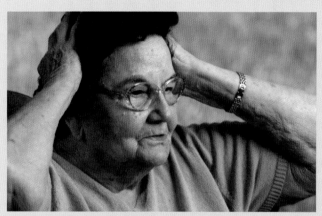

58. Mom—Cutaway (C/A). *"It was so dry and the winds up there, they could just get to going. It would just be rolling high in the air, you could see both ends of it and you could see how high it was..."*

59. C/A reaction. *"...like it was some big monster rolling in, and at daytime, at noon we lit the lamps it was so dark. If you didn't know you'd think the world was a coming to an end, you know, and I'll tell you what, and it could ruin a crop real easy."*

60. Still—Dust bowl. Mom—SOT: *"It would sting your legs, cause it had gravel in it, you know, and it would blow that sand so . . ."*

HOW TO CAPTURE FILM ON VIDEO

Dramatic images of the dustbowl were captured on film—videotape didn't exist. Chances are pretty good that some of your family's memories are preserved on 8 millimeter film. Some really old memories might even be on 16 millimeter film, which is what I found in making the Mom profile. If you want to use the footage in your story, you will need to transfer the images from the projected film to your digital video camcorder. There are many businesses that specialize in transferring film to tape. The quality is as good as it possibly can be, but you will pay a hefty price for it. Here are some suggestions on how it can be done with little expense and moderately good quality results:

Identify Your Film Type

Determine which type of film you have. You will most likely find regular 8 millimeter (mm) or Super 8 mm film. It is hard to tell the difference by just looking at the film, but check the center hole where the film reel attaches to the projector. Regular 8 mm will have a small hole, and Super 8 mm will have a larger hole. The two types of film are not compatible, and one cannot be threaded into a projector designed to show the other.

Find a Projector

Each type of film requires a different projector. You can usually rent the projector you need.

Determine the type of projector you need. Find one that has a variable-speed motor, and so, a variable shutter. Why does a simple film to tape transfer need all this? A film to tape transfer is the trickiest part of the process. Sixteen mm and Super 8 mm films run at 24 frames per second (fps). Various 8 mm film formats traditionally run at 18 fps. When the film is running at 24 fps, and the video camera is recording at 30 fps, you will get a "roll" pattern. The video camera will be photographing the closed shutter and various partially open positions, too. The simplest solution is to speed up the projector slightly, or slow the shutter on the video camera until the roll pattern goes away. If your projector will not change speeds, adjust the shutter speed on the camcorder. The object is to get the camera shutter speed as close as possible to the projector speed. Try all the shutter settings you have until you find one that does the best job of getting rid of the flicker in the picture and the bar that occasionally drifts through the frame. To be frank, unless you have at least a mid-level camera with a wide range of shutter adjustments, it is going to be hard to solve this problem. A shutter speed of 1/15th of a second works fairly well. When the shutter is open that long, some image blurring takes place.

Record Sound

It is unlikely that your film will have sound on it, but some 16-mm films have a sound track and most 16-mm projectors will play the sound. Your best bet for recording the sound is to plug into the output of the projector—which may only have a headphone output—and run an audio cable to your digital video camcorder. Some adjustment of audio levels will be necessary. If you don't have the right plugs for connecting the projector, your local video supply store will be able to help you.

Capture the Image

The projected image can be captured in a couple of ways. The first method is to shoot the projector onto a thin, white, translucent plastic sheet. The plastic material must have no pattern, and it must be thin enough to pass a clear image. Tracing paper is too thick. It diffuses the image just enough to make it undesirable. Your local art supply store should have the right kinds of plastic sheeting.

Stretch the plastic across a frame. There must be no wrinkles or waves in the material. A neat trick is to cut off the corners of the material when stretching it. The corners cause most of the problems in getting a smooth surface, and lopping them off just gets rid of that headache. Place the plastic square upright between the projector and the camera. Turn on the projector and focus the image onto the plastic. Observe it on the back side, or the side that the camcorder will shoot. If you see a clean, sharp image that is fairly evenly lit across the frame, then you are ready to record. This method offers a brighter and sharper picture because the camera is taking full advantage of the light from the projector. But it causes one rather significant hurdle that must be crossed: Because you are, in effect, looking at the back side of the picture, it is reversed left to right. You will need to flip it in the edit system by using computer software. If your edit system doesn't offer this effect, then the first method won't work for you.

An alternative method is to project the image onto a smooth, white surface, and record the reflected image with the camcorder. The light is usually smooth and will be bright enough if your choice of surface is correct. You might want to consider using a sheet of fine photographic paper (not the glossy kind).

Stretch a translucent screen tightly onto a frame, removing all folds and wrinkles.

Take care to position the camera alongside the projector so that it records the images in the same line of sight.

Capture the Image *(continued)*

It is important that the camera be placed on the same sight line as the projector or as close as possible. Any difference in the angle will cause a keystone effect, which means the picture will not have straight and square lines, but will appear stretched at the top or bottom. If one edge of the picture is closer to your lens than the other, you may also have difficulty keeping the entire picture in focus. Position the camera on its tripod so that the image is straight and square in the viewfinder. You may want to crop the film just a bit to get rid of any visible frame edges in the motion-picture film. Be sure to turn off auto focus! Set the exposure to manual—you don't want the exposure to wander—and make a sample tape. Play it back to check the results. If everything looks fine, rewind and record your film onto tape.

Place the video camera on a direct line of sight with the projected image. Be careful with the alignment. If the camera is looking up or down at the image, your final shot will be distorted.

Like the screen, adjust the panel so it's at right angles to the projector.

IMPORTING VHS TAPE

The digital-video era debuted scarcely more than a decade ago, and the use of digital video camcorders and edit systems in amateur projects became practical only recently. Consequently, any family memories captured on videotape are likely to be on VHS tape or 8-mm tape formats. All are analog formats that must be converted to digital to be imported into a digital edit system. Fortunately, there are several options to solve the analog-digital dilemma:

Video Capture Cards

The simplest solution to the analog-digital dilemma is the video capture card. This card plugs into your computer and has a video receptacle—usually a RCA-style plug—located on the back of the computer. Some capture cards also handle audio and will offer audio-input plugs alongside the video. The capture card converts analog video and audio to digital files and feeds the information into the computer and your edit program.

Digital Encoders

Some digital video camcorders also serve as digital encoders. Plug the video and audio signals from the VHS player into the video and audio inputs on the camcorder. Connect the FireWire cable to the camcorder and to the computer. Video signals will then travel through the camcorder—entering as analog and leaving as digital. The computer will accept them as normal digital video.

Plug the video and audio signals from the VHS player into the video and audio inputs on the camcorder.

Video signals will travel through the camcorder and be accepted by the computer as digital video.

Direct Dub

The last option is to dub the VHS tape directly onto a digital video cassette using the video and audio inputs on the camcorder. Connect the video and audio dub cables from one deck to the other and turn them on. It's as simple as that. Make sure to monitor the video for any signs of breakup or noise, and listen to the audio to make sure you are recording the proper levels. You can then play the recorded digital videotape into the edit system.

In all of these examples, use the best quality cables you can find with high-quality connectors. Use the shortest length of cable you can manage between the machines. Cable length also affects video quality.

VHS tape can be captured directly into the computer or through a properly equipped DV camcorder.

Use the best quality cables you can find with high-quality connectors. Cable length also affects video quality, so use the shortest length of cable you can manage.

PERSONAL PROFILE: LILLIE SEAL BRANDON
(continued)

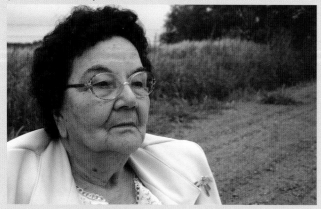

61. CU—Mom SOT. *"We had an old hen with a bunch of little chickens. She got her babies under her wing, and squatted and covered those little chickens, and that sand covered her."*

62. CU—Hen. Mom SOT: *"We found them and dusted them off and they went on...those little chickens was protected. I loved that old mother hen, she got all those babies under there and she knew what to do."*

63. MS—Mom SOT: *"Right here is where I turned the corner girls . . . like Junior Jones."* **Nell chimes in:** *"Yeah, this is where she turned that corner doing 90 miles an hour, like Junior Jones."* **Sonja:** *"Everybody knows about Junior Jones."*

64. CU—Hallie: *"And he's still making us laugh."*

65. CU—Scenics, flowers. Narration: *The dank, odors of the dust bowl are a distant memory this morning. Instead, it smells of springtime, all green and full of possibilities. The sunflowers are in full glory.*

66. Hallie voiceover (VO): *"We called it bear grass but it's called 'cholla' and it's in the seed right now in the pod. It grows up big white flowers in the spring."*

WS *Wide Shot* — MS *Medium Shot* — CU *Close-up* — C/A *Cutaway* — SOT *Sound-on-tape* — Narr *Narration* — NATS *Natural Sound* — Under *Sound softer than Narration* — VO *Voiceover*

67. WS—Hallie VO cont. *"The mesquite, it's in bloom. We've got some right down the road here that's got beans on them, but this is the light furry bloom. The plant with the little flowers on top is Johnsongrass and it's hard to get out of your crops."*

68. CU—Devil's Claw and Nell. Nell SOT: *"We always called this the Devil's Claw. Us kids used to pull these spurs apart, and they had a little black seed in there. We'd chew those and they were good tasting."*

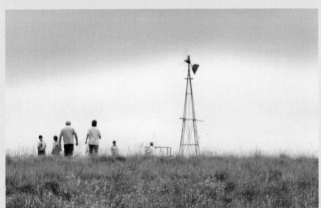

69. WS—Old family homesite—SOT Nell: *"Mama's and Papa's bedroom was in the boxcar. Just below there we had a windmill and cattle pens, and all kinds of animals we took care of."*

70. Old film—Nell sound under: *"The cow lot was just beyond that hill, and us girls done all the milking. We'd see who could get to the pen the quickest and get our cow. We usually had a special cow, and after you had that milked, you had your job done."*

71. Old film—Neil sound under (cont.): *"Dad always had a garden. We had peach trees, good old tomato plants, and all kinds of veggies. Everything we had to eat, we raised most of it, and we learned to like everything. That was a necessity."*

72. MS—Mom SOT: *"Used to have that hill covered in corn some years, and we'd go up there and gather sacks of it for roasting ears. We called it roasting ears because we cooked it on the cob a lot of times."*

PERSONAL PROFILE: LILLIE SEAL BRANDON
(continued)

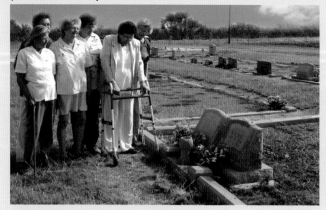

73. Transition to cemetery. Hallie—sound under: *"It's been a nice day and it brought back a lot of memories . . . getting up just before the sun came up and getting the calves in . . . milking the cows . . . Mama cooking breakfast."*

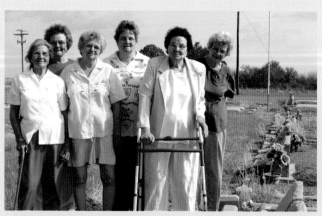

74. WS—Mom SOT: *"She must have been a strong woman. Her life wasn't easy, but she was always happy. She was always content with nothing. She just had us kids but she was content . . ."*

75. Old film—Mom sound under: *"Papa told me one time, 'Don't worry about things you can't change, just accept it and go on.' Mama said he doesn't practice what he preaches. Well, he had to worry, because he had all those kids . . ."*

76. Old film—Mom sound under. Narration: *When the weather is dry and hot and the crops are burning up, the man had to worry. Worrying is a family trait. Our grandparents worried, our parents worried, and we worry, too. . . .*

77. Old film—Narration: *Our Dad, R. L., was a champion worrier, but that doesn't mean he was an unhappy man. On the contrary, he led a full life. He loved hunting and golf . . . and he loved his wife.*

78. Stills of Dad—Mom sound under: *"Dad was good looking. He was tall. He was 6 feet, 3 inches. He was slender then, and he had a cute smile. R. L. stopped by and asked for a date, and I went with him."*

WS *Wide Shot* — **MS** *Medium Shot* — **CU** *Close-up* — **C/A** *Cutaway* — **SOT** *Sound-on-tape* — **Narr** *Narration* — **NATS** *Natural Sound* — **Under** *Sound softer than Narration* — **VO** *Voiceover*

79. Still of Dad. Mom sound under: *"I remember us buying a hamburger and he bought a coke. I always liked the Nugrape. We dated a little over a year when we finally married. I knew I loved him long before we married."*

80. Still of Dad. Mom sound under: *"After I got out of school that year and went back home, I really got lonesome to see him. That's when I finally decided that I loved him. One time I told Fern, I said don't fall in love, and she laughed at me."*

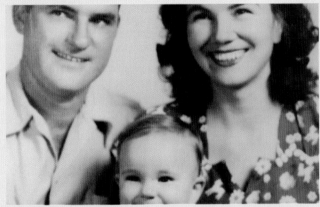

81. Still of Mom and Dad and baby Bob. Mom SOT: *"I think if we'd married right off we'd never have lived together, cause it seemed we never did agree on much. He was jealous...but after we married, he gained his confidence in me."*

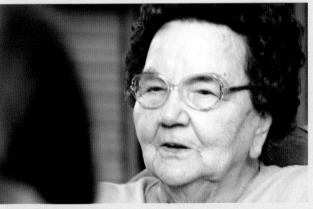

82. CU of Mom sound under: *"He worked at the bakery and he got $15 a week, and I worked at the café and I got $2 a week, plus our three meals a day, so I thought that counted pretty good you know. It would be our whole grocery bill, wouldn't have to buy groceries."*

83. Still—Bob's family home. *"And we had the first little two room shack that we had. The rest we had built on later."*

84. Stills of town. Narration: *The opportunity came to buy a bakery. They borrowed $3,000 and bought it.*

PERSONAL PROFILE: LILLIE SEAL BRANDON
(continued)

85. Still of old bakery site—Mom SOT sound under: *"A little after the first of the year, we had that bakery paid off. There was good years and bad years. We never thought they was that bad 'cause we were happy."*

86. Still of Mom and Dad—Narration: *Dad was a renaissance man. With a ninth-grade education he became an engineer, supervising the construction of roads and bridges. He was a craftsman who built precision target and hunting rifles that were prized by shooters.*

87. Stills of Dad. Narration: *He was a scratch golfer who could have been a club pro, but he decided to stay with a guaranteed paycheck. Security was important to someone who survived the Depression by his wits and hard work.*

88. Stills of Dad. Narration: *He was notoriously frugal and saved every penny he could. He loved to fish and hunt with his friends. He was a great father and we miss him.*

89. Still of Mom and Dad. Mom SOT sound under: "We had 59 years together before he died, and I thought that was pretty good. And we had two smart kids that took the education we tried to give 'em . . . All in all, I think I've been blessed."

90. Closing picture of thoughtful Mom. Narration: So have we, Mom . . . so have we.

WS *Wide Shot* — **MS** *Medium Shot* — **CU** *Close-up* — **C/A** *Cutaway* — **SOT** *Sound-on-tape* — **Narr** *Narration* — **NATS** *Natural Sound* — **Under** *Sound softer than Narration* — **VO** *Voiceover*

91. CU of Beverly. Over music to end. Narration: *Mom's daughter Beverly—our narrator.*

92. Still. Narration: *Mom's son Bob—the author.*

93. Still. Narration: *Mom's grandchildren . . . Ron and Kristi . . .*

94. Still. Narration: *. . . Kara, Chandler and Sean . . .*

95. Still. Narration: *. . . and Ellie.*

96. Closing shot: *The whole family at the reunion.*

CHAPTER 9: EDITING YOUR VIDEO

Editing the story completes the puzzle. The editor is handed a box full of parts and pieces and is asked to fit them together in the most coherent manner. The puzzle, when completed, must make sense, be entertaining, and have a strong message. It would also be nice if it appears to flow together naturally without any gimmickry or flashy techniques. In this chapter, you'll learn how to edit your footage on your home computer and create a professional and compelling finished video story that your audience will be happy to watch.

THE ART OF THE EDIT

Editing is a subtle art. Any edit that calls attention to itself is a bad edit. Transitions must become a part of the natural flow of the story in the same way that a photographic technique must be invisible to the viewer. It's tempting to add effects just because they are available, but remember, a simply told story with elegant cuts and transitions is the best way to get your point across.

Adapt and Improvise

When editing, it's important to remember to adapt and improvise. Don't become wedded to a prewritten script. Use the script as a guideline as the story progresses, and keep observing and thinking.

A STORY FROM THE FIELD

Editing the Personal Profile

My flight was late when I was shooting the profile of my mom. If I had been unwilling to adapt to the flight's delay in arriving in Texas, I would have been unable to move quickly into shooting the material that was available. I had to adapt many of my concepts as I moved into the edit process as well: I realized that a couple of scenes had no cutaway scenes to smooth the edits. I had to come up with an alternate plan. I decided to use still photos of related material as cutaways. The scenes that presented the most trouble were those of Mom going to church, and her arrival at her family reunion. In both cases, I adapted to the existing material. In the church scenes, I used the still photos when I needed to make an edit. In the reunion arrival, I dissolved scenes together to create the dreaded jump cuts. The dissolves softened the effect and made the jump cuts more acceptable.

The photos of Minnie Lee are too similar to simply edit together.

Dissolving the two images together softens the change from one scene to the next.

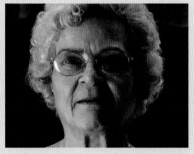

The viewer will scarcely know the scene has changed.

Movie Maker 2

Windows Movie Maker 2 is a non-linear editing program that is included with most copies of Microsoft Windows XP, and is available at your local computer store. It is a small and simple editing program that has some surprisingly elegant features. It is easy to learn and use, which is one of two very important features in any piece of editing software. The second most important feature is that it doesn't routinely crash when the transition that took an hour to fabricate is about to be added to the timeline.

The Program Interface

If you use computers, the program interface of Movie Maker 2 will look familiar to you. There are the usual menu options at the top of the frame with a couple of additions. There is a pull-down menu titled Clip and another titled Play. In Movie Maker 2, the screen is divided into three distinct sections: the Tasks window in the upper left of the screen; the Video window in the upper right, and the timeline or storyboard in the lower third.

The program interface for Movie Maker 2.

The Tasks Window or Collections Bin

The Tasks window displays information chosen from the menu on the far left side of the frame. This is also known as the collections bin. The editor can choose images stored in Collections, Video Effects, or Video Transitions. The selection then appears next to the menu and can be displayed as icons, thumbnails, or as a list. Thumbnails are usually the most helpful in finding the clip.

The Tasks window or Collections bin.

Video Window

The Video window shows the clip selected from the collections bin. The clip can be dragged to the image window or into the timeline. It will appear on the screen either way.

The Video window shows a clip selected from the collections bin.

The Timeline or Storyboard

The lower part of the frame is the business end. It graphically portrays the story as it is assembled. The view can either be the timeline or the storyboard. The timeline places a thumbnail of the scene onto the track labeled Video and shows the duration of the scene in minutes and seconds. It also shows the audio that is associated with the scene and the music and titles that have been selected to accompany the scene. The storyboard shows the shots in the order they were selected but discards the time, audio, and title information.

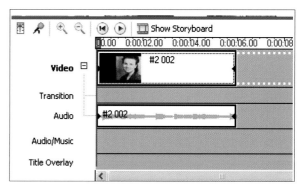

The Timeline shows the time, audio, and title information of your shots.

HOW TO GET STARTED EDITING

The first step in editing any project is to capture and organize the footage. Movie Maker 2 makes this almost effortless. Scenes can be imported via an IEEE 1394 cable, commonly known as FireWire, or digitized from composite video and audio outputs on the camcorder. The FireWire option is far and away the best choice when importing from a digital camcorder because the picture information remains digital. The video outputs on a digital camcorder are feeding a picture that has been converted from digital to analog and the quality will be significantly lower. To begin editing:

1 Open a new project on the File menu and give the project a name.

2 On the Tools menu, click on Options. This menu sets the parameters for the video standard—PAL or NTSC. PAL is the European standard for television and NTSC is the American standard. Also, choose an aspect ratio for the scene. Unless the project was deliberately shot in wide screen (16:9), choose 4:3.

3 Click on the Capture Video option in the File menu to import the video from the camcorder into the computer via the FireWire connection. Next, you will choose the quality level of the imported image. Movie Maker 2 offers quality levels from very low for Internet use to very high broadcast quality. The default is "Best quality for playback on my computer." This compresses the video and captures it at 640 x 480 pixels. This is known as the WMV or Windows Media File Format. For broadcast quality, select Digital Device Format (DV-AVI), and the video will be captured at 720 x 480 pixels. This is the highest level of video that Movie Maker 2 can record, and it is the standard broadcast quality level. "Other settings" will gear your video directly for myriad uses, from playback on your pocket PC to Internet video streaming.

Choosing a Quality Level

There are two things to consider when choosing the quality level for capturing video: 1) compression and 2) the amount of available hard drive space.

Keep in mind that compressing your file means lesser quality images. The quality of an edited video will not be equal to the quality of the original tape. If you plan to capture video from a digital video camera that you will edit in Movie Maker 2 and then save back to tape, you can choose the Digital Device Format (DV-AVI) option that lets you capture video as an AVI file. AVI stands for Audio-Video Interleaved. This option is well suited for recording back to tape because it preserves the digital information throughout the edit process and outputs it back to tape at the same quality in which it was captured.

You should also consider the amount of available disk space. Lengthy video and audio creates large files. The higher the quality level chosen, the more disk space required. The lower levels use only 2.1 megabits per second. The DV-AVI setting uses 25 Mb/s. Movie Maker 2 is not designed to handle that much information, so you will have to be content with a lesser quality image, although it will look quite nice.

Use the Video Capture Wizard to select the quality level. The Other settings button includes many other levels of compression, including streaming video for the Internet.

Capturing the Tape

You must now decide if you want to import the contents of the entire tape or only selected scenes. If you have been judicious in shooting your project, you will probably want most of the material on the tape to be imported. You can then take advantage of a feature in Movie Maker 2 that automatically records the contents of the tape while noting each scene and separating the clips onto the collections board as thumbnails. It will then be easy to locate each scene when editing begins. Movie Maker 2 will rewind the tape automatically and begin recording. On some computers, the scene being recorded is not displayed because the computer's resources are being used to accomplish the recording.

In the Tape Capture window, you select whether to import the whole tape or selected parts.

Creating Clips

The program subdivides the incoming material into clips if the Create Clips box is checked. Find the Create Clips tab under the Tools menu. It selects the start and end points of each clip by detecting when a significant change in video or audio occurs. If the Create Clips box is not selected, the video will be imported as a single clip, regardless of changes in the scene. Sometimes this decision can be rather arbitrary and may occur in the middle of what you might consider to be a contiguous scene. If this happens, the two clips can be rejoined on the timeline or storyboard with no loss of continuity or quality. When recording is finished, Movie Maker 2 automatically imports the clips into the collections bin under the name entered earlier.

Your video tape is divided into clips that appear in the Collections window.

This is a convenient feature that allows for rapid digitizing of material, but remember—editing is more than simply cutting scenes together, it is the search for the thread of the story. View all the material from beginning to end with an editor's eye without letting the circumstances of shooting the story enter into a decision about the relative value of a scene. Does it advance the story? Does it convey emotion? Does it fit the structure and context of the story?

Clips by Number

Movie Maker 2 assigns an ascending number to each clip. It's difficult to relate the clip to an arbitrary number so you should rename the clip with a one or two-word description. Clip #2-002 might become "Describes family." Or clip #2-106 would become "Exterior church." The real advantage to naming scenes is more evident when the collections bin is viewed in the Details setting. A larger number of scenes is displayed, but not the thumbnails. If the clip descriptions are well conceived, locating a particular clip is very easy. There is no need to scroll through long lists of thumbnails to look for that one necessary picture. Movie Maker 2 notes the time stamp assigned to the clip. It is not an important number except to help identify a scene that might otherwise be confused with other scenes. For instance, if you did two interviews with the same person on the same subject, but one was done earlier, then the time stamp would be a handy way to distinguish between the two.

PLACING THE FIRST SCENE

It's a good idea to start your editing work in a linear fashion, beginning with the first scene of the story. Some editors begin working in the middle or end of a story, and then fill in the rest afterward. If you shoot out of sequence, you may forget an important cutaway or close-up. The same applies to the edit. You may lose story context, structure, and pacing if you start cutting in the middle. How long should a middle sequence run? You won't know unless you understand how it will fit into the complete story. Choose a system of cutting that works for you—and keep continuity and consistent pacing in mind throughout the whole story.

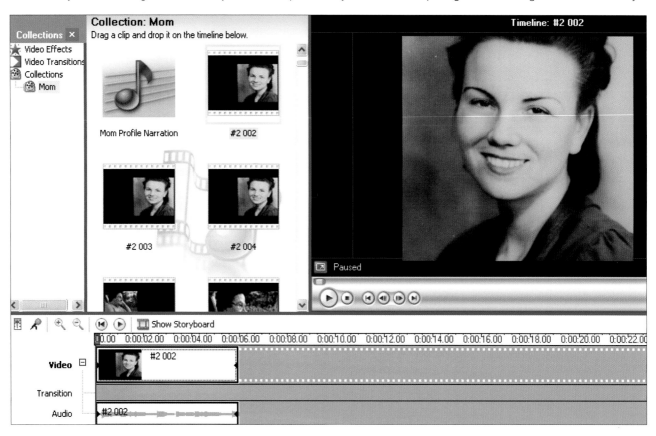

1 To place your first scene, grab a scene from the collections bin and drag it into the Video window.

2 If the clip does not begin playing automatically, click on the Play icon beneath the picture. Click it again to pause the clip. The Stop button returns to the beginning of the scene, as does the adjacent Rewind, or Back, button. The previous frame button will step the scene backward a frame at a time. To activate this button, it is necessary to press the play button again to pause the playback. Then, the Step Backward button and its adjacent partner, the Step Forward button, will work. The Fast Forward button will jump to the end of a shorter clip or speed forward in a longer one.

3 Grab and drag scenes onto the timeline or storyboard at the bottom of the window.

4 Click on the Play icon located just above the timeline. When the desired start point is reached, click the icon again to pause the playback. Move to the Clip menu and click on Set Start Trim Point. Click the Play icon once again to continue playing the clip until the desired end of the scene approaches. At the proper moment, click the icon to pause and return to the Clip menu. Click on Set End Trim Point. Movie Maker 2 removes the portion of the clip between the start and end trim points.

A LOOK AT THE TIMELINE

The timeline displays all the tracks being used to compile the story, including Video, Transitions, Audio, Audio/Music, and the bottom track called Title Overlay, to indicate what types of files have been added to the current project. Dragging the cursor along the timeline is called scrubbing. You can see your story in fast motion by scrubbing along the timeline.

The timeline is where you build your story.

Video

The Video track shows which video clips have been added to the project. After a clip is added to the timeline, the name of the source file appears on that clip. If any video effects are added to the picture, video, or title, a small icon appears on the clips to indicate that a video effect has been added to that clip.

Movie Maker 2 offers a selection of effects that can alter your picture.

A thumbnail image appears on the video timeline to help you identify your scene.

Transition

The Transition track displays any video transitions that have been added to the timeline. The only way to see a transition is to expand the video track using the magnifying glass tool. Any video transitions added from the Video Transitions folder appear on this track. The name of the transition will be shown on the track. The length of the transition can be changed by grabbing the start handle of the track and dragging it forward or backward.

When the timeline is in the storyboard view, a white box appears between the thumbnails to show the transitions between scenes.

Audio

The Audio track shows the audio that is included in any video clips. You can only see the Audio track if you have expanded the Video track. In Movie Maker 2, the Audio and Video tracks are locked together. If the Audio track is deleted, the accompanying video will also be removed. If you do not want to hear the audio, click on the Clip menu and then the Audio selector. Next, click Volume. A dialog box will appear that allows the volume to be adjusted downward or completely turned off. This can be accomplished on the Audio track or the Audio/Music track.

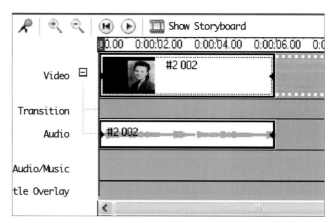

Audio appears as a wave form, which shows the volume of the sound as a graph.

Audio/Music

The Audio/Music track displays any audio clips that have been added to the project. The name of the audio clip appears on the clip. Audio may have been recorded off a CD, tape player, or a microphone. It will appear in the collections bin as a thumbnail. Name the selection for easy location later. Audio from the Audio/Music track can be added by dragging the clip onto the track. Only the audio from the selection, not the video, will be heard. The volume can also be adjusted. The volume adjustment applies only to the track that is selected. Volume levels must be adjusted one at a time.

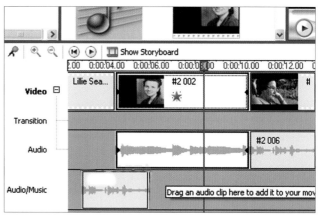

Additional audio such as narration or added music appears on the Audio/Music track.

Title Overlay

The Title Overlay track shows any titles or credits that have been created to appear over the picture. Titles can be added at any point during the program. The trim handle that appears can be dragged forward or backward when the title is selected to increase or decrease its length.

The title overlay appears at the bottom of the timeline.

Editing on the Timeline

Editing a clip can also be achieved directly on the timeline. Place the cursor on the blue line directly over the picture. An instruction will appear directing you to click and drag to trim the clip. Material will be trimmed in the direction the blue line is dragged. If the line is dragged backward, the material preceding it will be trimmed. If the line is dragged forward, the material that lies ahead will be trimmed. Here is a helpful hint: If the scene on the timeline seems impossibly small, use the magnifying glass icon to expand the timeline until the scenes are comfortably large. If a large section of the story is needed on the timeline at one time, use the (-) icon to shrink it until the desired size is reached.

You can move the cursor by grabbing the small square at the top of the timeline.

The Storyboard

The storyboard is the default view in Movie Maker 2 and offers easy rearranging of scenes and addition of effects or transitions. But the real editing will take place on the timeline. Use the storyboard to look at the sequence or ordering of the clips in the project and rearrange them, if necessary. This view also shows any video effects or video transitions that have been added. All of the clips in the current project are displayed. Audio clips that have been added to a project are not displayed on the storyboard; however, they are displayed in the timeline.

The storyboard offers a full visual representation of the timeline.

Add a Clip to the Storyboard

It is easy to add a clip to the storyboard. Just drag it from the collections bin onto the storyboard in the location desired. The entire clip will play, but clips can't be edited on the storyboard. Return to the timeline to trim any unwanted material from a clip. Effects are added to a clip by dragging the effect from the effects bin onto the small star in the lower left portion of the thumbnail. If, after playing the altered scene, you decide that the effect is the wrong one, right click on the star and choose Delete Effects. Transitions are added by dragging the desired transition from the transitions bin onto the small square between thumbnails. Any unwanted transition can also be removed by right clicking on the square and choosing Delete.

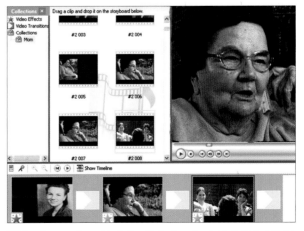

While clips can be added directly to the storyboard, they can be edited only on the timeline.

THE FIRST CUT

Now the magic begins. What scene will you, the editor, choose next? What will be the first cut? It is a big decision and one that carries a lot of weight. Old film editors first considered the cut to be merely a way to connect two scenes together to continue an action. For instance, in our featured profile, if Mom is walking into the church for Sunday services, the first scene would show her approaching the door and reaching to open it. The second scene would pick up on the same action of Mom opening the door, but from a different angle. Editors now know that the cut can be so much more. Things can be edited to appear longer or shorter, or actions not seen can be implied. A sign of a good cut is one that continues the action and advances the story.

What Is a Cut?

If you think about it, our days are a steady succession of cuts. Each time you blink your eyes, we cut the scene. Each time you change your gaze from one object to another, you cut. Look out a window, then return to this book. Your eye did not pan from the book to the window and back. It cut to the window, then back to this book, eliminating all the unnecessary material in between. The cut is exactly the same process.

Walter Murch, a celebrated Hollywood film editor, described his attempt to explain his profession to a person unfamiliar with the industry. He talked about achieving structure, using color, and the manipulation of time until the man said to him, "Oh, you cut out all the bad bits." At first Murch was incensed, but he later realized the man was fairly accurate in his assessment. The main question is: "What are the bad bits?" It is the editor's job to find all the bad bits and remove them. But the editor must know how to determine the bad bits from the good ones, and whether removing one bad bit will affect an adjacent good one.

The cut wears many costumes, and they change constantly. The plain cut has subcategories such as the match cut, the cutaway, and the jump cut. The match cut is one in which the action of the first scene is matched as closely as possible to the action in the second scene. If the actor has his right hand in the air in the first shot, then he must have the same hand in the same position in the second shot.

Things to Think About When Making Your Cuts

When do you make a cut? How do you determine when to cut away or to cut in for a close-up? The answers are, of course, subjective. Give the same material to three different editors and they will cut it three different ways.

The director John Huston cut his films by the "blink" theory. He noticed that when he looked across the room at a lamp and then back to a person's face, he blinked. Huston said, "Your mind cut the scene. First you behold the lamp, and then you behold the face." Huston suggests the mechanism of the blink as an interruption of perceptual continuity—the blink becomes a cut. A relaxed person viewing a pastoral scene may blink once a minute. An agitated and angry person involved in an argument may blink every few seconds. The pace of the blink is like the pace of the edit. Slow and peaceful scenes should run longer than high-action scenes. Feel the pace of the video, let the rhythm sink in, and the cut will reveal itself to you.

Active scenes, like driving in the car or a sporting event, should be shorter than slow and peaceful scenes.

Emotion

Is the cut true to the emotion of the moment? Every well-composed scene conveys emotion whether it be a close-up of an individual or a scenic landscape. The editor must maintain that emotion in the cut. A beautifully shot scene can be ruined by a bad edit. If a gorgeous sunrise skyline is raucously chopped into small pieces or interposed with a rock band slamming guitars on stage, the intent—the emotion of the scene—will be lost. Ask yourself: "What is the intent of the scene? What is the emotion contained within that moment?"

Here the subject is struggling to remember a long forgotten name.

Story

Does the cut advance the story? The next scene should seamlessly transport the viewer along the thread of the story. When you begin to think of every cut as an invisible element that furthers your story, your piece will be more cohesive and interesting.

A cut to an image of an old boxcar helps tell the story of the subject's childhood.

Rhythm

The rhythm of the story is something that develops over the span of several sequences. Does the cut adhere to the rhythm? It is easy to determine the rhythm of a piece of music, but a bit harder to find the rhythm in a visual scene. But pictures do have rhythm and it is found usually in the edit. The pace of the edit follows the pace of the picture. An especially energetic scene can be cut with more vigor than a slow, pastoral scene. Beautiful, scenic photographs or intimate character studies require more time to appreciate and should not be rapidly cut. The addition of music under a scene imposes a rhythm onto the pictures. The rhythm of your music should complement, not conflict with, the rhythm of the image.

Pastoral scenes, especially wide shots, require more time to absorb and appreciate.

Screen Direction, Eye Trace, and Subject Position

If the subject is moving from left to right in the first shot, he should continue moving in the same screen direction in the next shot. If two people are talking to each other, one should look left and the other should look right and those directions should be maintained throughout the conversation. Consider eye trace and subject position when making a cut. Eye trace is the movement of the viewer's eye as the scene changes. Is the eye forced to jump from side to side or top to bottom? Can the eye relax and watch a single portion of the frame for the essential visual information? The story may require that the eye move across the frame. In the case of two people talking, the eye would naturally shift from one person on the left side of the frame to the person on the right side of the frame as the conversation progresses.

Regardless of your shooting position, keep each subject's nose pointed in its original direction.

A LOOK AT TRANSITIONS

The cut can take other forms, such as dissolves, wipes, flips, and squeezes. The goal is the same: joining two scenes to enhance and advance the story. The question becomes one of aesthetics. Does placing an effect onto the cut make the story better or does it just get in the way of the storytelling? Generally these effects are distracting to the viewer and you should avoid them, but there are times when an effect will enhance the story. For example, a dissolve is an effective transition. It softens the cut and smooths the visual change when a cut might be too abrupt.

Placing a Transition

Transitions are found in Movie Maker 2 under the Tools menu.

1 Click on the Transitions tab and a selection of available transitions will appear on the screen.

2 Place the blue cursor line where you want the transition, then click, drag, and drop it between the two scenes on the Video track. It will be added to the transition line on the timeline. In the storyboard view, the transition icon is inserted between the thumbnails of the two scenes. The transition cannot be longer than the shortest of the two scenes. The default transition length is set on the Tools menu, Options tab.

3 The length of a transition can be adjusted in each case. To lengthen the transition, grab the beginning of the transition and drag it toward the start.

4 To shorten a transition, grab the beginning and drag it toward the end. The transition begins before the cut and continues into the second scene. The length is divided equally on both sides of the cut, so a two-second transition would begin one second before the cut and continue for one second after the cut.

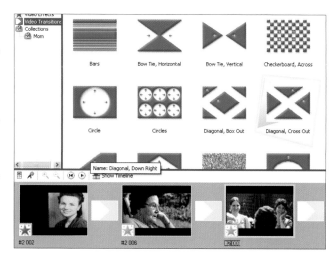

A number of transitions, shown here in the collections bin, can be used in your storyboards. Drag a transition from the bin to a box between the scenes.

PRO TIP: Avoid Special Effects

The cut can be adulterated with all sorts of special effects. These effects do not add any value to the story, and tend to disrupt the viewer's train of thought. Use the work of respected professional editors as a benchmark for your editing style. It is a rare occasion indeed when any sort of fancy effect appears in films edited by men like Walter Murch, Jamie Selkirk, or Lee Smith. In the television business, we know when we see a special effect it means the editor had no other means of making the cut, so he was covering up the bad transition. When you see an interview cut together with dissolves from one clip to the next or with a white flash between clips, you know there were no cutaways to use or other illustrative footage to insert.

THE EFFECTS BIN

To view Movie Maker 2's available video effects, click on the Tools menu, and then the Video Effects tab. The collections bin turns into the effects bin, which offers the editor some useful tools. The Brightness-Increase and Brightness-Decrease tools will help correct images that are either underexposed or overexposed. The Ease Out effect will slowly zoom out on the picture. This effect is a nice one to use on a still photo to give it some movement. The move is very slow and not intrusive. The Fade In tools are useful at the beginning of the program or between major sections of the program. The Film Age tools, which mimic the scratches and dirt on old film, are rather gimmicky, but they might add character to some old photos or footage. The Pixelate, Posterize, and Sepia tools are of limited use because they dramatically alter the picture, as are the Mirror-Vertical and Rotate tools, but the Mirror-Horizontal can be a very functional tool.

For example, in the previous Sporting event story, the girls were constantly running in both directions. If a shot was needed of a girl running to the left and the only shot on hand showed her running to the right, the Mirror-Horizontal tool can be used to flip her direction. This is a good example of an invisible effect—one that the viewer is not even aware of, but it advances the story. The Slow Down-Half tool is also very valuable. Adding this effect to a scene slows it down to one-half of its normal speed. In the profile of Mom, there was a small amount of footage of the dust bowl, but not nearly enough to cover all the edits made to the soundtrack. Slowing the footage down effectively doubled the length of the footage. The tool also allows important scenes to be examined more closely and in more detail. If slowing the scene by one-half is not enough, drag the effect on top of the first one again and the scene will be slowed to one-quarter speed. The effect can be added a number of times. By the same token, the Speed Up Double tool can make a very slow scene more practical by cutting the run time in half. Look at these effects carefully and decide what you like, but—as with transitions—don't feel that you have to use them just because they're available.

The "A" Roll and the "B" Roll

The terms "A" roll and "B" roll are television terms that have crept into general editing parlance. They refer to the early days in television before videotape when news and documentaries were photographed on film. The technology did not exist to allow editors to rapidly cut a story that included both the sound on film and other pictures shot when the sound was not recorded. So editors would cut two rolls of film. One contained the sound on film and the other contained pictures used to cover some of the sound. The reel containing the sound film came to be known as the "A" roll and the picture reel became the "B" roll. The terms still exist today. "A" roll pictures are the ones recorded with the interview or of someone talking to the camera. "B" roll pictures are everything else. In the edit, "A" roll refers to the track that contains the main sound track, and "B" roll refers to the pictures that will be added to cover the narration and portions of on-camera sound.

It is helpful for your story's organization and pacing to assemble the "A" roll first, and then return to fill in with "B" roll pictures. This does not mean that adjustments can't be made in the "A" roll after it is entirely assembled. One of the remarkable features of non-linear editing is that the editor can cut and paste material anywhere along the timeline at any time.

EDITING THE MOM PROFILE

I decided that a title to introduce the piece would be a good idea, so I clicked on the Tools menu; then I chose Titles and Credits. Movie Maker 2 asks where to put the title, so I answer that I want it at the beginning of the piece.

Movie Maker 2 provides a text box for me to enter the title information. I type it in and click on Done. I could have placed the title over a picture, but I decided that I liked the simplicity of seeing it over a plain background. Movie Maker 2 adds a fade in and fade out to the title and attaches it to the beginning of my "movie."

The First Scene

I pull down to the timeline a photograph of my mother when she was young. I can then preview the first two scenes to see how they are going to play. I am watching for content and for pace. I want to get the feel of the picture and the rhythm of the image. I will do this repeatedly as the edit progresses. The first two scenes serve as a cornerstone of the edit. Now I have an official starting place, so I can get to the business of building an "A" roll.

I begin my narration with the first picture of Mom.

Narration:
Her name is Lillie Anise Seal Brandon.
She is a Seal by birth, a Brandon by choice.
She is 85 years old, her mind is sharp,
 and she has many stories to tell.
All of us can learn lessons about life from her stories.
All of us can benefit from her wisdom.
All of us are enriched by her goodness.

The Interview

Next comes the first piece of Mom's interview

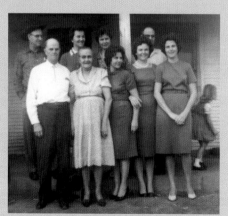

Mom:
We have the best country in the world to live in. Our forefathers came for freedom of religion, so they could worship God like they want to, and I think it's just a great, great privilege.

How the Author Approaches the Process

I find the interviews in the collections bin and drag them onto the timeline. I listen for my cuts and trim the sound to remove everything but the pieces I want. I continue in this fashion for most of the script, making occasional adjustments as I go to allow for changes that become evident when I lay down the various pieces of narration and interview.

I review the edits every so often to "see" the pictures in my mind that will accompany the sound and try to imagine how it is going to look and sound when finished. I can catch pacing mistakes at this stage that will make the edit easier when I come back later to add the "B" roll. I keep all of the main sound on the "A" roll so the other available sound track can be used for either natural sound (NATS), such as chirping birds, the church choir, train sounds, or music from a CD. Movie Maker 2 offers only two audio tracks. More elegant edit programs offer 20 audio tracks or more. This allows individual sounds to be placed on separate tracks where they can be controlled more precisely when the final audio mix is performed. For this project, I will limit myself to deciding which sounds are more important, natural sounds or music.

When to Use Transition Effects

As previously mentioned, a cut or dissolve that calls attention to itself is a distraction and an intrusion and should not be used. Transitions must be invisible. However, there are many edits that call for dissolves and they can be used to enhance the story.

A nice, slow dissolve will help advance the transition from one location to the next. For instance, I needed to move Mom from the church, onto the road traveling to the family reunion. I could have built an entire sequence of her leaving the church, entering the car, and driving away. But I shortened the process by dissolving very slowly to the shot of the train traveling alongside the car out on the highway. A train whistle helped to enhance the effect. The sound of the church congregation singing a hymn slowly fades out as the sound of the train slowly fades in. To achieve this effect, right click on the end of the Audio track and select Fade Out. Then right click on the beginning of the music track and select Fade In.

The sound from one scene can be made to slowly fade out as the sound of the next scene fades in.

A dissolve usually indicates the passage of time and/or a change of location.

This effect can help to ensure a smooth transition from one scene to another.

COMPRESSION AND OUTPUTTING YOUR VIDEO

The reason digital video pictures are so good when compared to the older analog recording formats is that they can compress larger amounts of picture information onto a tiny little tape. Since the DV program is recording a digital file—a series of 1s and 0s—it can choose to apply a compression scheme to the file and eliminate some of the 1s and 0s. It will replace them with a marker that will remind the decompression device how to restore them when the file is decompressed. There are many compression schemes. But be aware, the quality of compressed images will always be less than the original images.

Movie Maker 2 offers an importing and exporting scheme known as DV-AVI. It is a purely digital format that preserves the integrity of the imported image file through the edit process. The same amount of information is available for export when the program is finished. The downside is that the files are huge and will occupy a large space on the hard drive. There is just no way around this. The higher the quality, the larger the file.

Ready for Export

When the project is ready for export, click on the File menu; then choose the Save Movie tab. Movie Maker 2 asks for a destination. If the project is destined for recording back to DV tape, click on the DV Camera option. You'll be prompted to cue the tape to the spot where recording is to begin. When you were editing your video, only a preview of what it would look like was displayed in the preview window. The actual video doesn't exist until Movie Maker 2 is told how it is to be distributed. Then it is rendered in the format desired.

The rendering process applies the proper compression and conversion scheme and saves it to a temporary file on the hard disk. This requires a lot of computing power and disk space and could take two to three times the running length of the piece to render. Plan the render at lunchtime or at the end of the day, so the computer can be left to do its job. Rendering will occupy all of the computer's resources and nothing else can be done while it works. When rendering is complete, the computer will copy the video from the temporary file to its final destination—the DV tape—and clean up the temp file.

The Save Movie Wizard helps you choose where you want to save your video.

Play Your Video

When the recording is complete, play the tape on a monitor or TV set. Watch carefully for any glitches that may have crept into the render. Computers are not infallible. A line may be dropped, audio may be muffled, or the color may be incorrect. If this happens, try to determine the cause of the problem. The computer's hard drive may require defragmenting to make it more efficient, or the problem may simply have been a transient one that will not happen the next time. It is also a good idea to perform a brief test of the process before committing the time necessary to render the entire piece. Record a small section and play it back. Any severe problems should be evident. If everything looks fine, continue the render.

Play the video in its entirety. Make the Playback window as large as you can, so you can see problems more easily.

Burning a DVD

Distributing the finished film to other destinations requires making a few more choices. If the final destination is to be a DVD, some manipulation is necessary. Unlike the more advanced edit programs, Movie Maker 2 does not offer a record to DVD option. The project must be saved on the computer where it can be accessed by DVD-burning software. Choosing the Best Quality for Playback on My Computer option might seem like the obvious choice, but the images are taken from the DV-AVI format and converted to a WMV file and compressed even more. This does not produce the best-quality final picture, so choose Other settings, and then DV-AVI. The file size will skyrocket. Make sure there is adequate space on the hard drive. Click Save and take a break because this step will take a while.

Movie Maker 2 will save the finished piece in the My Videos folder. It can then be called up by another program that can author and burn the DVD. Many different companies offer DVD-burning software. Newer computers may arrive with a DVD program already installed. If your computer does not have DVD software, purchase a program and install it.

Sonic is one of the many available brands of DVD authoring and burning programs.

Adding a Menu to Your DVD

Most DVD programs will not only burn the program onto a DVD, but they will give you an option to "author" the program. The DVD will contain a title page with a button to click to play the piece, just like the menu you see when you play a movie on a DVD. This is not necessary if there is only one program on your DVD. If several videos are added to one DVD, a menu can be created that will list all the offerings. A text box is provided in which the title is entered. Give the program a name that is easily remembered and descriptive of the contents. The menu backgrounds on some title pages can be animated. The program also offers different backgrounds, plus the option to add a custom background and your choice of music.

Watch the lower left corner of the screen as your videos are added to the menu. The readout will indicate the amount of disk space remaining. Do not exceed the capacity of the disk. When every video has been added, titled, and ready to burn, save the project. Next click the red Burn button and the DVD software will begin encoding the files and transferring them to the DVD. This can also be a lengthy process—maybe several hours depending on the length of the programs. The results are worth the wait. The completed DVD is a polished, professional-looking program that offers instant choices of high-quality pieces to view.

DVD programs usually offer many menu templates.

EDITING ON YOUR MAC

Apple computers, like this iMac, come with the iMovie program installed.

Owners of an Apple computer can use the non-linear edit program called iMovie. There are more similarities than differences between iMovie and Movie Maker 2. Both programs allow the capture of video footage, though iMovie is somewhat more restrictive in the quality level settings it will allow for captured video. It assumes that you want to capture digital video from your DV camcorder and that you want to create a QuickTime movie with it. QuickTime is the Apple standard codec or compressor for all video. iMovie will accept only those audio files that will work with QuickTime. The standard audio file type for QuickTime is AIFF.

Making Clips

You can determine how captured scenes are to be separated by consulting the Preferences menu, which is found under iMovie on the toolbar. You can choose to have scenes broken into clips on scene changes, or to let the captured video appear as a single clip. You can also start and stop the capture process manually and create a new clip each time you begin capturing video again.

Screen Display

The screen display looks similar to the Movie Maker 2 screen, except that the collections bin appears to the right of the viewer window in iMovie. The storyboard/timeline is familiar and can be switched from one to the other by choosing the filmstrip icon for the storyboard or the clock icon for the timeline.

The iMovie window shows the collections bin, the screen display, and the timeline.

Timeline

The iMovie program offers a couple of enhancements on the timeline, such as overlaying the audio waveform onto the audio tracks. This is helpful when finding a point on the tape where a section of audio begins.

Scenes can also be trimmed in the viewer. Small icons represent the in point and out point of the edit. You just drag the icons to their positions along a mini-timeline at the bottom of the viewer frame, press return, and the edit is made onto the real timeline.

The timeline in iMovie is very similar to the timelines in other non-linear edit programs, including Movie Maker 2.

Transitions

Transitions and effects are added in much the same way as they are in Movie Maker 2. Click on the Transitions icon at the bottom of the collections bin and it changes to a list of available transitions, such as fade in or out, or dissolve. Drag the desired transition onto the timeline and place it between the scenes you want to affect. The transition automatically nestles in between the scenes and a blue icon notes its presence.

Effects can be added to any scene by opening the effects bin in the same way you found the transitions. Click on the Effects icon and a list of available effects appear in place of the collections bin. Choose the effect you want by dragging its icon onto the scene in the timeline. Some of the effects have controls that allow you to alter the intensity of the effect and see a preview.

Like Movie Maker 2, iMovie offers transitions such as this spinning transition.

Saving to DVD

Saving your completed project to a DVD is amazingly easy. Click the iDVD icon below the collections bin and the bin changes to a chapter markers bin. Add chapters in the order you would like them to appear on the DVD, and then click Create DVD Project. A selection of menu templates appears beside the viewer window. Choose the menu you like, fill in the required title information, then click Burn and voilá. You have created a DVD. iMovie offers various compression settings for your DVD project. The menus are clever and the quality of the QuickTime codec is excellent, which means your DVD will be a joy to watch.

REVIEW YOUR WORK

When the last scene has been laid into place, you'll be tempted to output the program as soon as possible. But this is the time to carefully review the entire program. Look for obvious mistakes and try to judge whether you've told an interesting story.

Final Review Checklist

Here are some things to watch out for as you look over your final edit:

✓ Jump Cuts

Some cuts occur when two similar scenes are cut together, making the subject appear to jump. Jump cuts sneak into a piece, especially when lots of sound bites are strung together with the intention of covering them with "B" roll.

✓ Flash Frames

A flash frame is a single frame of video that was mistakenly left between two scenes when an alteration was made. Flash frames will "pop" on the screen and be gone in the blink of an eye, so a careful review is the only way they will be spotted.

✓ Audio Problems

An audio track can also have flash frames, jump cuts, or up cuts. An up cut happens when the audio track is trimmed too closely and a portion of the first word is missing. Other audio problems include volume mismatches, suchas when the music track is too loud and obscures the narration track. Keep the volume of the music track lower than you think it should be and you will avoid this problem. All editors battle the same audio glitches, so consider yourself in good company when you find one.

✓ Pacing and Rhythm Issues

Sometimes the final review will be the first time a pacing problem will emerge. There will be a temptation to let it slide and continue the output. But keep in mind that these issues can compromise the quality of all your hard work.

✓ Sequence Development

Do the sequences advance the story? Or is there a cutaway or a cut-in that could help that sequence?

✓ Does It Tell the Story?

Become a tough editor. List all the things that do not absolutely belong in the story and consider removing them. Shorter is always better. Every editor wants his audience to come to him complaining that it wasn't long enough. You want to leave the viewers wanting more. You will instantly know if you have them captivated. If the audience starts talking during the performance, you should make note of where this happens and consider revising the program at that point, because something caused the audience to lose its desire to watch.

✓ Find a Critic

Find someone who will be brutally honest with you and ask for a critique. Put your ego in your pocket and listen to what they have to say. A lot can be learned by listening to the opinion of someone not directly involved.

✓ The Closing Shot

The last scene in the program is the one that will stay with the audience the longest. If you create a powerful closing shot, the viewer will forgive myriad earlier sins. Make sure you leave them laughing or crying. And remember the little details such as making sure the music ends when the picture fades to black. A neat, clean ending is important.

THE FINISHED PRODUCT

Nothing reaches an audience in the same way as a video. Video has a very genuine quality; it allows the viewer to experience a subject's real-time life. Words spoken directly to the camera cannot be misquoted. A sly smile is captured in its true context.

Anyone with an ounce of creative ability can have fun and communicate great ideas with video. Its possible uses are limited only by the imagination of the user. Producing a video can be an addictive avocation. It is time consuming from the beginning to the end, and you will find yourself sitting for endless hours in front of the screen editing and re-editing. However, nothing quite compares to the sense of satisfaction that comes with laying in that final scene and playing the finished piece.

If you want to learn more about the art of video production, consider taking a class at your local community college. Most offer many different courses on the various aspects of moviemaking. A class is an excellent place to learn about writing a script, applying makeup, or building a set, as well as the familiar shooting and editing topics.

Your Imagination

There was a great piece produced by a young man in New York City who had never even touched a video camera. He wanted a novel way to propose marriage to his girlfriend. He decided to produce a video based on his search for the perfect woman. He created a silent movie with title pages and starred in the piece as a Chaplinesque character. The video was treated to look like old black-and-white nitrate film. A solo piano was the only sound—as it would have been in the first silent movie houses.

When the story was finished, he rented a movie theater for an evening and took his girlfriend to what she was told was an art-house film titled, "The Search for the Perfect Woman." They were the only two people in the theater, so she had a great seat when he appeared on the screen, waddling through his search for the perfect woman.

In true storytelling form, his movie concluded with his strongest shot, the payoff shot where we see for the first time that she is the perfect woman. He mouths silently, "Will you marry me?" She, of course, said yes. His was an audience of one. You can imagine the joy he felt just by completing the project, even though thousands would not see his work. The size of the audience is almost irrelevant. Creative types hunger for approval, and want someone, anyone, to see their work and tell them they've done well. When you pop in your DVD, sit back and enjoy the applause, because you will have earned it.

The movie begins with the hero pondering how to find the perfect girl.

Title cards provide the thread to keep the audience informed of his thoughts.

He plays the bar scene and thinks he's found a candidate.

Until she stands up.

The title card reveals the secret. The perfect woman is in the audience.

He proposes to her as a heart-shaped mask squeezes the frame to black.

RESOURCES

Producing personal videos has become a very popular hobby, and for some people, a vocation as well. If you want to learn more about video production and editing, here are some useful resources:

Web Sites

www.windowsmoviemakers.net
A subscription-based online tutorial service that covers video photography and editing from A to Z. It offers articles on subjects such as managing clips, adding transitions, and producing a finished DVD. It also offers many forums for its members.

www.microsoft.com/windowsxp/using/moviemaker/default.mspx
This official Microsoft Web site for Movie Maker 2 offers tips for better videos and newsgroups where you can ask questions and read other editor's suggestions.

edtech.kennesaw.edu/nisa/moviemaker.htm
The Georgia Movie Academy offers a step-by-step PowerPoint presentation that includes lots of good hints for better videos as well as additional links for more information.

www.nppa.org
The National Press Photographers Association is dedicated to the advancement of photojournalism, still photography, and videography. The association offers its members a library of video winners in the numerous competitions it sponsors. The winning stories are full of great examples of storytelling expertise.

www.apple.com/support/imovie/
This site offers an assortment of problem-solving tips for the iMovie user. It covers subjects such as working with clips and audio and adding transitions.

www.videouniversity.com
This site offers tutorials, home-study courses, and several books on both the artistic aspects of wedding videographer and the business considerations of making wedding videography a profitable adventure.

www.videoguys.com/family.html
Some really good suggestions are listed on the site, such as unique transition ideas, how to shoot kids, where the best action is found—all really hard-working ideas for the photographer who is serious about family videos.

Books

Microsoft Windows Movie Maker 2 Quickstart Guide by Jan Ozer is perfect for the editor who will never wade through a long user's manual, but wants to dive right into a project. With just a little reading, the user can begin a project and refer to the book as needed as the project progresses.

Blink of an Eye by Walter Murch offers excellent insight into the theory of editing. Murch is a well-known Hollywood editor who cut *American Graffiti*, *The Godfather* series, *Apocalypse Now*, and many others.

Editing Digital Video by Robert Goodman and Patrick McGrath is a complete textbook on video editing. It includes a CD-ROM that you can follow along on your computer.

Make it Memorable by NBC News Correspondent Bob Dotson explores visual storytelling on a more advanced level. Dotson has filled a 30-year career with memorable stories on NBC as detailed in his memoir, *In Pursuit of the American Dream*. He has the wonderful gift to be able to condense a thought into a mere few poetic words that are, in fact, memorable.

Television News Writing by former Colorado State University and University of Oklahoma professor of journalism Fred Shook, is a gold mine of storytelling ideas. Shook has advised the best storytellers in the business, including Bob Dotson. Shook has written several books on the subject; they are geared toward teaching students about television news reporting, but the storytelling basics that he uses are applicable to any video project. His latest book is *Television Field Production and Reporting* (Fourth Edition).

How to do Everything with iMovie by Tony Reveaux and Gene Steinberg is as complete a primer as you will find for iMovie. The book is limited to technical operation of the software with little storytelling advice.

Start Here: Movie-Making with iMovie by Rory O'Neill and Eden Greig Muir uses the tutorial teaching style to cover everything from purchasing a camera to creating a finished video.

Writing, Directing, and Producing Documentary Films by Alan Rosenthal is a book more advanced readers will want to read. Rosenthal describes the day-to-day problems of creating a "new" documentary. He follows the sequence of the process and discusses ideas, research; script structure; preproduction and production; editing and narration writing; and styles.

Lighting for Digital Video and Television by John Jackman explores the finer points of lighting for video. Whether you're a beginner or a seasoned professional, you'll find practical answers that you can understand and use. In fact, many topics have answers available in two or three levels. So there will be something for everyone who is interested in video, from a beginner still using a VHS camcorder to experienced engineers who need cutting-edge-technology answers.

Audio Post Production for Digital Video by Jay Rose takes the reader through the essentials of producing great sound for your video project. His second book, *Producing Great Sound for Digital Video* expands on the first book to include production techniques in the field to improve audio recording.

The devoted storyteller can also find nuggets of wisdom in many books not specifically related to video:

A Celebration of American Family Folklore—Tales and Traditions from the Smithsonian Collection by Holly Cutting Baker, Amy J. Kotkin, and Steven J. Zeitlin is a collection of family folklore told by great storytellers at the Smithsonian Folklife Festival. It includes a section on how to collect your own family folklore.

The Storytellers Guide: Storytellers Share Advice for the Classroom, Boardroom, Showroom, Podium, Pulpit, and Centerstage by Bill Mooney and David Holt includes the authors' interviews with more than 50 storytellers—professionals, teachers, actors, and authors. It provides advice for the novice teller as well as the beginning professional on topics ranging from learning stories to ethics to setting fees and marketing yourself.

In the United States

B&H Photo, Video, Pro Audio
420 Ninth Avenue
New York, NY 10001
(212) 502-6300
(800) 924-3999
www.bhphotovideo.com

J&R
Park Row
New York, NY 10038
(212) 238-9000
(800) 806-1115
www.jr.com

In Australia

www.famm.org.au
The Federation of Australian Movie Makers has links to many clubs, including New Zealand clubs.

www.ncc.asn.au
The Northside Camcorder Club is one of Australia's leading video camera clubs.

www.videocamera.com.au
The official Web site for *Australia Video Camera*, a magazine that covers the needs of the camcorder enthusiast in Australia.

In Canada

The DV Shop
2967 Dundas Street West
Toronto, ONM6P 1Z2
(416) 604-1492
Toll Free (866) 252-1394
www.dvshop.ca

VISTEK
496 Queen St. East
Toronto, ON M5A 4G8
(416) 365-1777
(888) 365-1777

1231 10th Ave. SW
Calgary, AB T3C 0J3
(403) 244-0333
(800) 561-0333
Email: sales@vistek.ca
www.vistek.ca

GLOSSARY

4:3 The ratio of picture width to height. The historic standard for television recording has always been a picture that is 4 units wide by 3 units high.

16:9 A wider-screen format. The picture is 16 units wide by 9 units high.

A

A roll The main track of an edited tape or timeline in a nonlinear edit system. It contains all the principal audio of the piece, interviews, narration, and music.

Anamorphic The method of squeezing a wide-screen picture into a 4:3 format screen. The picture is squeezed, recorded, and then unsqueezed in the edit process.

Ambient sound The sound heard immediately around the microphone.

Aperture (See F-stop.)

Automatic gain control (AGC) The audio is protected from over-modulation by an automatic-gain control circuit. The automatic circuits are designed to prevent a catastrophic over-modulation of picture or sound that could damage the recording.

Available light Light that is available at the moment. It may be sunlight, fluorescent lights, or the headlights of an automobile at night.

B

B roll (See A roll.) The B roll contains all the additional pictures and perhaps some natural sound to complete the story on the A roll.

Backlight Also known as the "kicker," or "rim" light, the backlight illuminates the subject from behind, creating a separation between the subject and the background.

Bit A single unit of digital information, either a 1 or a 0. Its name is derived from "binary digit."

Byte There are eight bits in a byte, which completes a single block of alphanumeric information or character. It is then processed by the computer as a single unit of information.

Box The frame in which a picture is composed. The photographer must train himself to see events or landscapes as fitting inside the box creatively.

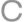

C

Camera microphone The microphone permanently mounted on the camera. It records ambient sounds near the camera but is ineffective more than six feet away.

Cardioid microphone A directional microphone that accepts sound in front and to the sides more clearly than from the back. It is a good choice when high ambient sound levels will compete with a voice that is to be recorded. Not intended for use when sounds are farther than a few feet from the microphone.

Circles of confusion (Also known as the "Bokeh Effect.") The light that arrives in front of and behind the imaging chip of the camcorder. Visualize as a cone that narrows to a point at the chip. The point is where the image is in focus. Any slice of the cone on either side of the chip will look like a circle.

Close-up A shot that narrows the field of view of the scene to concentrate only on the main subject. Close-ups usually consist of a shot of someone's face or hands, or of any single object.

Composition The way a scene is constructed in the frame of the camera.

Condenser An electrical sensor inside small powered microphones. The condenser replaces the transducer as the primary sensor of sound waves that are converted into electrical signals.

Cukaloris A large board with irregular patterns cut into it so light can shine through in unpredictable shapes. The cukaloris, also called a "cookie," may be constructed of heavy wood board or of lightweight foam core or cardboard.

Cut The point at which two scenes are joined together. It may also be used as an active verb, as in "cut" from a wide shot to a medium shot.

Cutaway A scene that is not part of the action being recorded but is related to the scene, often a reaction shot from onlookers.

D

Decibel (dB) A unit of measure of sound loudness.

Depth of field The area that appears in focus in a scene. In a very wide shot almost everything is in focus so the depth of field might be from 1 foot to infinity. A telephoto shot may have a depth of field of only a few inches. Depth of field usually includes the area one-third in front of and two-thirds in back of the point of focus. It changes with adjustments to focal length, aperture, and ISO.

Diaphragm The diaphragm is the collection of overlapping blades connected in a circular pattern that, when twisted, form a small opening in the center that increases or decreases the size of the aperture. Camcorders have electronic "blades." Nothing ever twists or opens or closes. The camcorder measures the light electronically and accepts only as much as it needs.

Digital zoom Camcorders have the ability to magnify the image on screen by zooming in on the pixels. The effect appears to increase the zoom range of the lens. But closely examined, the resulting image quality is reduced because individual pixels are being enlarged.

DV-AVI Digital Video-Audio/Video Interleaved. Because digital video is essentially a file of 1s and 0s, the video and audio information can be woven together, or interleaved, into one continuous file. DV-AVI is the best way to use the FireWire data transmission protocol.

Dynamic microphone A microphone that contains a diaphragm connected to either a voice coil or a piezoelectric crystal. The vibration of the diaphragm inside the microphone generates a small electric pulse that is sent to the camera and recorded as sound.

E

Enhancer filter Enhances warm tones such as reds and yellows and deemphasizes blues and greens. It is useful when shooting under fluorescent lighting.

Exposure The amount of light admitted to the camera to create the image. It is controlled by the iris, the shutter, and the gain control.

F

F-stop The ratio between the size of the aperture and the focal length of the lens. With each f-stop, regardless of the focal length or film format, the same measurement of light is reaching the film. Each change in f-stop indicates either a doubling or halving of the amount of light passing through the aperture of the lens. Therefore, f/11 is half as much as f/8 and f/5.6 is twice as much light as f/8.

Field one Half a video frame. The NTSC standard for video mandates 525 lines of information. The camera captures every other line in the first pass, which creates one field. On the second pass, the alternating lines are captured and then the two fields are interlaced to produce a frame.

Fill light The light source used to fill the shadows on the dark side of the subject.

FireWire An Apple computer term for the IEEE 1394 video protocol, which allows audio, video, and data such as time-code information to be delivered over a single cable. The same cable can also provide power. FireWire has simplified the connection of video recorders to computers through the use of a common language.

Focal length The distance from the imaging chip of the camera to the rear element of the lens. It is useful in computing the f-stops on the lens and is usually the benchmark for determining the telephoto capabilities of a lens. The longer the focal length, the greater the telephoto.

Focus The point at which rays of light, visualized as a cone, enter the lens and converge. The picture appears sharpest when the point converges precisely on the imaging chip of the camera.

Foreground interest Items that appear in the foreground and relate to the background. These pictures work best when shot with a wide-angle lens.

Frame two Fields of interlaced video consisting of 525 individual lines. The NTSC standard calls for 30 interlaced frames per second. The actual technical standard rate is 29.97 frames per second.

Frame The window through which the photographer sees life. The photographer fills the frame with visual information to tell a story.

Frame rate The number of film or video frames exposed within one second. The standard film frame rate is 24 frames per second. Video is recorded at a standard rate of 60 fields per second interlaced to produce 30 frames. Some video cameras can record at variable frame rates by exposing the chip for varying periods of time.

Fresnel Named for the French physicist Jean Augustin Fresnel, a lens that is placed in front of a light source to focus and direct the light.

G

Gain A method of measuring the increase in sensitivity of the image-sensing receiver chip in an electronic camera. Increasing gain brightens the scene, but it also adds unwanted video "noise."

Graduated filters Glass panes placed in front of the lens to alter the amount and, on occasion, the color of light entering the camera. Graduated filters typically are clear on the bottom and smoothly change to a color to tint the scene or a neutral gray to reduce the amount of light.

H

Halogen Lightbulbs containing a halogen gas into the bulb. The gas that interacts with the filament to produce a more intense light.

Hand microphone Also called a "stick mike." A handheld microphone placed near the speaker's mouth. Its sound-gathering ability is not enhanced electrically, so it is not able to amplify sounds farther away than a foot or two. It is rugged and will work in conditions that cause other more fragile microphones to fail.

Hard light Light shown directly from the source onto an object with no filtration or diffusion placed in between.

Hertz A measurement of the frequency of energy.

Hyper-cardioid A pattern of response to sounds around a microphone that resemble a narrow oval. It will accept sound in front while rejecting sounds from the sides and the back.

I

IEEE 1394 (See FireWire.)

Iris An adjustable metallic diaphragm used to vary the diameter of a central aperture to control the amount of light admitted from the camera lens.

Impedance The level of resistance to an electrical current. In the camcorder world, impedance is encountered when working with audio feeds to the camera from professional mixing boards or public-address systems.

Incandescent The description of a normal lightbulb, which glows by passing an electrical current through a tungsten filament.

J

Jump cut When two scenes are edited together—they are similar but contain different segments of the action—the actor will seem to "jump" from one place to the next when the scenes are played.

K

Kelvin The scientific color temperature scale developed by Lord Kelvin, a British physicist, which assigns a temperature to each wavelength of energy in the spectrum. The color temperature of the lowest-frequency visible light is in the 300° K range of near infrared light and extends through about 20,0000° K for near ultraviolet light. Videographers are concerned with temperatures between 2500° K of candlelight to 15,0000° K, the temperature of overcast high-altitude snowy days.

Key light The main light source providing illumination for the picture. The sun is the most popular key light for shooting outdoors. When shooting indoors, the photographer may use available light from fixtures or windows, or he may provide light of his own.

L

Lavaliere microphone A small condenser-powered microphone designed to clip onto, or be hidden beneath, the clothing of the speaker. It performs best when placed within a few inches of the speaker's mouth, and will reject most sounds from farther than a few feet away.

Lighting ratio The difference in the amount of light falling on the bright side and the dark side of an object. The difference is expressed as a ratio but measured in f-stops. A lighting ratio of 2:1 means that the bright side is twice as bright, or one f-stop brighter. One f-stop equals twice the light as the next-lower f-stop number.

Look The visual design of a project encompassing the color scheme, set design, camera type and movement, and use of sound.

Lux The measurement of the intensity of light expressed as the amount of light from one candle as seen from one meter away. A unit of illumination equal to 1 lumen per square meter; 0.0929 foot candle.

M

Medium shot The composition of a scene that is more intimate than a wide shot but not as close as a close-up. It is sometimes called a "two shot" because a typical medium shot would show two people talking.

Megabits (Mb) (See Bits.) One million bits. Used to describe huge blocks of binary information.

Megabytes (MB) (see Bytes.) One million bytes. Information flow rates in digitizing video information are referred to as "MB/sec."

N

Neutral density A filter designed to reduce the amount of light entering the lens without affecting the color of the scene.

Noise Unwanted grainy texture resembling the "snow" on a television set when tuned to an empty channel. Noise is most often seen when the gain is increased in the camera.

NTSC The abbreviation of National Television Standards Commission, the governing body that set the standards for television broadcasting. As it relates to video recording, NTSC defines the number of scan lines on the television screen and the rate at which they are scanned. The NTSC standard is 525 scan lines at 60 Hertz (cycles per second).

O

Omni-directional microphone A pattern of response in a microphone that is equal in sensitivity in all directions. A common pattern in non-powered handheld dynamic microphone.

Optical The term refers to the capabilities of a zoom lens. A 10X lens is capable of producing a telephoto focal length 10 times the widest angle. If the widest angle is 10 mm, then the longest focal length is 100 mm.

P

Pan Moving the camera from side to side.

Peak The term used to affirm that the audio level has reached its loudest and the measured level on the meter of the audio-recording device (mixer, DAT, MP3, or camcorder) has reached its highest point. Audio levels should peak at "0 dB" on the meter. Levels on digital recording devices should peak at "-7 dB."

Pixel A single sensor that gathers light on the imaging chip and assembles it into a picture. The quality of an imaging chip is expressed by the number of pixels it has. A 5 megapixel chip will have 5 million light-sensitive pixels.

Plane of focus The specific distance from the camera at which the image is in focus.

Point of view In photography, the position from which the camera observes.

Polarizer filter A filter that fits on the front of a lens, which, when rotated, allows only light polarized in a specific direction to enter. It can darken a blue sky and make blue and green colors richer and more vivid.

Progressive scan A method of recording video in which the picture is a complete non-interlaced frame. The normal method of recording video is 60 fields per second interlaced to produce 30 frames.

R

Rack focus A technique for changing the plane of focus during a shot to shift emphasis. For instance, a shot of a flower might slowly change into a shot of a city skyline in the background by changing the plane of focus.

RCA Plug The RCA or UHF plug is used to carry analog audio and video signals into the camcorder. There may be three plugs in a wiring harness included with the camcorder: red, white, and yellow. The red and white plugs carry audio and the yellow plug carries video.

Reflector A shiny or white surface that reflects light onto a subject.

Rule of thirds A reminder for composing scenes. Imagine overlaying a tic-tac-toe grid on the picture and placing the center of interest in one of the areas surrounding the center block. Avoid putting the center of interest in the middle block.

S

Screen direction The direction of the action within the frame or the perceived direction of action inferred by the way a subject is placed in the frame—even if it is not moving. A person looking from left to right is considered to have a screen direction of left to right.

Sequence The assembly of several scenes into a visual story. A typical sequence begins with a wide shot, followed by a medium shot, then a close-up.

Shotgun A microphone designed to capture sounds from several feet away. It is also known by pros as a cardioid or hyper-cardioid microphone.

Shutter speed The length of time the shutter opens to allow light to reach the receiving chip inside the camera. Speeds are measured in fractions of a second, such as 1/30, 1/250 of a second.

Soft effects filters Filters designed to soften the image. They have names such as Soft FX, Promist, and Black and White Nets. Each filtration method has a slightly different look, but all accomplish the same thing.

Soft light Light that is filtered or diffused in some manner between the light source and the object being lit.

Sound bite Slang term for a short piece of narration or interview that can be inserted into a video to help illustrate a point or advance the story.

Stereo microphone An omnidirectional microphone, which records sound coming from any direction, that is mounted on the front of the camera.

Stereo pin plug A popular three-tip plug on camcorders, which carries audio signals on two connectors and a ground on the third.

Super-cardioid A pattern of response to sounds around a microphone that resembles an elongated oval. The microphone will accept sound from in front better than from the sides or the back.

T

Three-light setup The basic arrangement from which all lighting scenarios are derived. It is comprised of a key light, a fill light, and a back (or kicker) light.

Tilt The movement of the camera when the tripod is rotated up and down.

Time code An identifying number given to each individual frame of video that makes it unique from all others on the reel. Time code is based on the clock, so the maximum number it can display is 23:59:59:29.

Timeline A graphic representation of the video and audio tracks in a non-linear edit system. Each video or audio clip is displayed and referenced to a horizontal line that contains the time-code number of each minute, second, and frame of the story.

Tone An audio signal used to calibrate the audio record and playback levels. The standard tone is 1000 hertz, or 1000 cycles per second. It is recorded at 0 dB on the VU meter of the camcorder.

Transition a) Any change in the visual or audio portions of a story. A cut is considered a transition by some videographers. Other transitions might include dissolves, wipes, spins, and other effects. b) A technique used to affect a change of scenery or emotion. One example of transition is a person exiting frame, then reappearing in frame in a different location.

V

Videography The art of using video to report, document, or tell stories about people and events.

VU An acronym for volume unit. The scale on the meter used to measure sound loudness is measured in volume units and is called a VU meter. 0 dB on the VU meter is considered the standard for the highest level safely recorded. It is the level at which a tone is recorded as the benchmark for the sound recorded onto the tape. Anyone playing back the tape on any machine can calibrate the playback machine to match the camcorder level and receive an accurate playback.

W

White balance The video camera must be calibrated according to the type of light in which it is being used. Placing a white card or sheet of paper in front of the lens and pressing the white balance button will accomplish this. The camera will adjust all other colors compared to white.

Wide shot A scene that displays a wide area. The wide shot is most often used as an establishing shot to begin a sequence. It sets the place and time of an event. A typical wide shot might show the exterior of a building or a whole soccer field.

Wireless microphone A radio transmitter that connects to a microphone. Audio is transmitted to the camcorder and received on a matching receiver. The transmitter can come in a variety of shapes and sizes, but most are small enough to fit in a pocket or clip to a belt.

X

XLR plug The standard plug for professional recording. It has three pins and is used to produce a "balanced" signal. A balanced signal has two conductors with equal currents running in each direction, plus a ground wire. An "unbalanced" signal uses only two wires with current running on one and the ground on the other.

Z

Zoom The method by which a variable focal-length lens changes its angle of view.

Zoom lenses All cameras except those designed for professional movie-making are fitted with a zoom lens. The zoom lens can be thought of as several prime lenses packaged into one. The lens can be set on wide angle, medium focal length, or telephoto.

INDEX

PHOTO CREDITS

All photographs by Bob Brandon except:

Christopher L. Cook: 33, 95, 101, 103, 105, 144-151

Karen Prince: 51, 52, 61, 64, 67, 71, 72, 73, 74, 77, 78, 82-83, 84-85, 94, 98, 102, 104

Chuck Richardson: 36, 39, 50, 96, 103, 111

Gail Greainer: 37, 49

Sean Moore: 37, 71, 74, 82-85, 86, 87, 99, 104

Michael Stern: 44

Michael Wright: 66, 67, 70, 75, 86-88, 91, 92, 93, 95, 102, 104

Christine Bender: 59, 104

Jim Hobbs: 104

Drew Noah: 174-176

Joaquín Ramon Herrera: 28, 30, 31, 127, 135, 172, 224

Wolf Camera: 93–95, 99, 102

Mark Morache: 116-117

Mike Simon & Lorie Hirose, Simon Productions: 162-165

ACKNOWLEDGMENTS

It all began serendipitously for me. I was working my way through college at West Texas State University as a salesman at J. C. Penney & Co. I had been there a while and thought I deserved a raise, so I made an appointment with the store manager and made my case. He refused. In a pique of anger, I quit.

It suddenly hit me a few hours later—I had to have a job or I could not afford school. I had joined a fraternity in my freshman year and an alumnus of the fraternity, a commercial photographer and filmmaker named Bill Rhew, had become a friend and mentor. I stopped by his office that evening and was lamenting my predicament when he said he thought the local television station, KGNC, was looking for someone. He asked if I would be interested and I said yes. I didn't really care what job they gave me; it sounded exotic and I needed the money.

Rhew arranged for an interview. They must have liked me, or maybe they were just desperate, because they hired me on the spot. I was told to report to work the next afternoon in the News Department. The News Department!

I arrived early not knowing quite what to expect. KGNC was a combination radio and television station and the news department served both. The news director surprised me with my first assignment. I was to gather football game scores from all the high school games that evening, write the reports, and deliver them live on the air on radio! I was terrified. In the first place, I did not have a clue how to gather the scores and knew even less about writing for radio. Moreover, my west Texas accent was thick enough to cut with a butter knife. I was thankful that my radio audience was comprised of like-speaking west Texans who could understand me.

I survived that first night and then began an odyssey that continues to this day. I greet each day as a new adventure because I never know what I will be doing. My second day on the job at KGNC someone handed me a Bell & Howell model 70DR 16-mm film camera and told me to go cover the story of the premature arson of a local high school's homecoming bonfire. A prankster had maliciously set fire to the huge pile of boxes and boards the day before the scheduled celebration. I grabbed the camera and leaped for the news cruiser to drive across town to the high school. The cruiser was Walter Mitty's dream ship. It had police-radio monitors and two-way radios to the station and to the sheriff's office. It even had a rotating orange caution light on the roof and antennas hanging from the trunk lid and bumpers. It was the closest thing to a Batmobile that I would ever be allowed near. I presumed I was supposed to turn on the light and race to the scene. The one thing I didn't know was what to do when I got there.

Bell & Howell designed the 70DR as the 16-mm successor to the 35-mm version used by combat photographers in World War II. It was spring driven and would run for about 25 seconds before it needed winding. It did not have the option of looking through the lens with a viewfinder. Instead, it had a surrogate lens mounted alongside the real lens through which the photographer composed his shot. There were three lenses mounted on a turret and consequently three viewfinder surrogates on a smaller turret. Gears connected the two turrets so that the viewfinder turrets turned in sync with the lens turret. However, turrets could sometimes get out of sync and the photographer would be looking through the wrong viewfinder lens. And it was on my first film assignment. I was looking through the viewfinder for the wide-angle lens when in fact, the image in the telephoto lens was what the camera saw. The result was 100 feet of overexposed out-of-focus mush. I was devastated.

The newsroom was nowhere as upset as I was about the travesty of the bonfire footage loss. One gentle soul, another photographer named Tom Higley, took the time to explain to me what I had done wrong. It would be something Tom would later regret, because he spent the next three years explaining many things to me. I pestered him daily with questions. There was a lot to learn and I was impatient.

Tom was one of many men and women who have endured my impatience with forbearance and wisdom. Bill Rhew, who launched my voyage, also initiated me to the concept of looking "inside the box" to compose images. He was the first person I knew to shape a rudimentary frame with his hands and squint through it to imagine what could be placed there. Dick Risenhoover was news director and guided me for much of my four-year tenure at KGNC. Risenhoover later left to become the voice of the new Texas Rangers baseball team. He was as thorough a reporter as I have met. He demanded the best of everyone, including himself, and we all worked our tails off to give our best because he deserved it. Dick persuaded the station to hire a linguist, Dr. Willis Clark, a professor of speech at West Texas State, to teach us the magic of proper grammar and sentence construction. He monitored all our newscasts and wrote a weekly critique of our work. Dr. Clark may have had

a command of the English language but diplomacy and discretion were not his strong suits. He spoke plainly when describing our deficits, but I learned more from those critiques than from any book on the subject.

Risenhoover saw something in me worth developing, so he arranged for private lessons with Dr. Clark. I had no future in broadcasting with my accent. Even the word "accent" would come out of my mouth sounding like "aak-sieant." Dr. Clark hammered, pounded, bent and shaped my voice into something resembling a Midwestern accent, which was the preferred dialect. It was not an easy process and I suspect Willis regretted taking me on but he never said so.

Dick was also responsible for my "magical week." He persuaded me to attend a news photography workshop at the University of Oklahoma. He had to convince me that spending a week in Oklahoma was a good thing. By 1969 I had become something of a local celebrity and was sure I was on track to become a network correspondent. The Oklahoma workshop was as close to boot camp as one could come without joining the Marine Corps. The instruction was intense, unrelenting, and long, lasting well into the night every night. Each photographer shot an assignment, which members of the faculty critiqued. The critiques were brutal. The faculty rarely found compliments but rather focused on areas needing improvement. Our class certainly needed improvement. I remember one frustrated critiquer who had promised himself he was going to find something nice to say to each student. One poor hapless fellow shot a story so badly the teacher turned to him and said, "You sure have nice teeth." But as heartless as they sound, the critiques drove home to a few of us the basics of storytelling. One guy was asked at the end of his story, "Do you have any other skills, any other way you could make a living?" That guy is Darrell Barton who left the workshop with a fire in his belly so hot that he eventually was named Photographer of the Year twice. Photographer of the Year is the highest honor a news photographer can receive.

It was a magical week, a week that turned my head forever from being a network correspondent to becoming the best news photographer I could be. One fellow, Ernie Crisp, stood head and shoulders above the rest of the faculty. Ernie was liked and respected by everyone at the workshop because he was the only one who had been there and done that. He was a Photographer of the Year. Ernie had worked at KWKY Television in Oklahoma City before joining the staff

of the Eastman Kodak Company as an instructor. He was paid to take knuckleheads like me and make news photographers out of us. However, to Ernie it was more than a job. Ernie loved telling stories on film. The only time he was happier was when he was at the stick of his restored 1938 Waco biplane. Ernie left an impression on me that sticks to this day. I left Oklahoma that spring of 1969 a changed man. I was filled with fire and could not wait to shoot my first assignment of my new life. I have never looked back. I don't regret for a minute my pursuit of photography instead of television anchordom. In storytelling, I found my passion.

Soon after Oklahoma, a fellow photographer at the workshop, Frank Dobbs, recommended me for a job at KPRC Television in Houston. I climbed behind the wheel of my 1964 Ford and slammed the door on the west Texas wind for the last time in January of 1970. Fourteen hours later, I arrived in Houston—a different world. Incessant wind was replaced by persistent humidity. The brown earth had turned lush green with bugs and critters everywhere.

I was figuratively, then literally, thrown from the frying pan into the fire. Almost immediately, after I began work at KPRC race riots broke out in different parts of the city. Police battled with a particularly ferocious group linked to the Black Panther radical organization. I spent a very long night underneath a police car in the middle of an intersection with bullets splattering onto the pavement around the car. It was a real revelation for me. I was growing up in a hurry. The police eventually stormed the building where the snipers were holed up. They killed one sniper and arrested several others and the long night was over. But it is vivid in my mind to this day.

My new boss was Ray Miller, an ex-submariner who ran his newsroom in much the same way he ran his boat. There was a dress code. Everyone wore a tie. He relented on coats only because it was 99 degrees and 99 percent humidity outside. Every day we appeared in front of his desk to receive our assignment. It would be a hard-news story because Ray was not a feature piece kind of guy. There was no shortage of hard-news stories in Houston in the '70s. The city was enveloped in an oil boom. It was the age of the urban cowboy. Gilley's was the honky-tonk of choice. Things were happening everywhere. Ray was the best News Director for whom I ever worked. His ethics were unimpeached. He had a nose for a good news story like a bloodhound. His leadership was respected and honored nationwide. Awards for excellence in journalism covered the walls of the newsroom.

Ray taught me the gift of skepticism. I came from innocent and honorable surroundings in rural west Texas where the mere thought of someone telling a lie was abominable. But he taught me quickly how easily the media could be used and abused by a person with an agenda, how to work to get both sides of the story, to verify all our facts with two sources—all the basics of good journalism.

I was blessed with several mentors at KPRC, among them Jack Long, my chief photographer; Fred Edison; Ron Stone; Larry Rasco; Steve Smith; Gary James—the list goes on and on.

I stayed at Channel Two for nine years. Toward the end of my local television adventure, I felt I had reached a plateau and was not growing as a storyteller. I found myself covering the same stories every year—the livestock show and rodeo, the Homebuilders Association convention, and the football games and baseball games. My options were to seek another job in another city, a lateral move in my eyes, or find a way to shoot larger projects for bigger and more demanding clients. I decided to try my hand at freelancing. It cost an unheard of $60,000 to buy the equipment necessary to shoot for clients such as NBC News or ABC News 20/20, but I took the gamble, borrowed the money, and made some phone calls to people I had met at the networks. Before long, I was packing my gear onto airplanes and flying around the country covering stories and shooting documentaries. It was the best decision I ever made. I shot exciting assignments and worked with the best in the business. I will be eternally grateful to people like Bob Dotson, Charlie Thompson, Sid Feders, Bert Medley, George Lewis, and Tom Jarriel for their help along the way.

In 1980, ABC News 20/20 called me to shoot their coverage of the explosion of the Mount St. Helens volcano. We were the first crew on the mountain after the blast. We flew in with a search-and-rescue team looking for some missing miners whose shack was on a slope facing the volcano and about a mile from the crater. We found them, but they were long past any help we could offer. They were buried under three feet of hot ash. Our story detailed the use of a search dog that helped locate the bodies. Search-and-rescue dogs were still a novelty at that time. But we were nearly trapped up on the mountain. As we were flying back to base camp the volcano erupted a second time, covering the area we had just left with another three feet of ash. The ash fell like a blizzard all the next day. We had to travel from Chehalis, Oregon to Portland for our flight home. The two-hour drive

took us eight hours because we had to stop every couple of miles to clear ash from the radiator and change the air filter. The piece ran for 25 minutes that Friday night. We were all pretty proud of ourselves.

The show 20/20 really liked our work, so we spent lots of time with them over the next few years. We did an hour documentary on the death of Elvis, which named for the first time Dr. Nikopolis as Elvis' drug provider. We did a piece on newfound tensions between locals along the Texas Gulf Coast and newly arrived Vietnamese crab anglers. We did a story on the newest Trident submarine, and copper mining in Chile.

The years from 1980 to 1999 all just seem to blend into a kaleidoscope of colors and forms. I cannot even begin to remember all the stories I covered. The highlights include: covering every president since Nixon; watching the Berlin Wall fall, Nelson Mandela walk free from prison, and the Pope meet Gorbachev. I have spent time in most of the North and South American countries, Western Europe, and parts of the Middle East and Africa.

These days I am shooting fewer network assignments and more commercials, corporate projects, and doing some teaching and writing. This new crook in the road has led me to an incredibly creative crowd of writers and editors at Hylas Publishing. They have grabbed my hand and yanked me along as we assembled this book. I want to thank Sean Moore, the publisher, for taking the chance on a first-time writer. My project editor, Gail Greiner, has been my cheerleader—the person in charge of picking up the pieces. David Perry, Gus Yoo, Joaquin Herrera, Loraine Machlin, Edwin Kuo, Wayne Ellis, Lori Baird, and Karen Prince have filled in all the creative gaps—and there were plenty—that developed in the process.

Thanks, too, to the talented folks at Reader's Digest who shepherded this project along and added their invaluable input, namely Kim Casey, George McKeon, and Dolores York.

But my special thanks go to my editor, Marjorie Galen. She soothed my tirades with a gentle, "I know, I know," and steered me back to the work at hand. It is no exaggeration to say that without her this book would not have been completed. My life long friend and advisor, Sid Feders, will continue to play a pivotal role in this effort as we take the Shoot Like A Pro video concept into other venues. Sid's counsel has been invaluable. And of course there is Mom, Lillie, down there in Texas, patiently waiting to see herself in a book. Who would have ever thought the day would come?